FIGHTER.

FIGHTER.

The Fighters of the UFC

REED KRAKOFF
Foreword by Sam Sheridan
Interviews by Rachel Felder

VIKING STUDIO

VIKING STUDIO
Published by the Penguin Group
Penguin Group (USA) Inc., 375 Hudson Street, New York, New York 10014, U.S.A.
Penguin Group (Canada), 90 Eglinton Avenue East, Suite 700, Toronto, Ontario, Canada M4P 2Y3
 (a division of Pearson Penguin Canada Inc.)
Penguin Books Ltd, 80 Strand, London WC2R 0RL, England
Penguin Ireland, 25 St. Stephen's Green, Dublin 2, Ireland (a division of Penguin Books Ltd)
Penguin Books Australia Ltd, 250 Camberwell Road, Camberwell, Victoria 3124, Australia
 (a division of Pearson Australia Group Pty Ltd)
Penguin Books India Pvt Ltd, 11 Community Centre, Panchsheel Park, New Delhi – 110 017, India
Penguin Group (NZ), 67 Apollo Drive, Rosedale, North Shore 0632, New Zealand
 (a division of Pearson New Zealand Ltd)
Penguin Books (South Africa) (Pty) Ltd, 24 Sturdee Avenue, Rosebank, Johannesburg 2196, South Africa

Penguin Books Ltd, Registered Offices: 80 Strand, London WC2R 0RL, England

First published in 2008 by Viking Studio, a member of Penguin Group (USA) Inc.

10 9 8 7 6 5 4 3 2 1

Copyright © Coach, 2008
All rights reserved

ISBN 978-0-670-02043-0

Printed in Spain by Imago
Set in Andale Mono-Regular
Designed by Rebecca Wong Young

contents

foreword

Fighting is about the truth. At its heart, stripped down to the essentials, it's a collision of realities. You have yours—who you are, what you will do—and he has his. Only one reality survives this meeting. We call it a sport, but it's more than that. It's a sanctified version of the most primal spectacle in human myth and history: alpha male against alpha male. In a ring, in a cage, the truth will out. It is a stage for artists, rendered with extreme emotion and desperate struggle.

The Ultimate Fighting Championship, first held in 1993, was billed as a contest to see who was the toughest guy with the deadliest style. Anything goes; and the world would finally find out whether a boxer could beat a kung-fu master, or a sumo could beat a wrestler.

Two men entered the Octagon (the chain-link cage named for its shape), and they fought with punches and kicks, knees and elbows. If the fight went to the ground, they continued to fight, they wrestled and choked. It was, and is, simple and pure.

The UFC, developed in part by Rorion Gracie, was essentially an extension of the Gracie Challenge in Rio de Janeiro, as the Gracie family had developed its own particular version of jujitsu and issued public challenges to practitioners of any and all other martial arts, to fight *vale tudo* ("anything goes" in Portuguese). These fights were a step back into history, closer to a real fight without rules.

The first UFC was won not by the biggest and baddest man in the competition but by the slender Brazilian Royce Gracie. He relentlessly brought the fight to the ground, where he dismantled his opponents. It was strangely spectacular, and it convulsed the fighting world. He didn't win with the big clean knockouts or flying kicks people expected from kung-fu films, but the audience could sense the truth of what happened. The vaunted karate black belts and professional boxers were helpless once the fight hit the mat. The UFC's effect on the martial arts world was nothing short of revolutionary.

In the last few years, the UFC made its way from pay-per-view onto cable TV and into mainstream America. The fighters are doing something real, creating (and rediscovering) a real sport with all the technical virtuosity of professional boxing, or kick-boxing, or Olympic wrestling, judo, and more. There is an art and science behind what they do, playing an endlessly profound technical game, from the striking into the clinch to the takedown to the groundwork. There is a strength-and-conditioning component that is unrivaled in any sport. Combine that with the savage ferocity of a life-and-death struggle and you have the UFC.

The fighters, the subject of this book, are the ones who made it happen.

What an artist does is about the truth—and it takes a real photographer, a great one, to reveal truth in his pictures, to find it and hunt it down, to weasel it out. For longtime mixed martial arts fans who think "Oh, more pictures of fighters" and who know all these faces, I say this: Look again. Look closely. It takes a minute to appreciate what Reed has done.

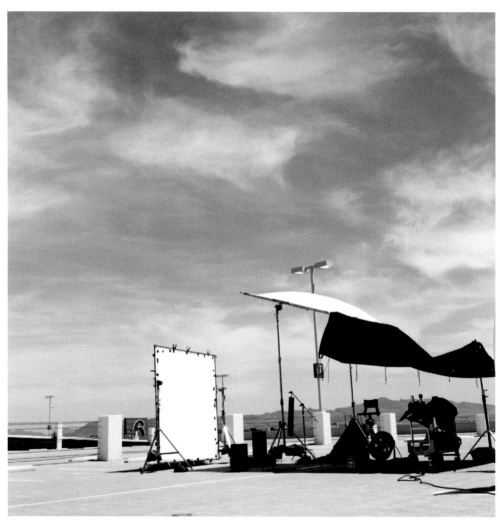

Photoshoot Set. Las Vegas, Nevada, May 2007.

On the faces of the fighters there is confusion, trepidation, sorrow, moments of doubt. But also acceptance, and perhaps calmness. The pictures look past the savage appearance, the tattoos and scars, to find the ordinary person—uncertain men going forward in uncertainty, just like you and me.

Reed has revealed the humanity and caught the truth, giving proof to the superstitious dread that a photo could capture a soul. There is Dana White, the sometimes abrasive president of the UFC, revealed for what he truly is first and foremost: the UFC's biggest fan. Quinton Jackson's face betrays his wry self-aware humor, tempered with an iron resolve that he has proved beyond question. Georges St-Pierre's face shows a young man, almost intoxicated with his own physical gifts, maturing before our eyes, acquiring wisdom and coming into his own.

Reed told me, "I saw it was just a cross section of humanity, no different from any other profession, a mix of personalities. There is a timelessness and purity to their lives."

These purveyors of violence, proven masters of their craft, we see here as ourselves, as ordinary men who proceed in doubt and fear. Our greatest heroes are those who do so—icons with feet of clay. A hero prevails because of his heart, his belief in himself, and his truth—that free will is the most important thing to a man. A fight at its core is about free will. If you've been knocked out, or submitted, you've lost control of your fate.

A professional fighter has to be aware of his identity; he has to be in touch with the truth of who he is, literally for his own survival. If you're a top-flight jujitsu guy, don't stand and trade blows with a knockout artist. Make him play your game, understand who you are.

The fighter comes to know that fighting isn't so much about destroying someone else as it's about perfecting himself. If his defense and offense are perfect, and his conditioning is at its peak, then there is no limit to what he can do, to whom he can fight and beat. The opponent is just the other, the test. The stronger he is, the better the test for you. UFC fighters ultimately love and respect one another because they provide one another with this test. It takes a certain type of man to seek that out, and fighters have more in common than not. They share a mutual respect for the long road they've all walked—the thousands of hours of mat time, the bag work, the road work, sparring and drilling; the bruises, breaks, and blood.

Fighting is about the truth, as are these pictures. In a fight in a cage, the truth will out. If you're not prepared, we'll find out. If he's stronger, we'll find out. Reed has captured an essence of the men who have the ability and drive to fight at that level; the demons, the devils, and the savage joy. They are just men, in the end—they are you and me.

SAM SHERIDAN

ice man

Train hard, fight hard, play hard.

—CHUCK LIDDELL

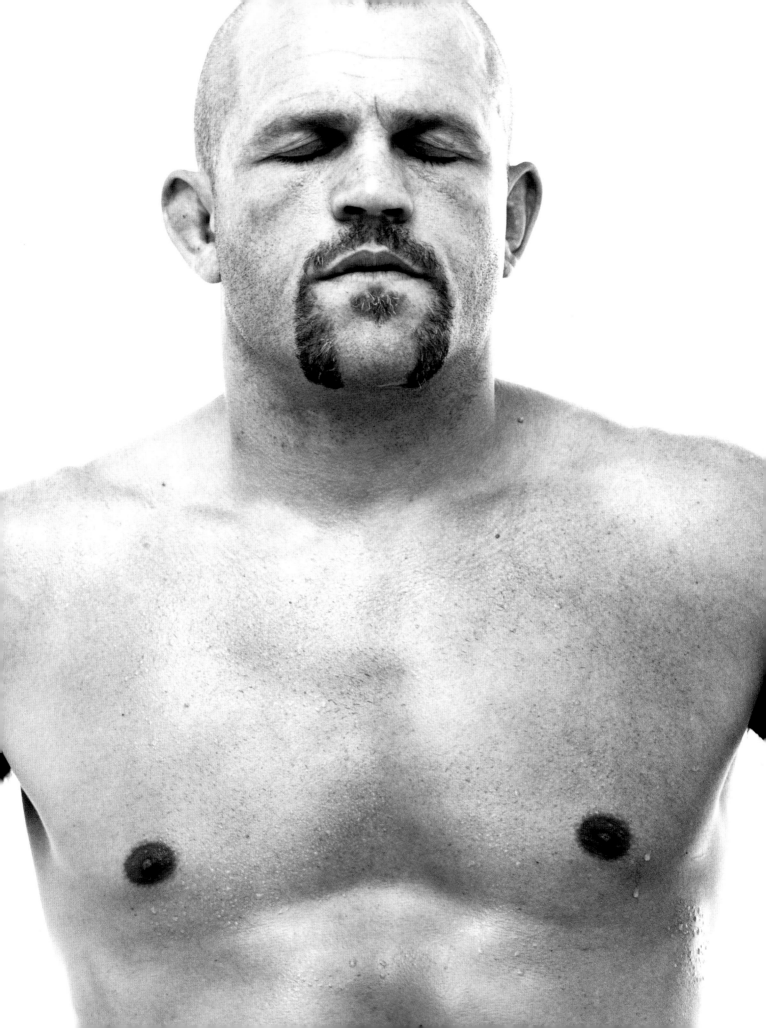

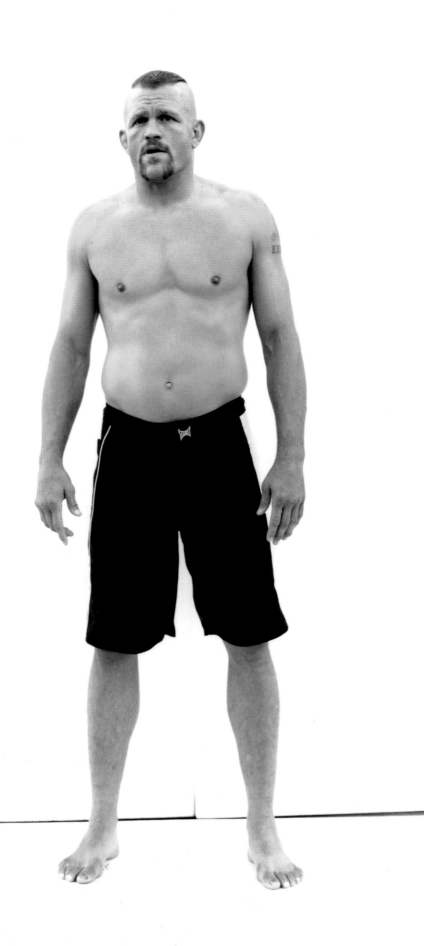

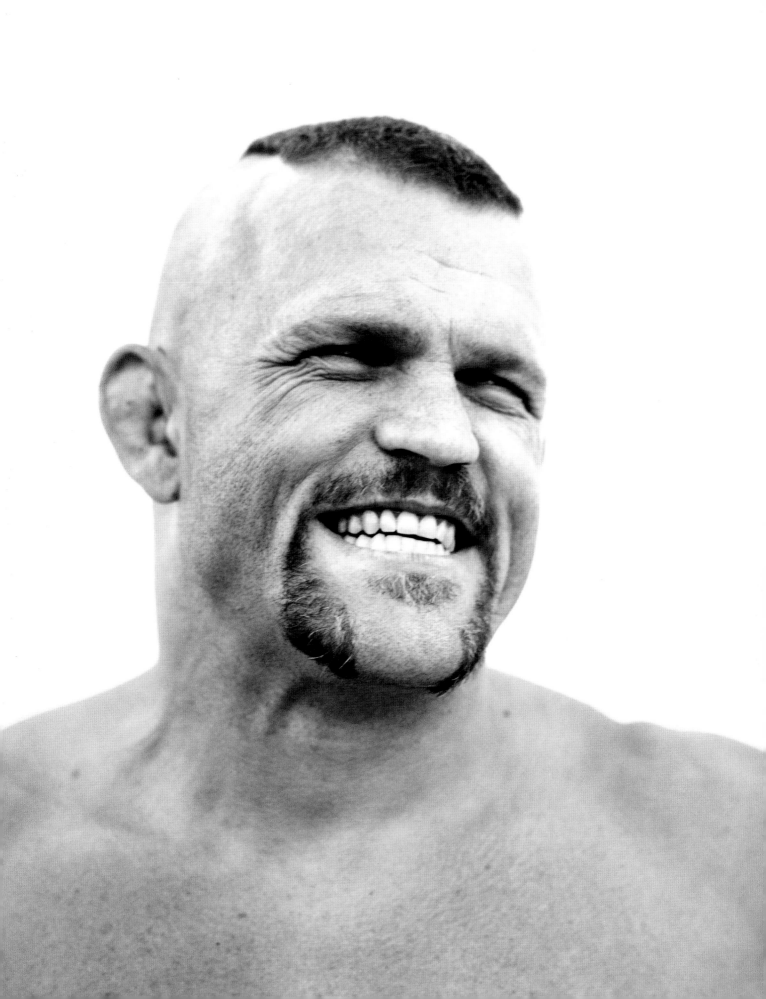

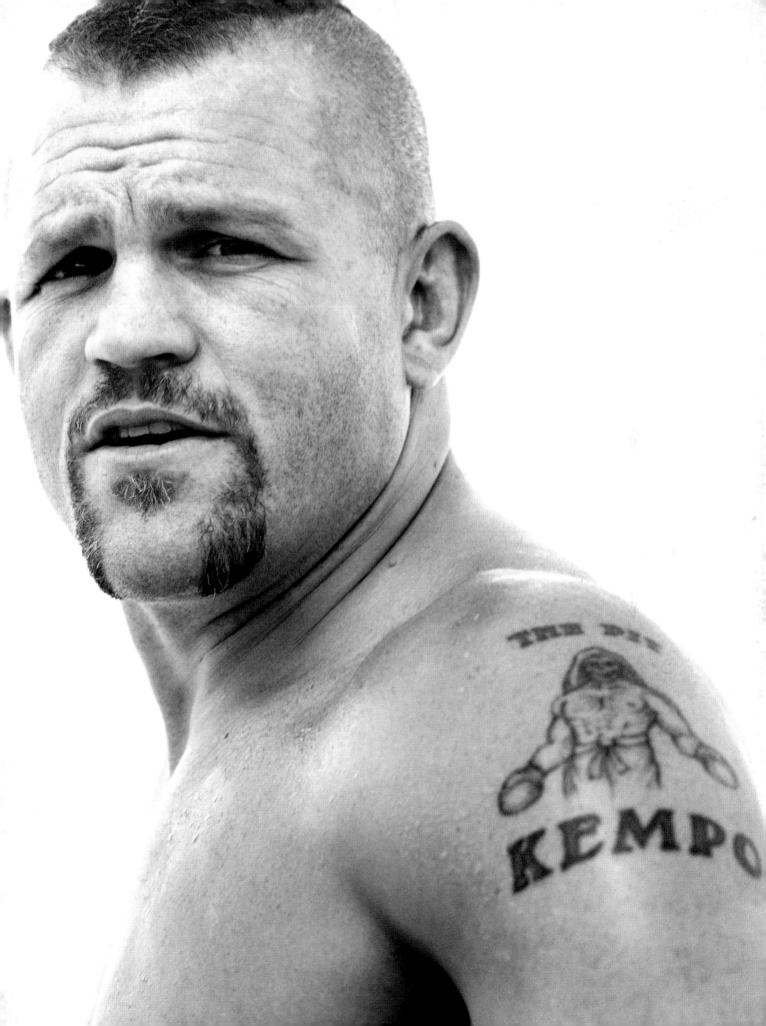

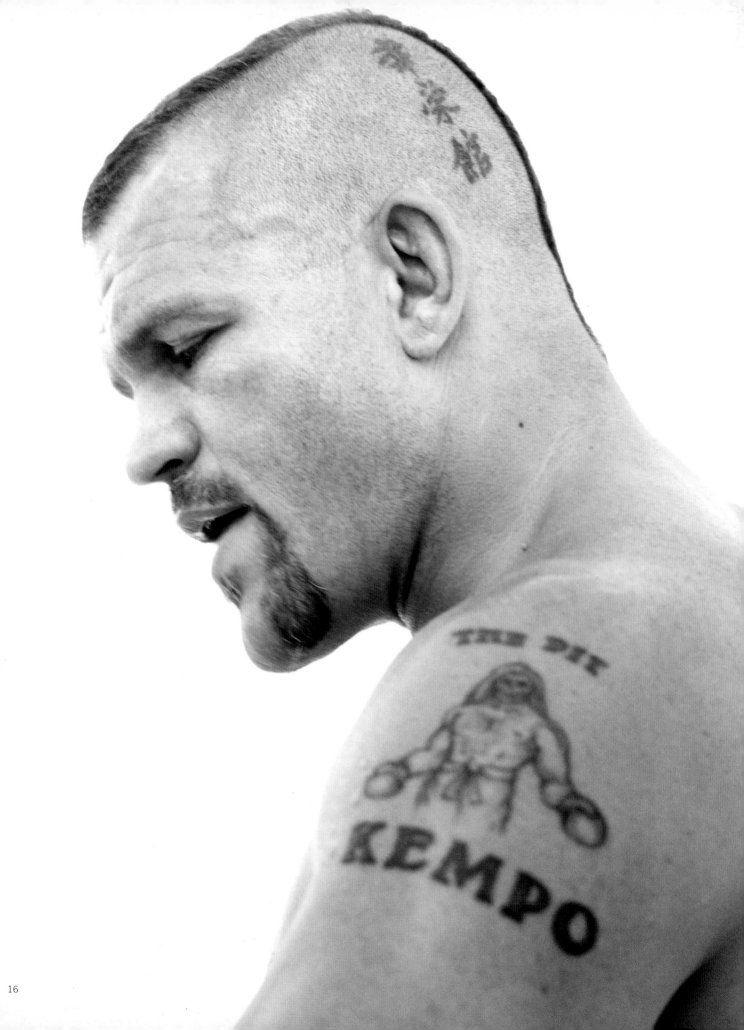

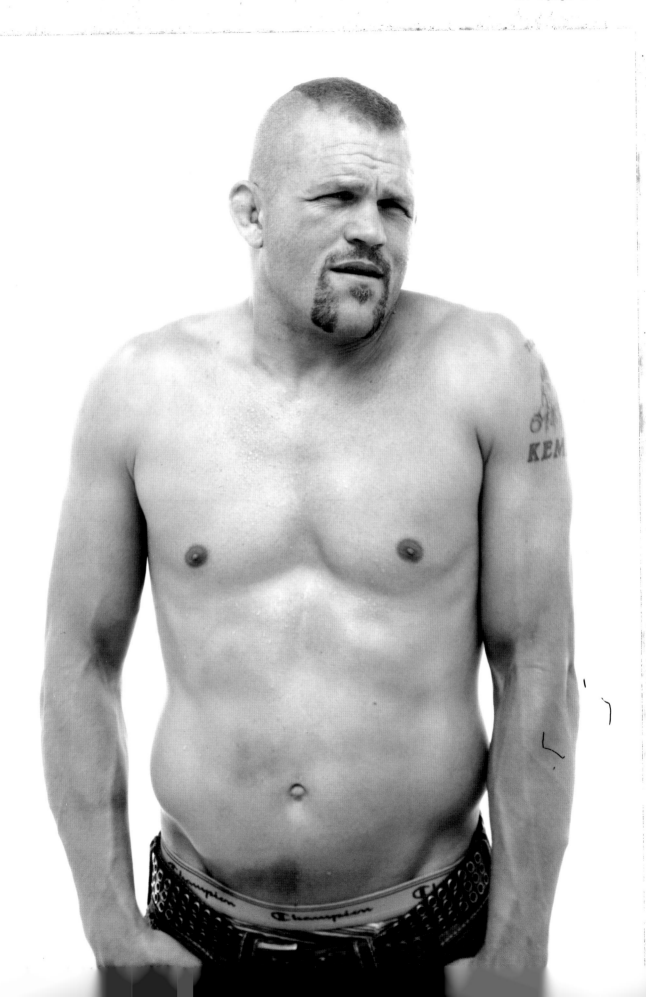

night

I grew up fighting. I was always the type of person who wanted to fight the biggest guy.

mare

—DIEGO SANCHEZ

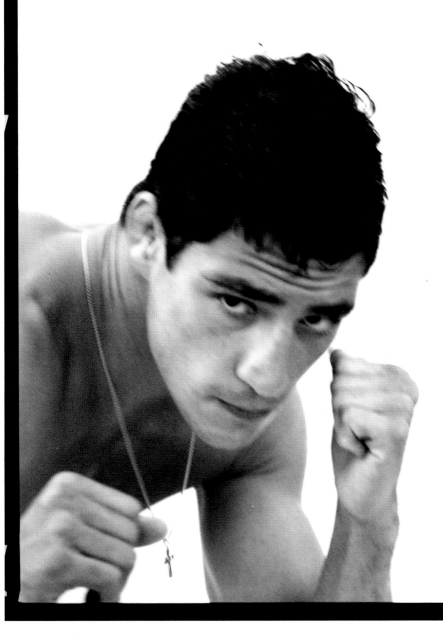

KP

44

KODAK 320TXP

45

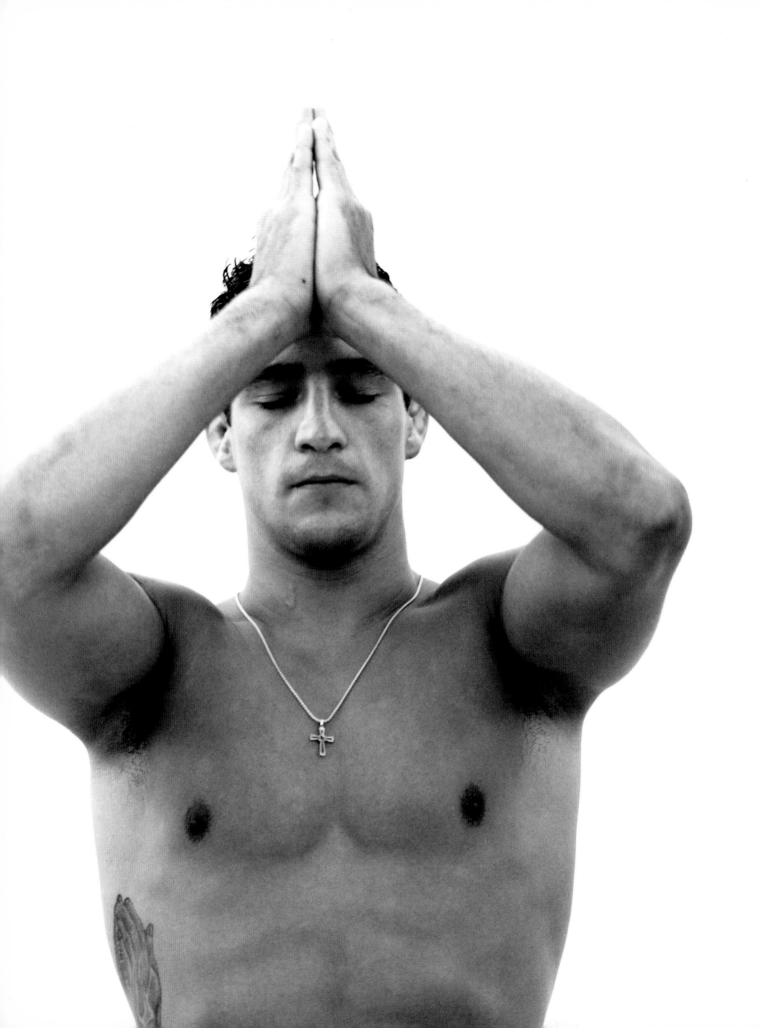

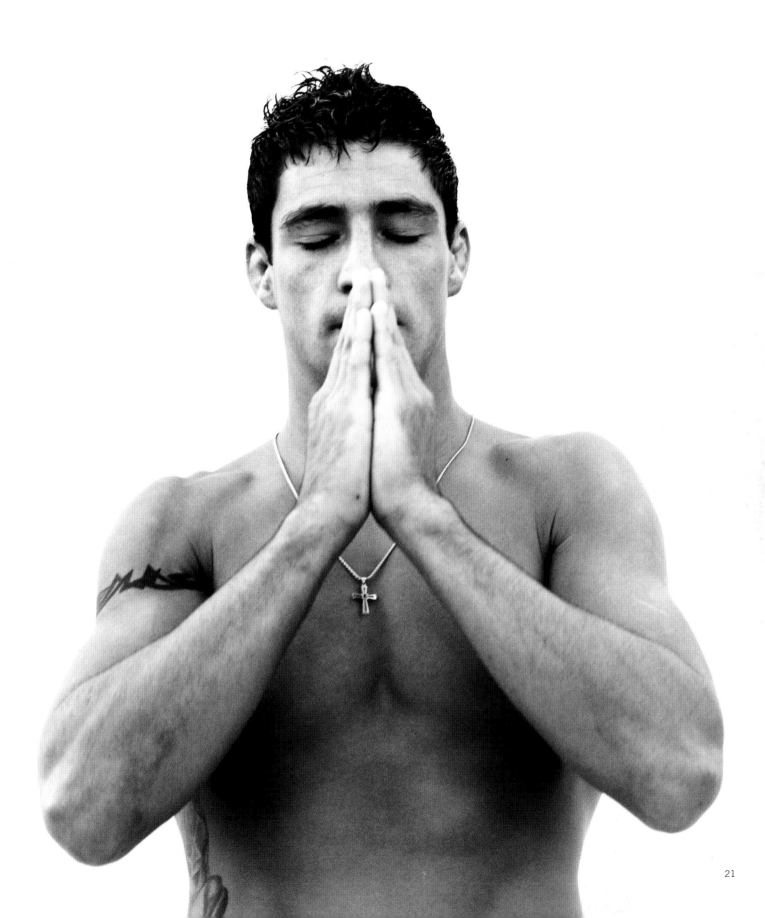

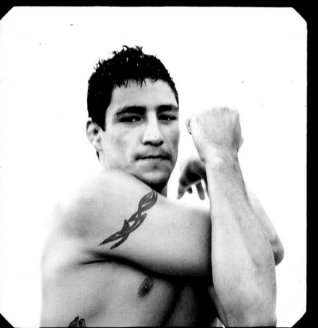
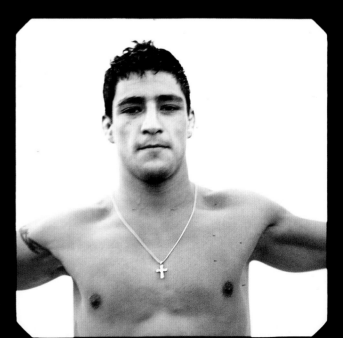

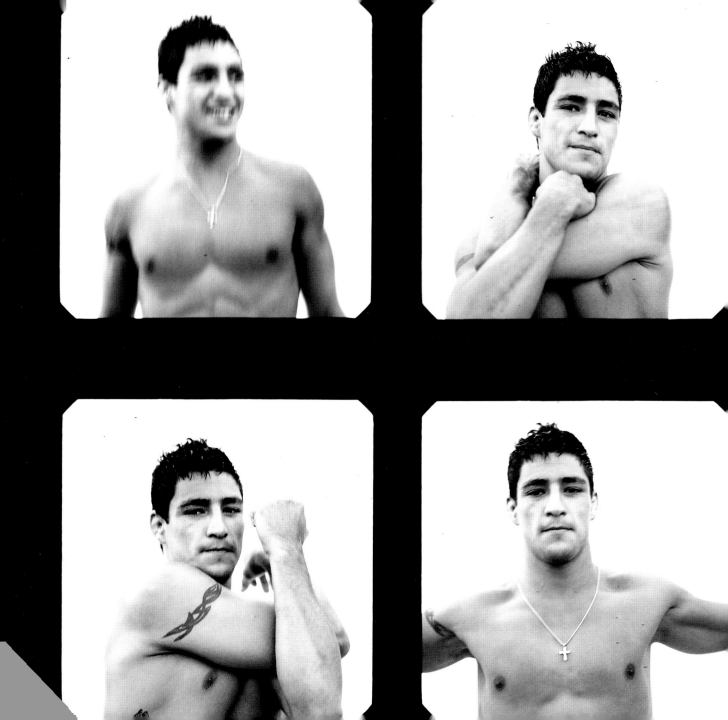

hendo

'm trying to **improve** all the time. If I quit striving to
mprove, then I should retire.

—DAN HENDERSON

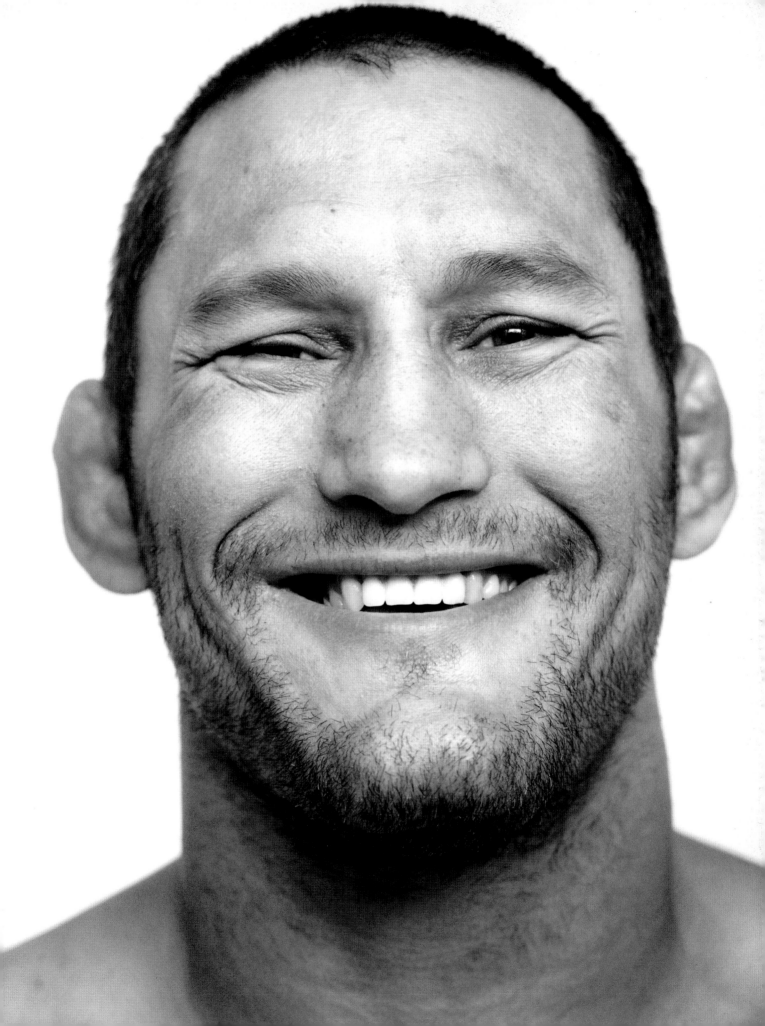

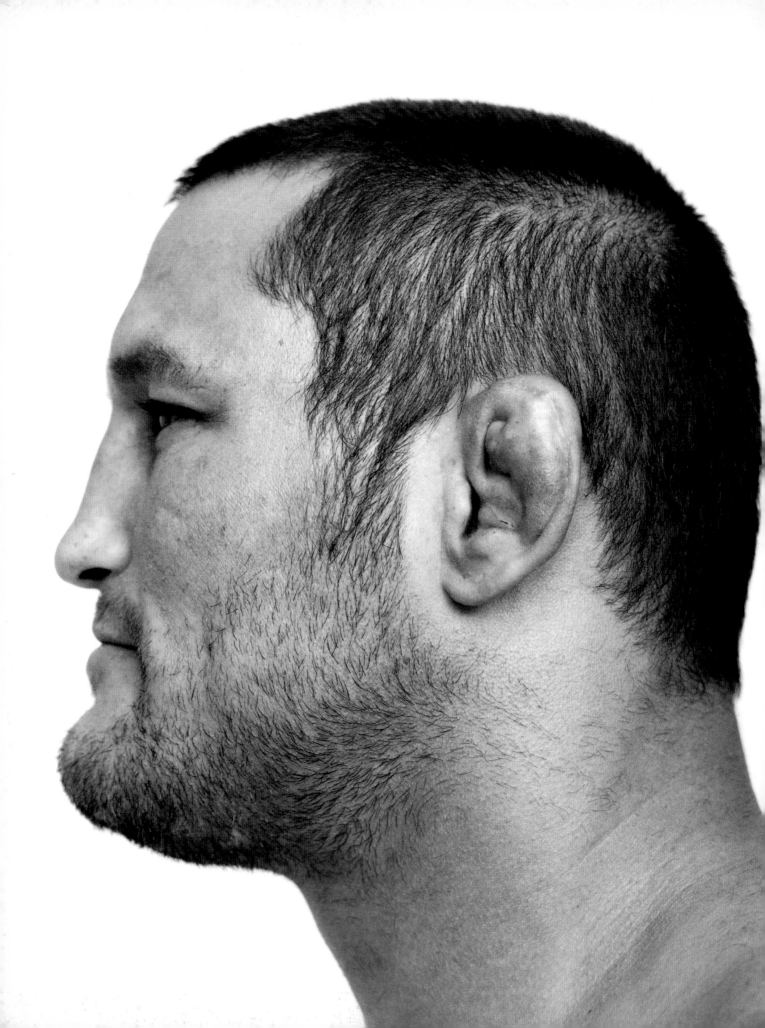

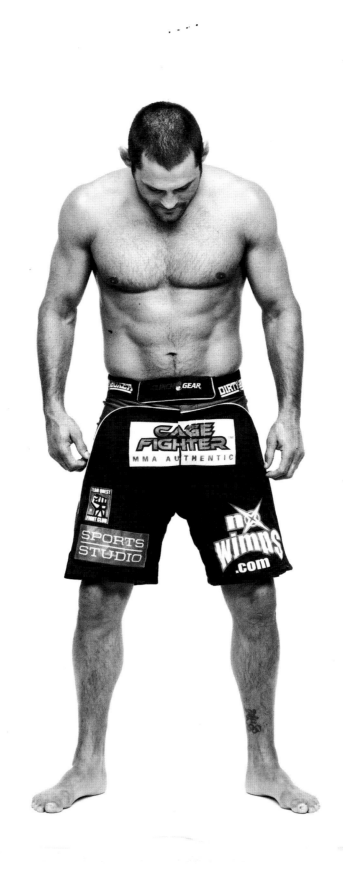

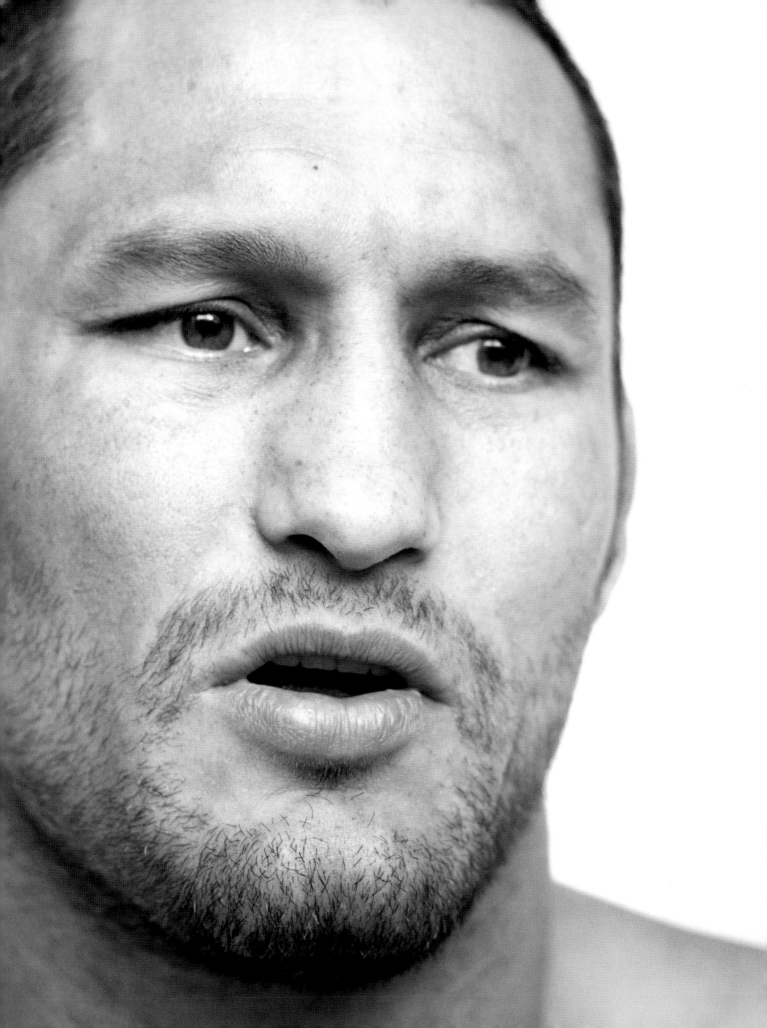

rampa

On the day of the fight, things change. That's when **Rampage just takes over.** I don't know what goes through his mind. He's a warrior. He just goes out there and fights. In boxing, you've got to worry about punches; in my sport, you've got to worry about everything.

If I try hard enough, **I can do any-thing.**

—QUINTON JACKSON

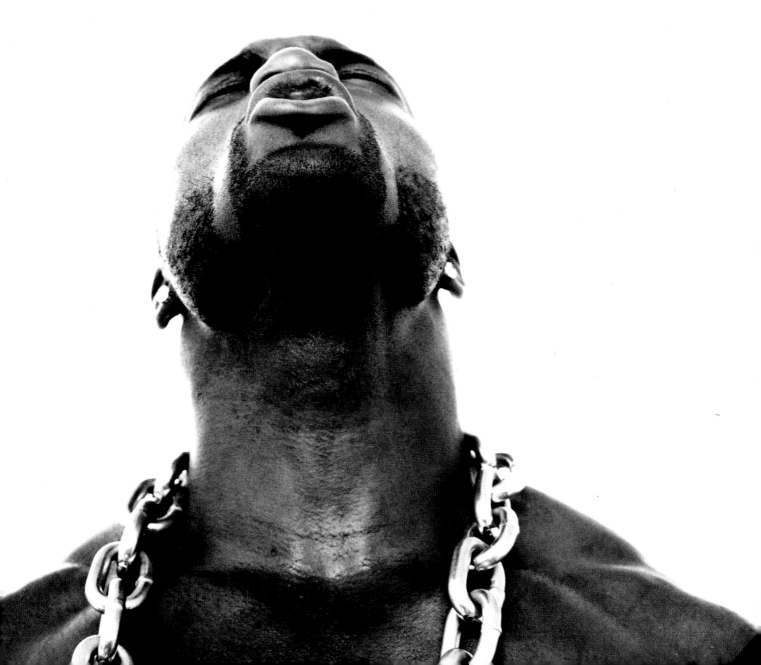

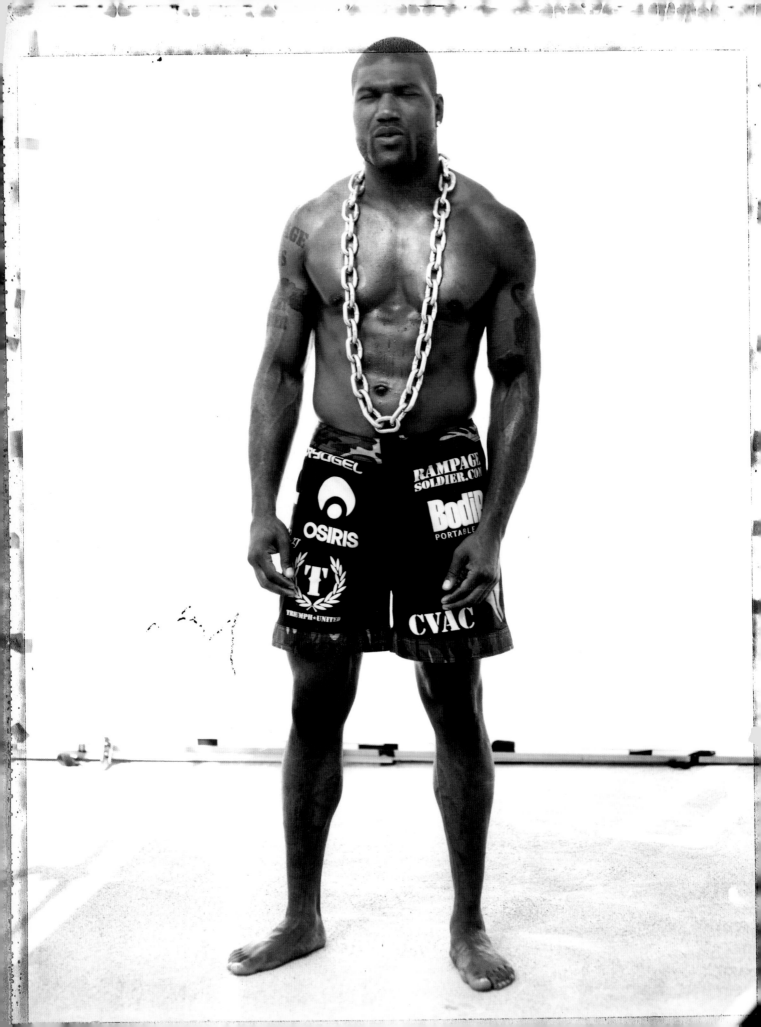

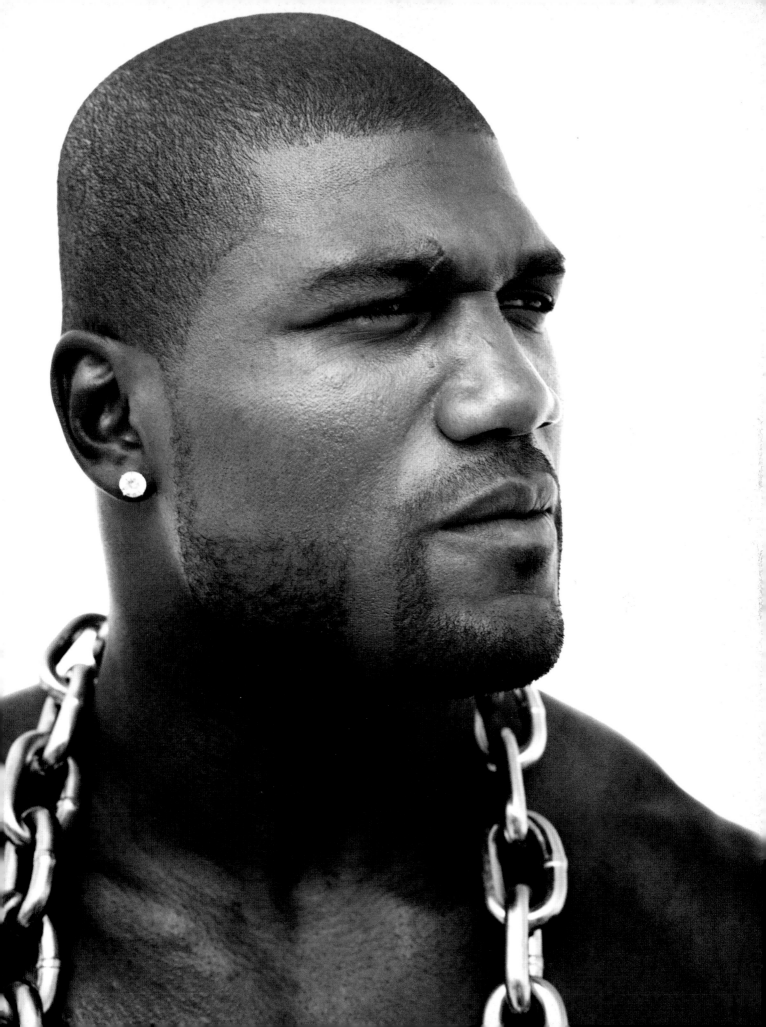

dean
of

Before I go into the Octagon, I thank everybody that's in my corner. It's kind of like off to work, here we go.

mean

—KEITH JARDINE

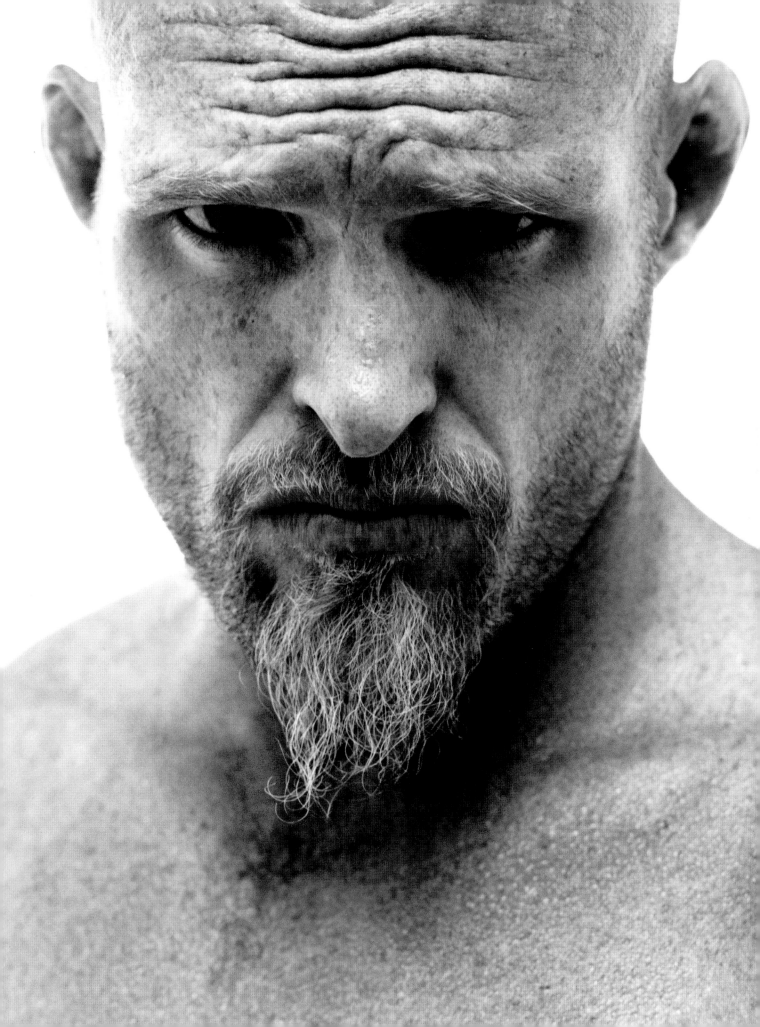

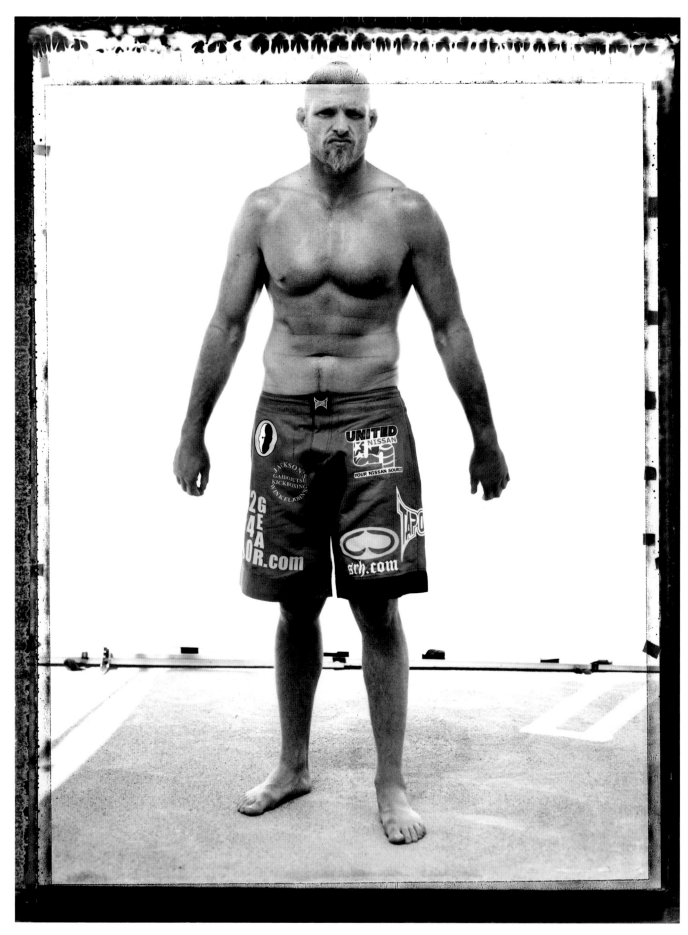

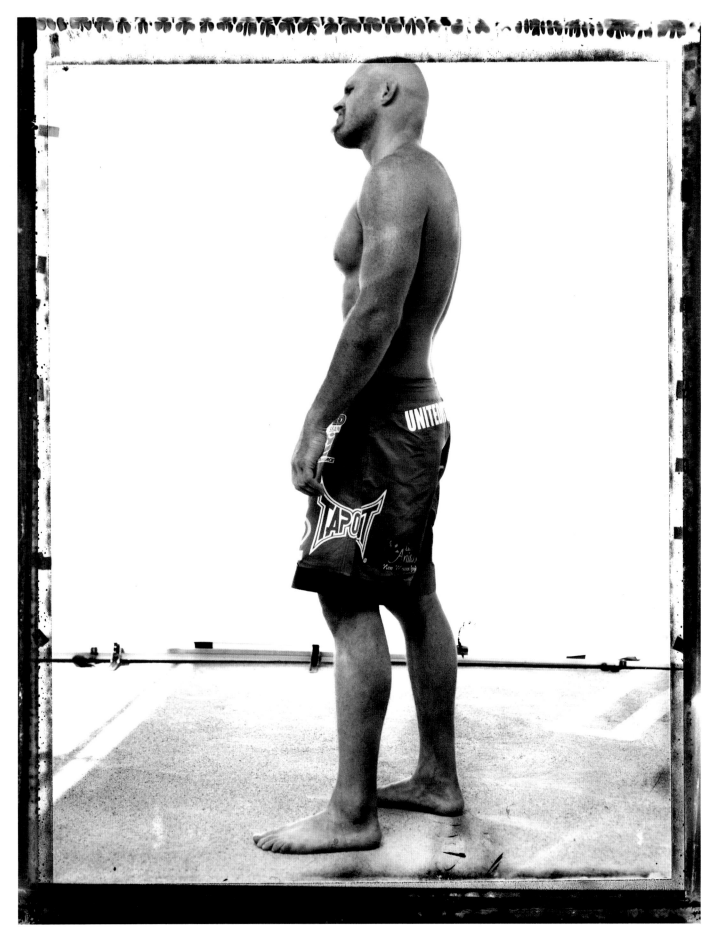

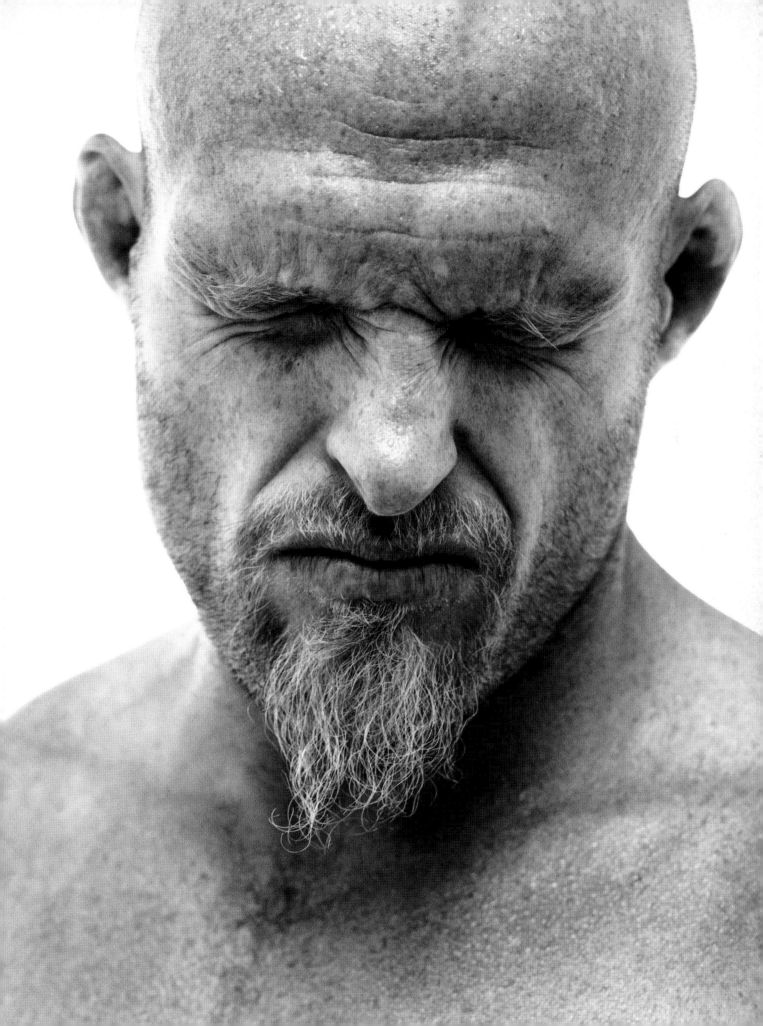

terr

I'm known for being aggressive.
I like to be a do or die fighter.
That's the way I want to fight for the rest of my career.

—MATT SERRA

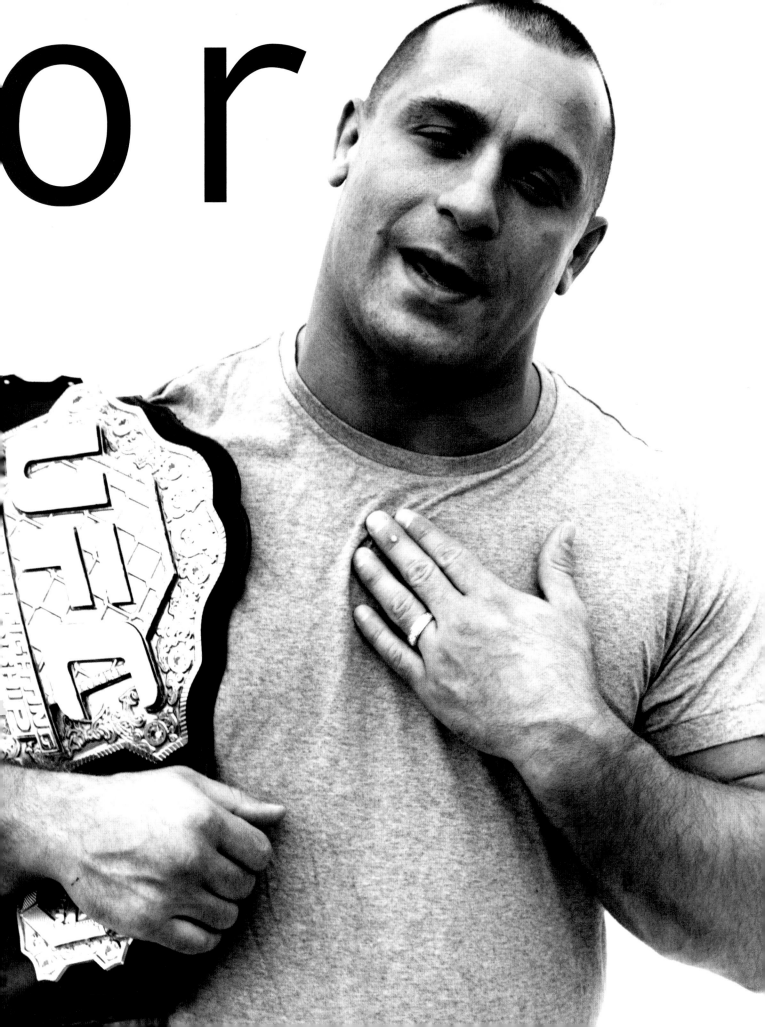

or

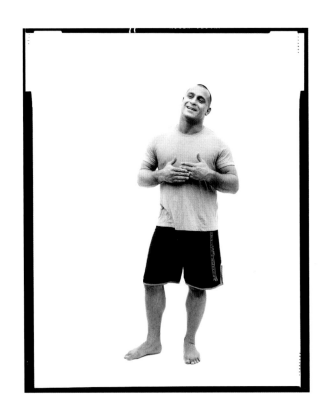
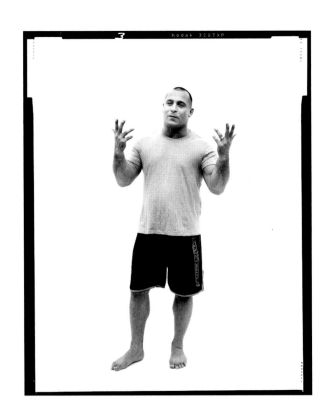
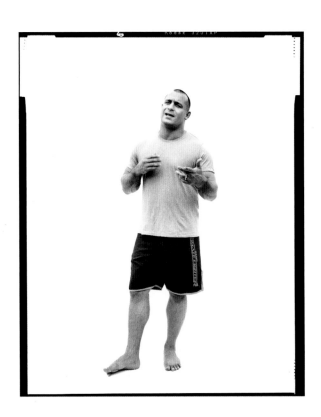
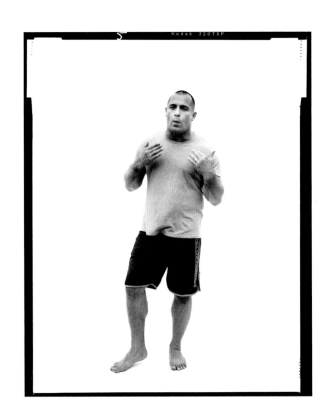

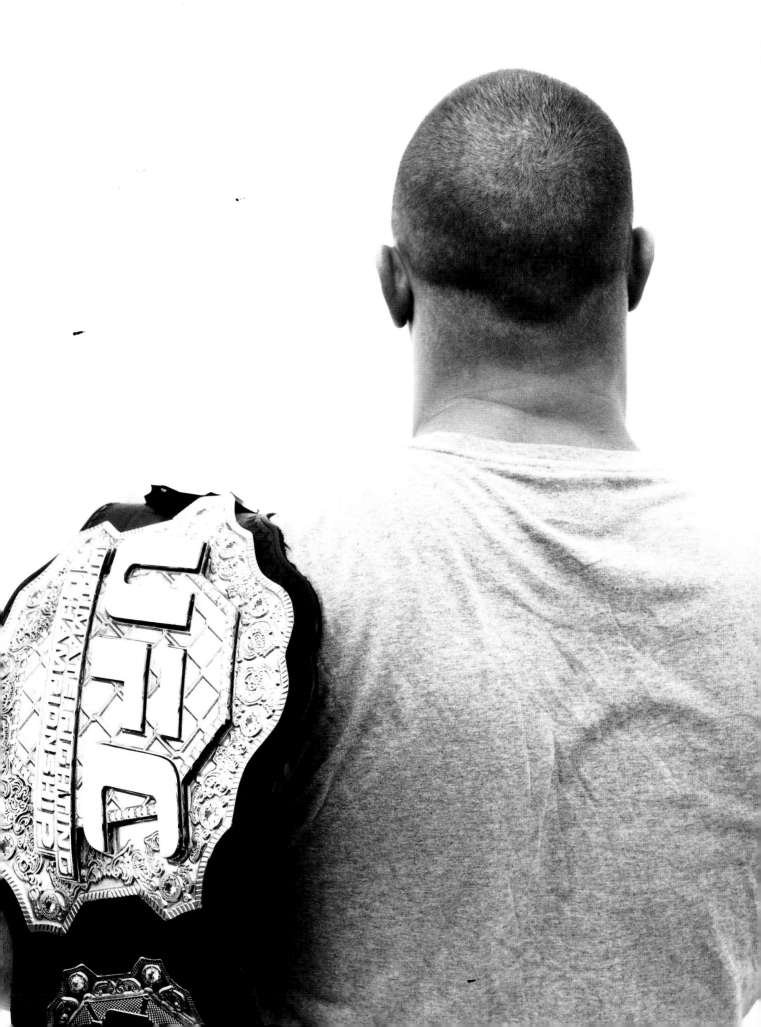

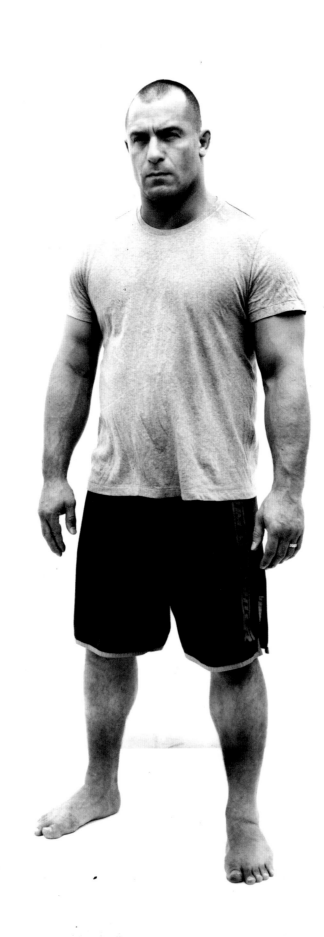

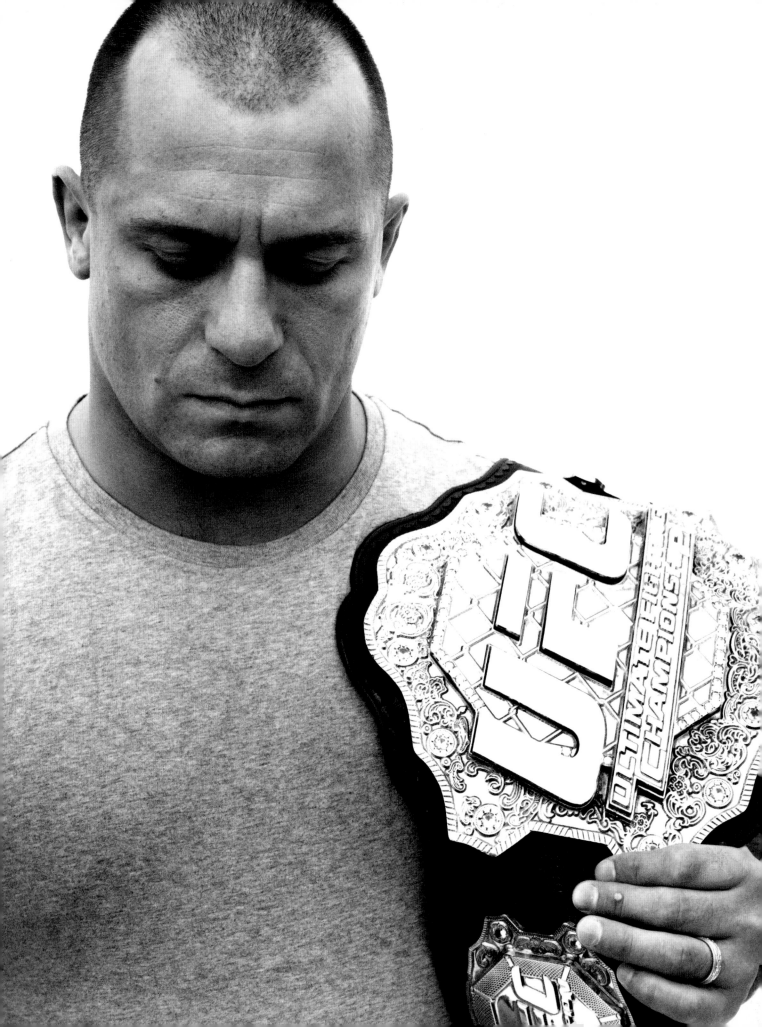

ken
flo

Right before I enter the Octagon I feel almost like I did a bunch
of practice paintings and now I have this empty canvas and
I can create this picture in front of everyone and
make it beautiful.

—KENNY FLORIAN

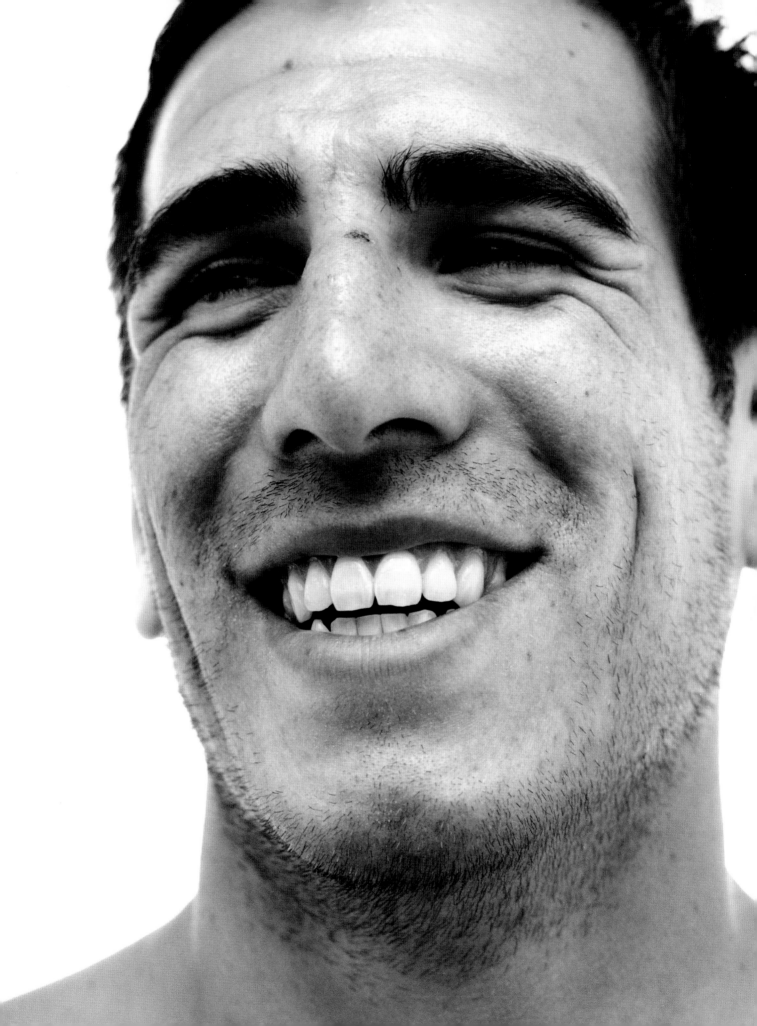

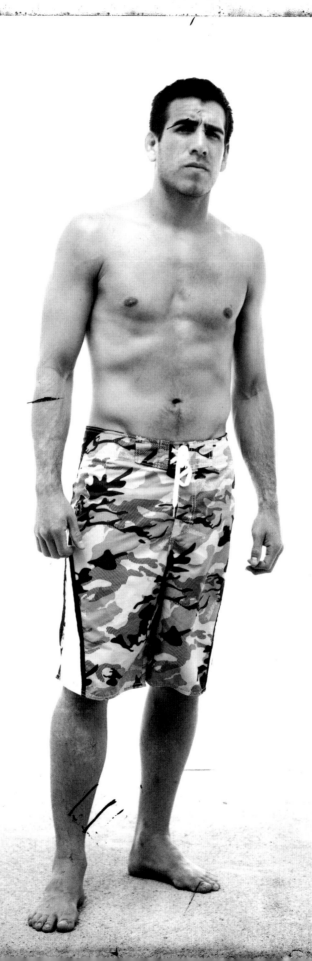

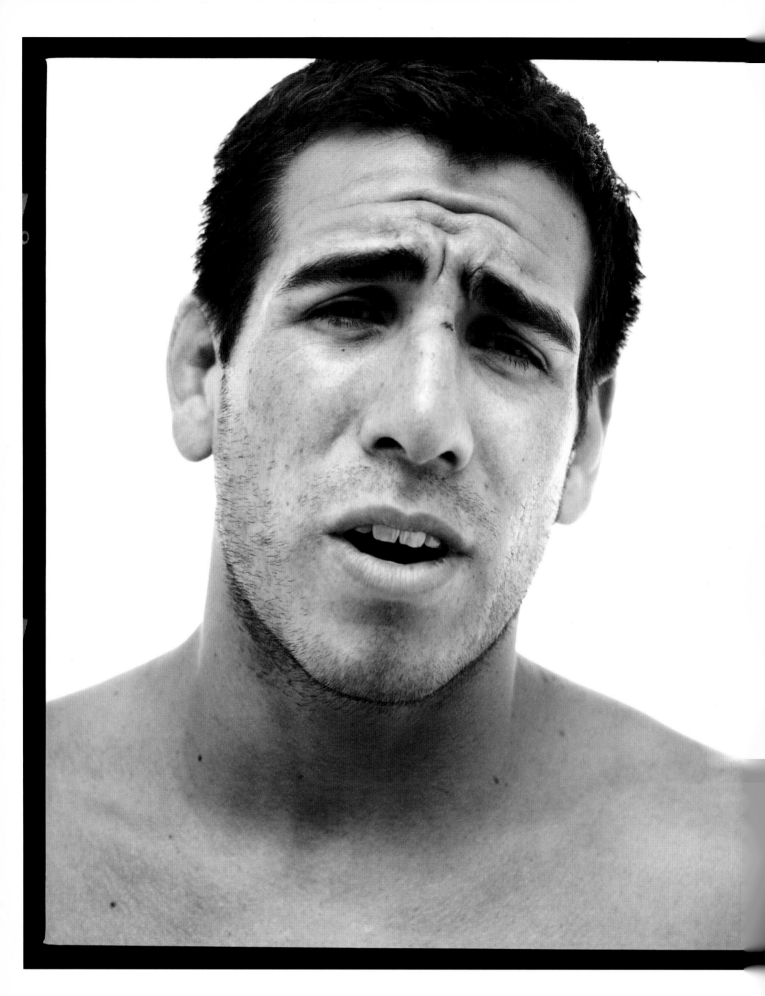

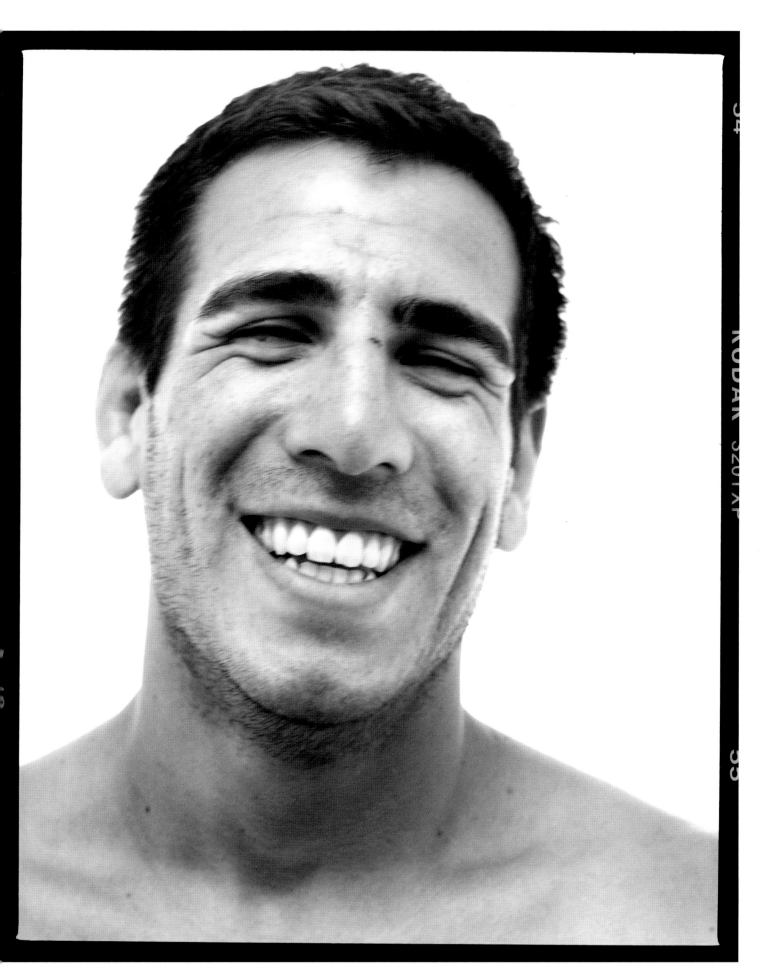

danzi

When you're in the Octagon it's almost like a meditation in a way. You slip into a different frame of mind and you're thinking about **nothing but technique** and what the right things to do are to finish a fight properly.

—MAC DANZIG

g

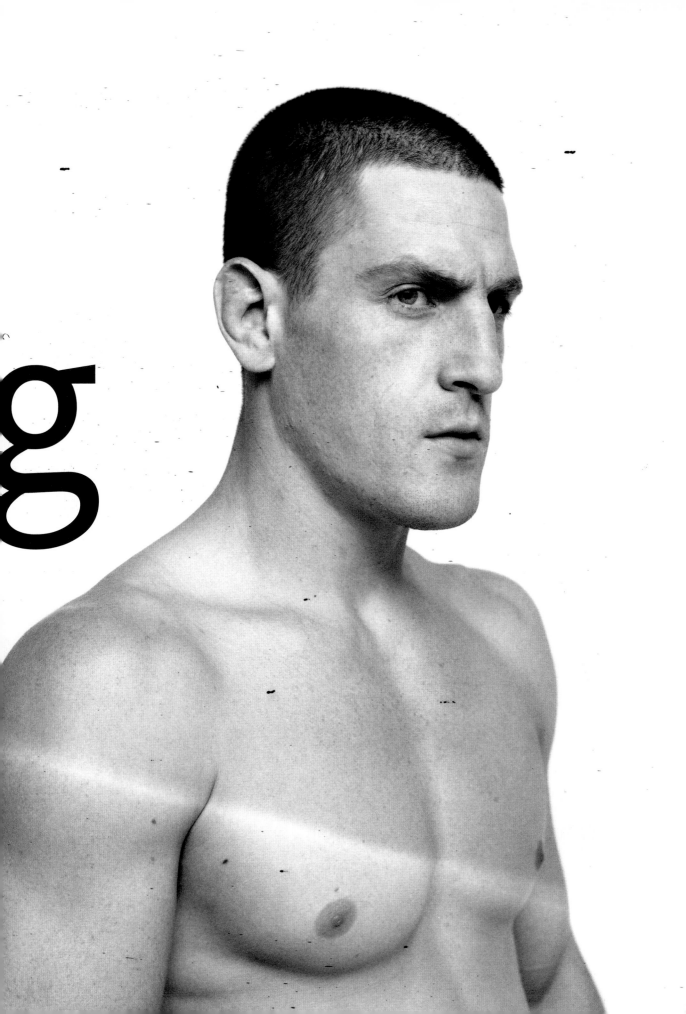

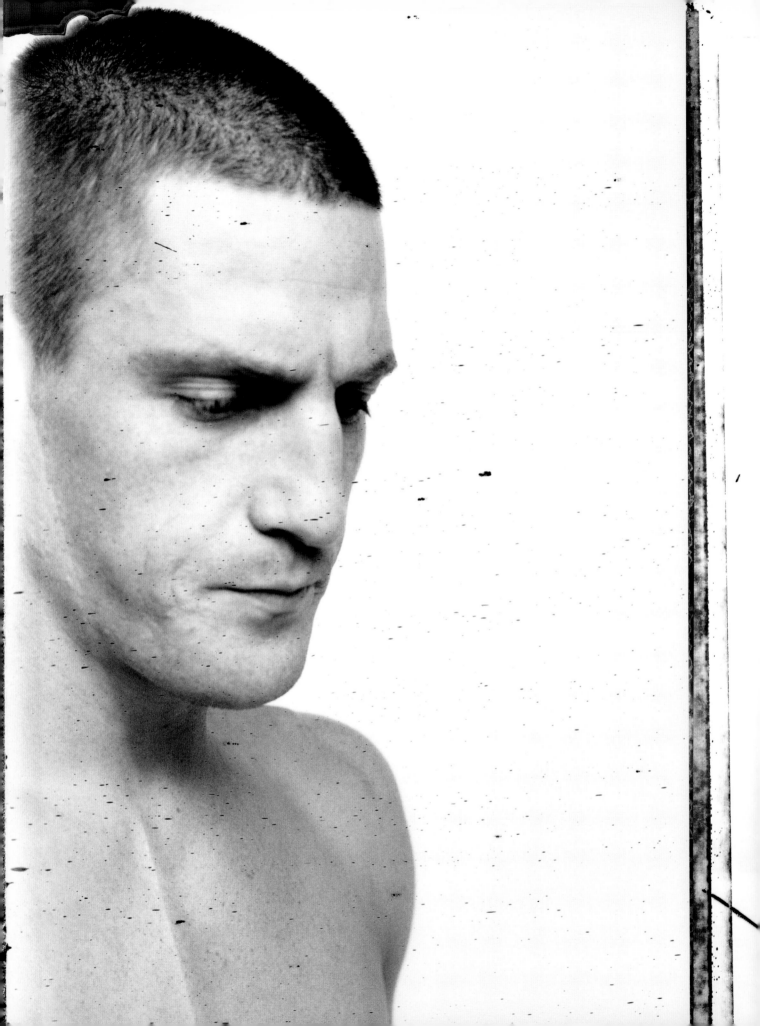

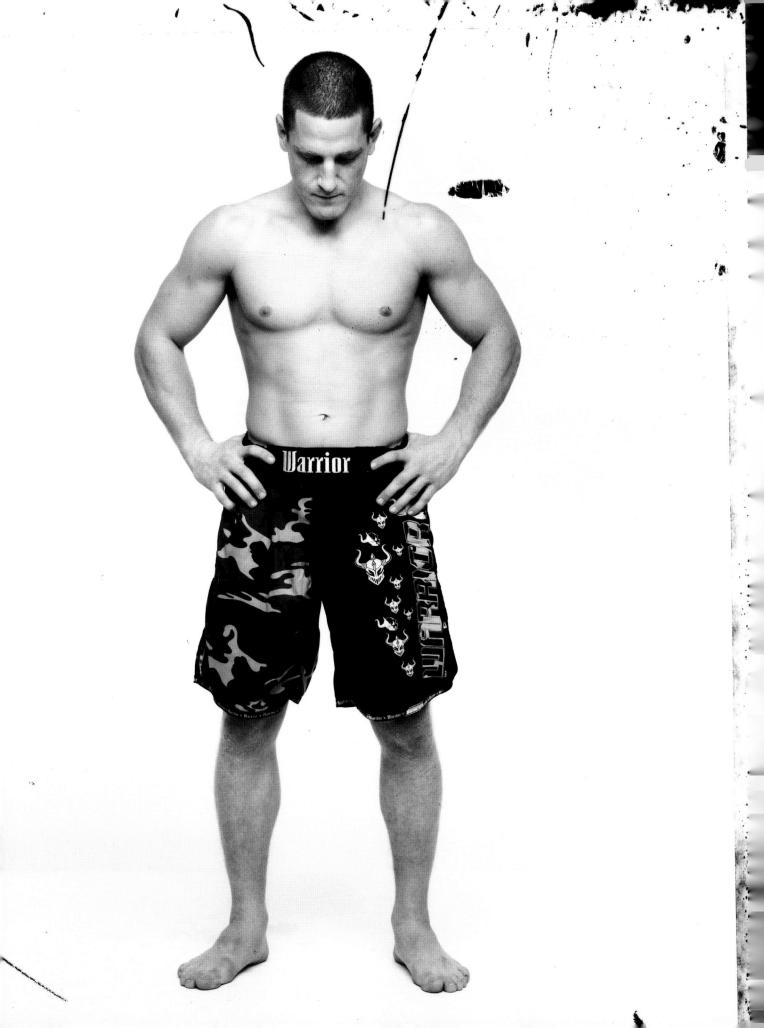

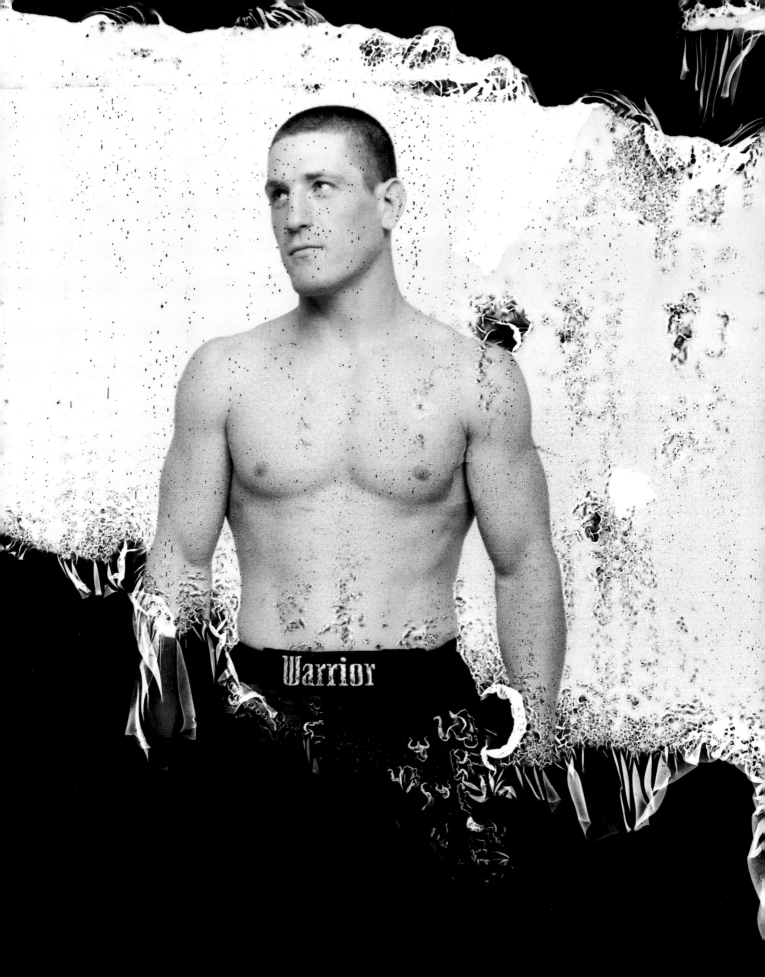

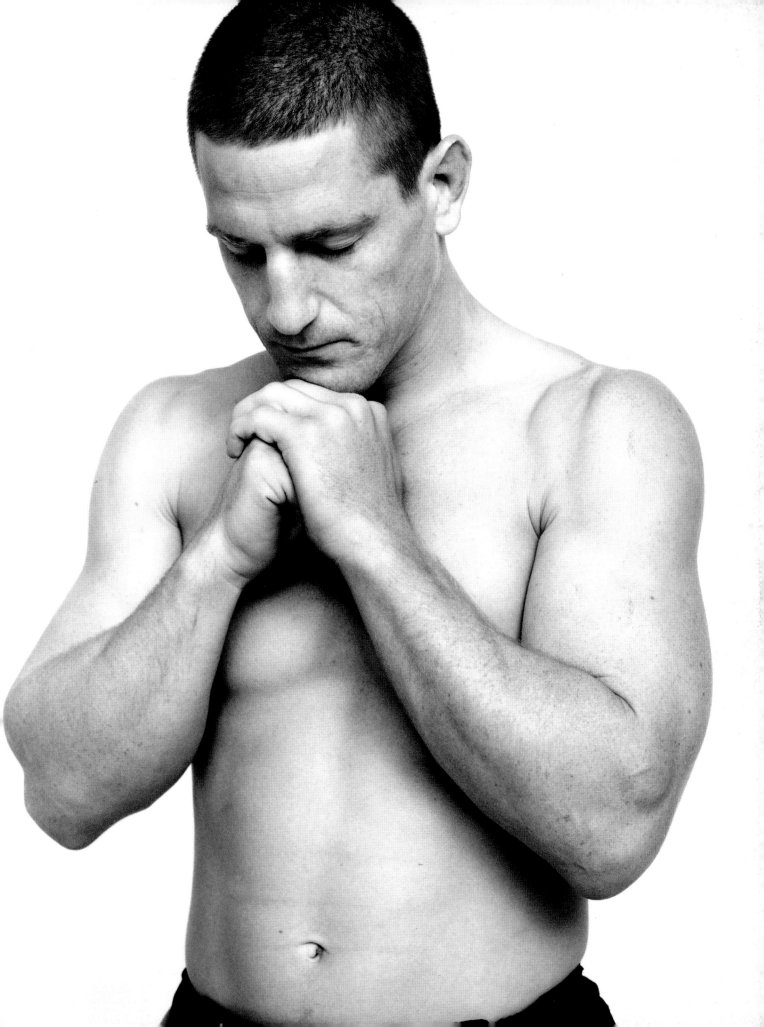

el mata-dor

I fear no man and I work hard to win easy.

—ROGER HUERTA

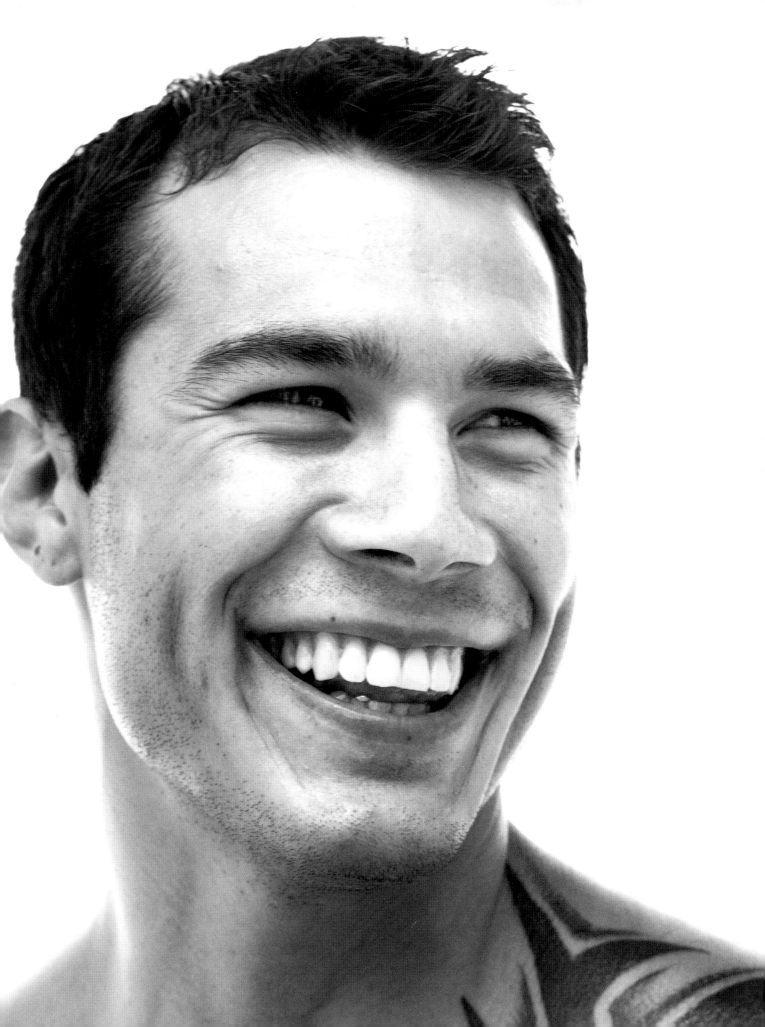

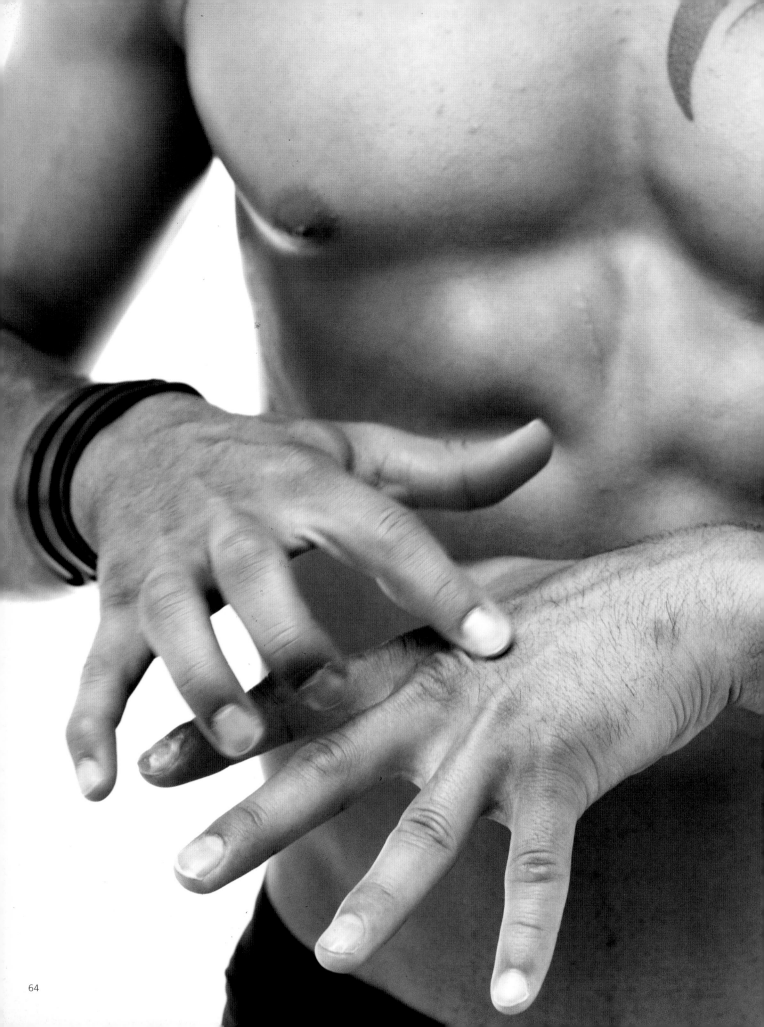

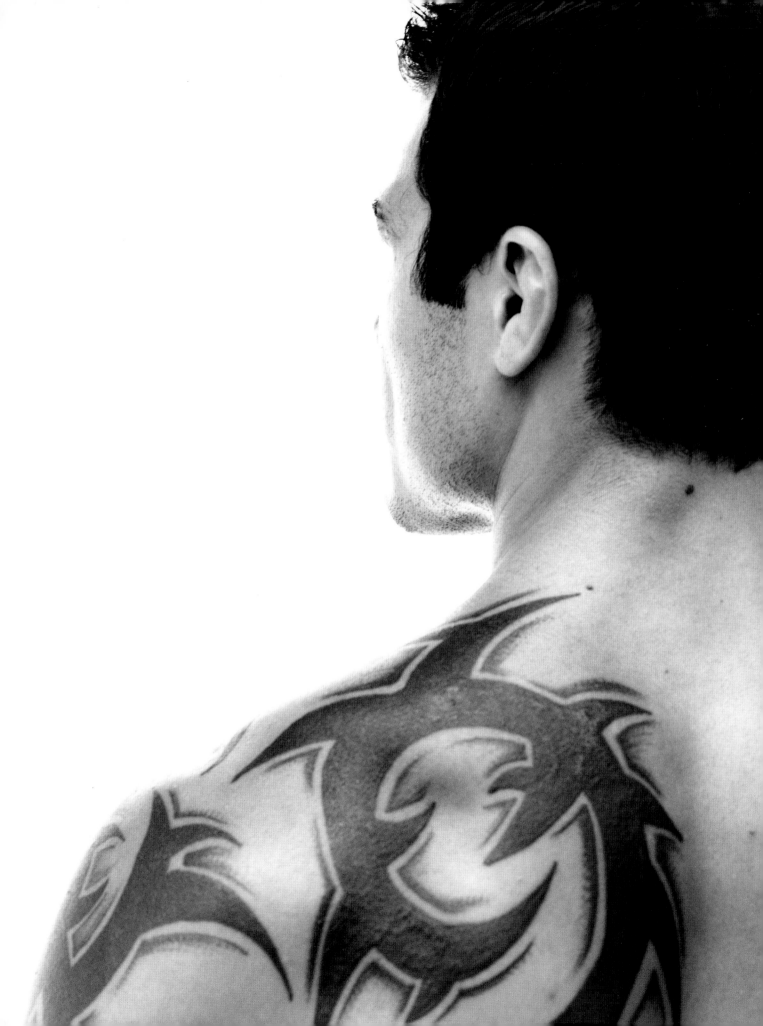

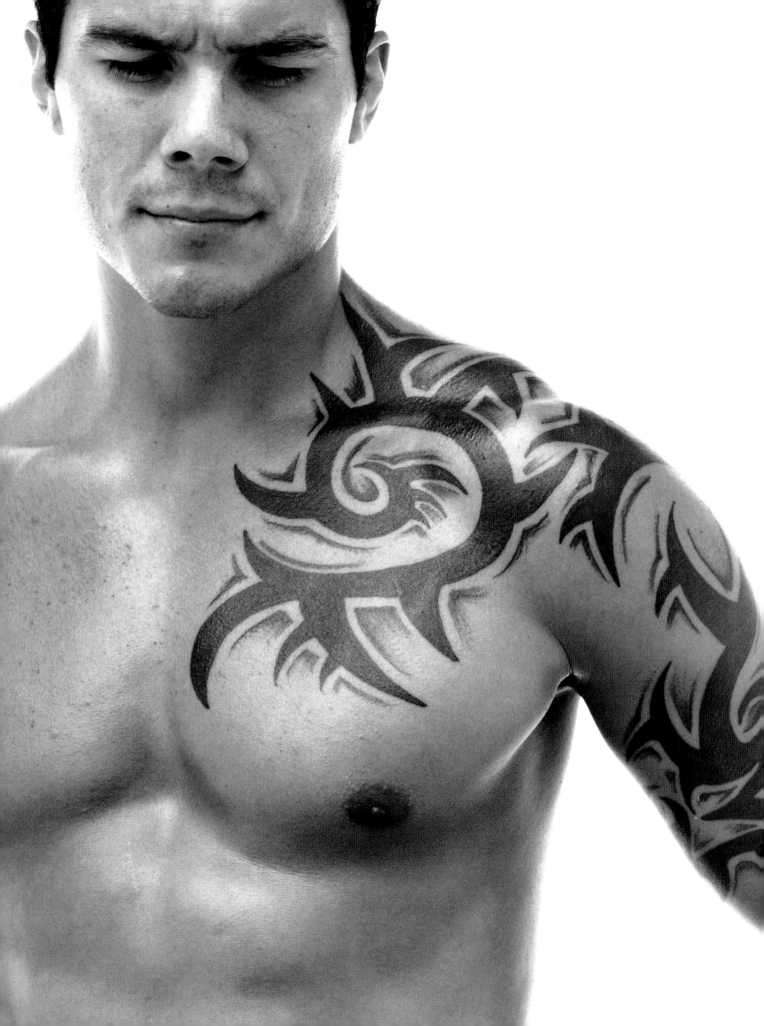

kongo

Everybody dreams to fight like the last epoch—
it's romantic.

—CHEICK KONGO

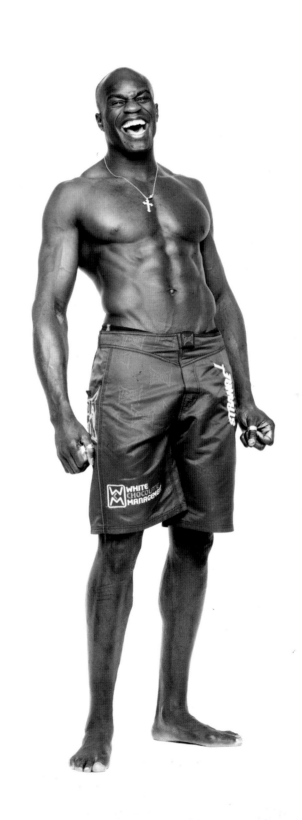

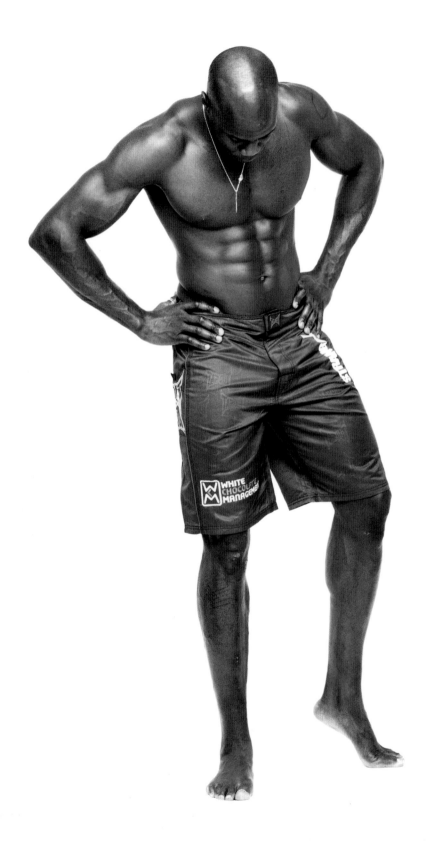

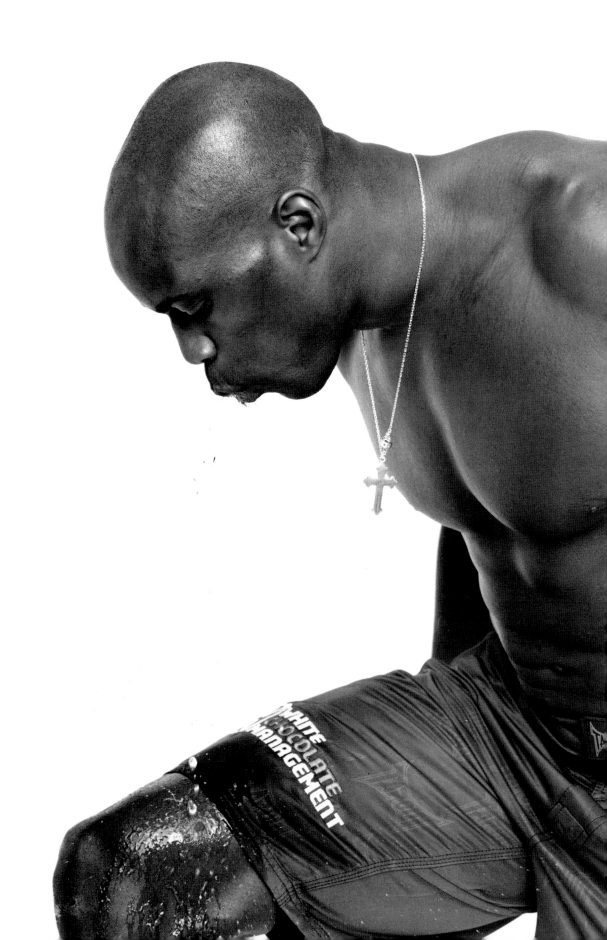

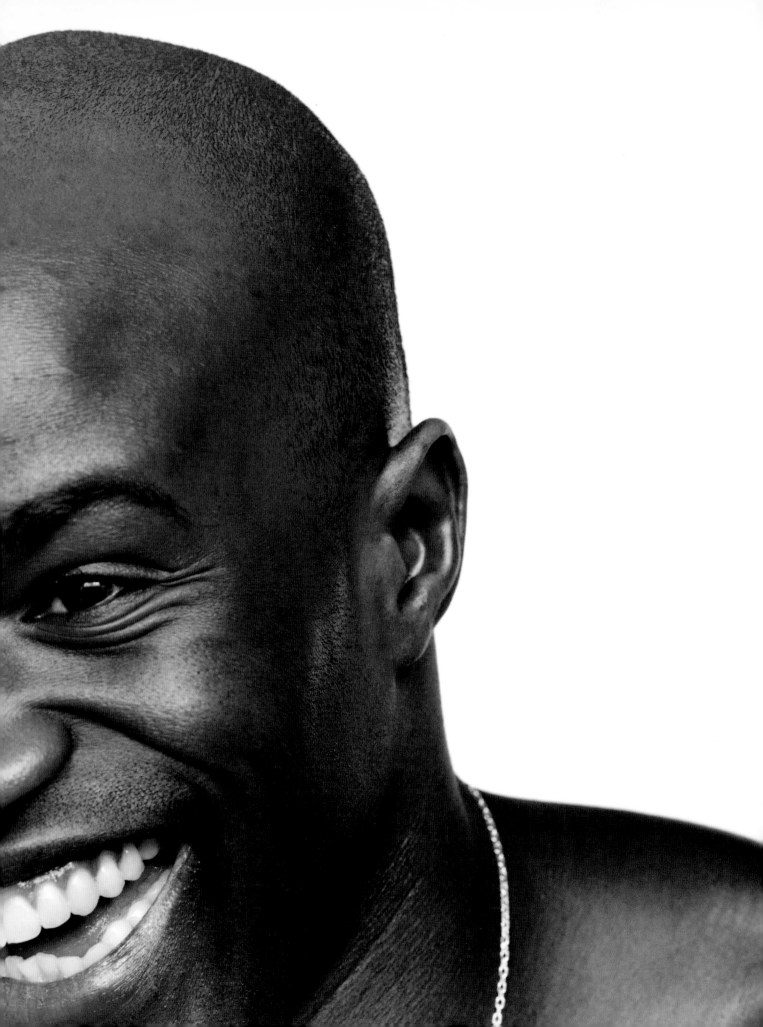

ivan

There are not enough words to describe what we do.
It's beautiful in every respect.

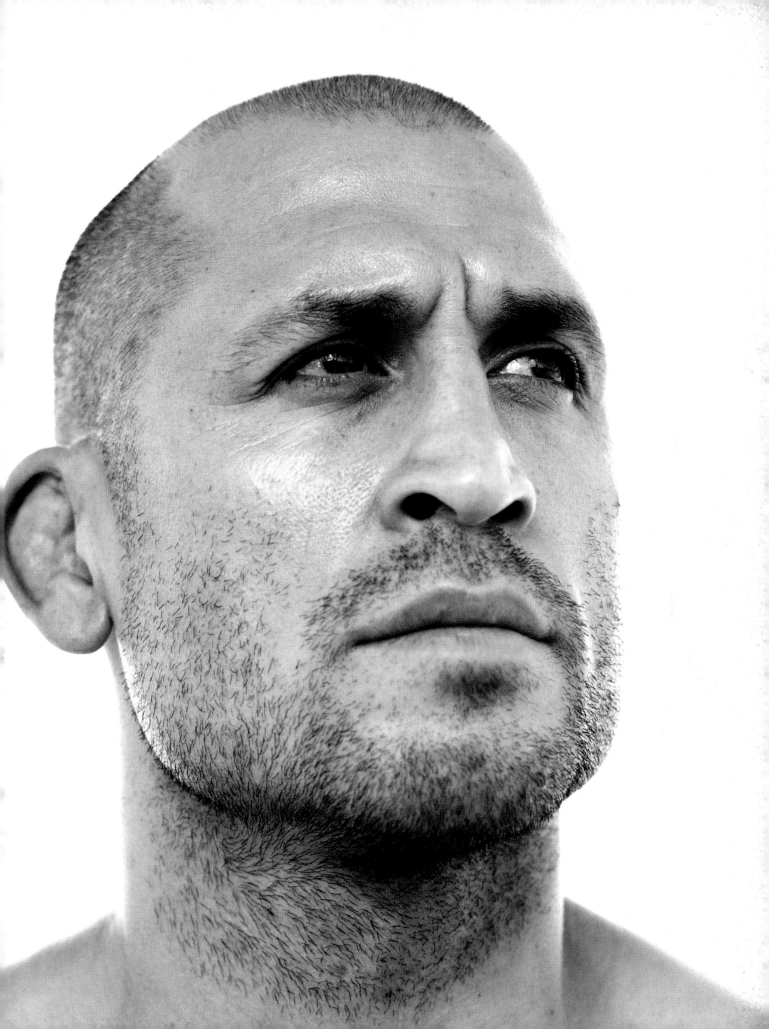

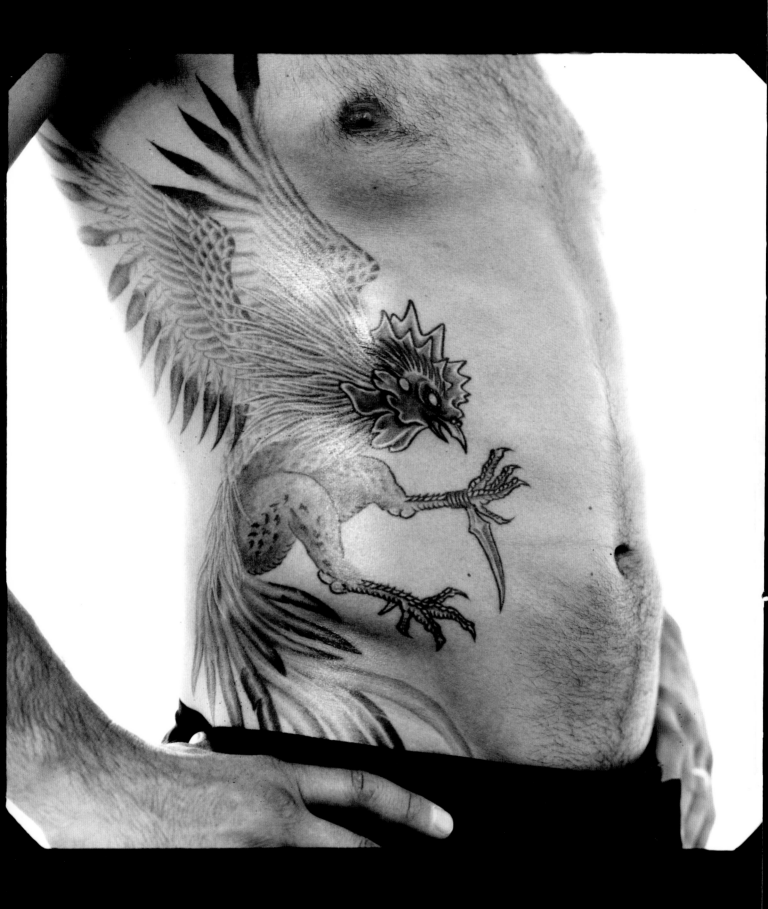

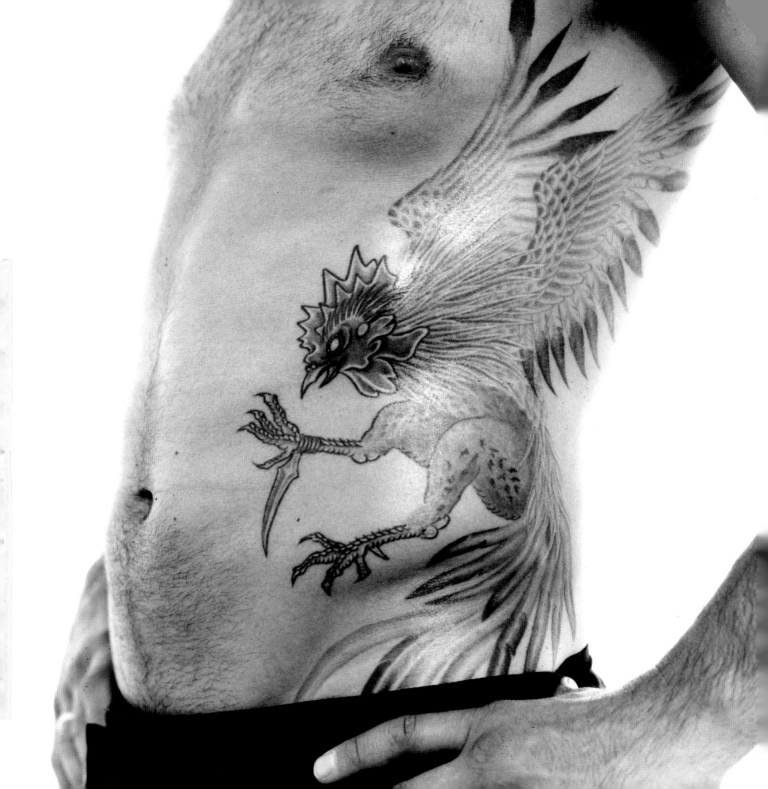

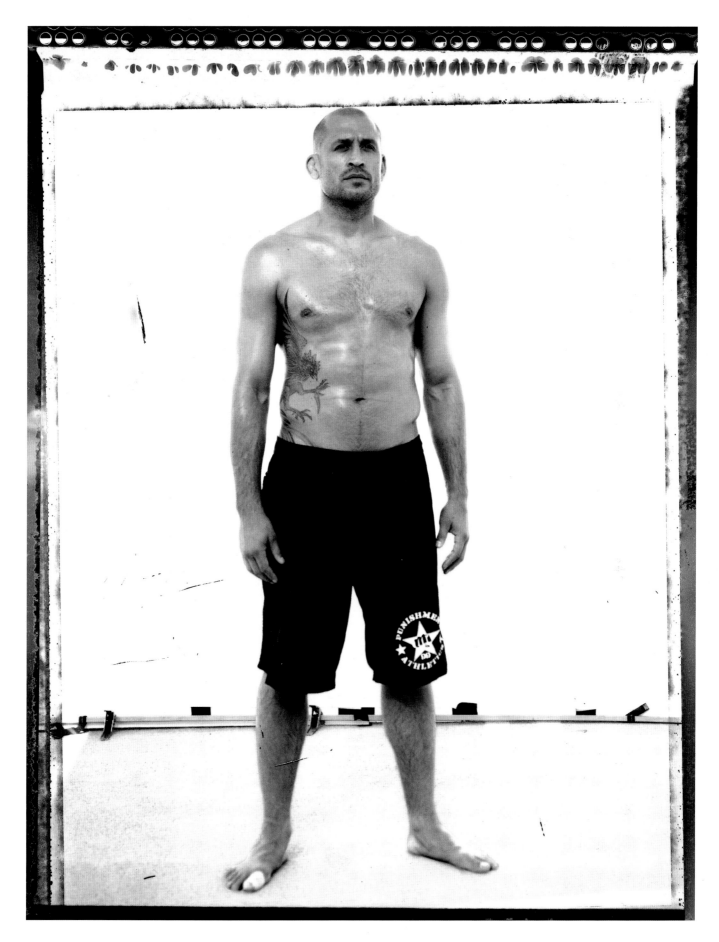

the
king

I always think about losing when I train. That motivates
me to train that much harder.
Give up is not in my vocabulary.

—SPENCER FISHER

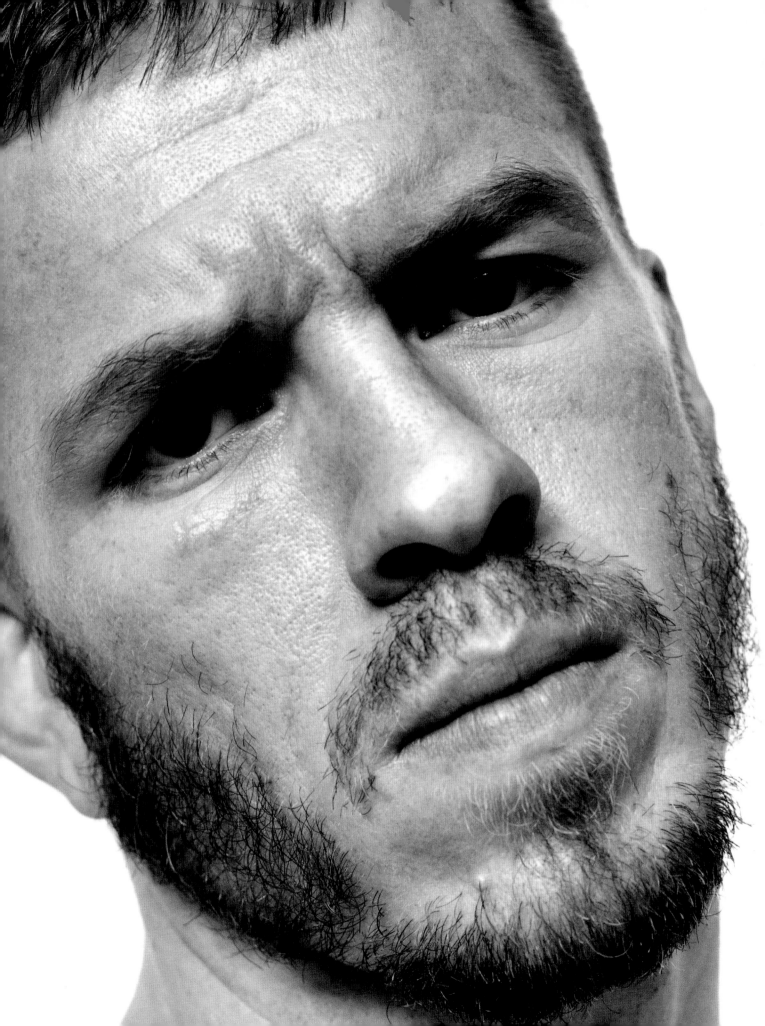

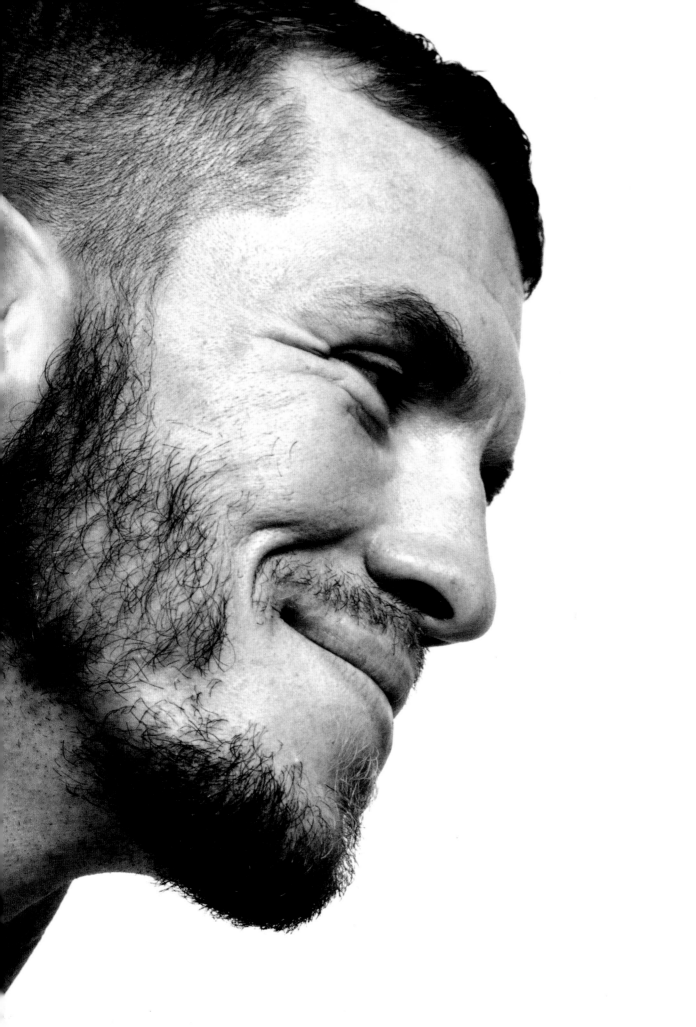

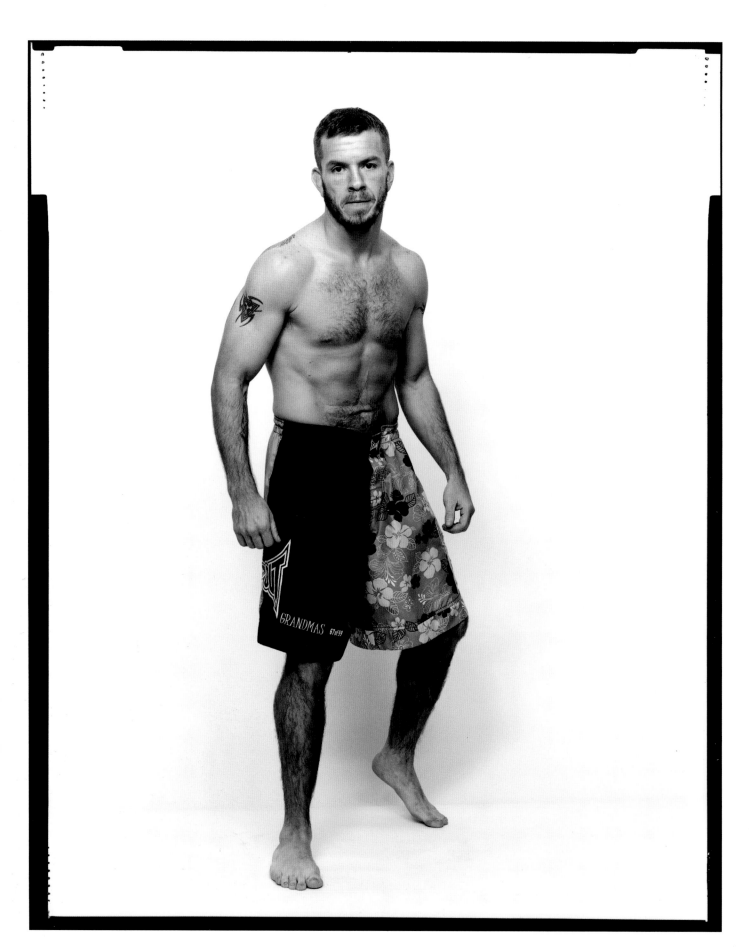

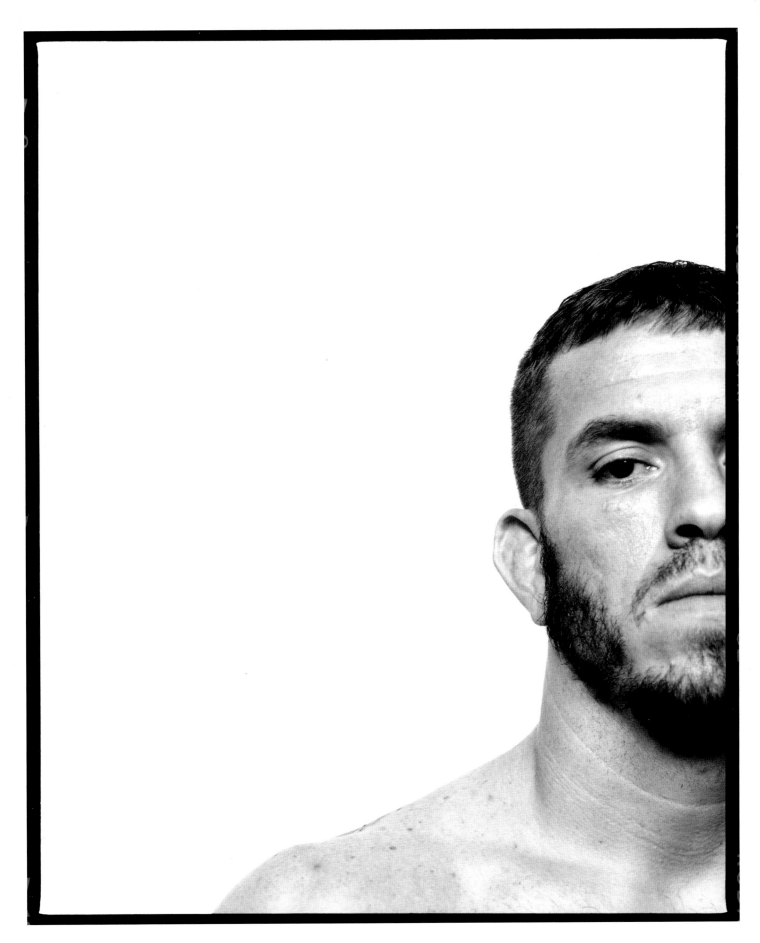

mino-tauro

When I am in the Octagon I just face my opponent.
I think of nothing else.

—ANTONIO RODRIGO NOGUEIRA

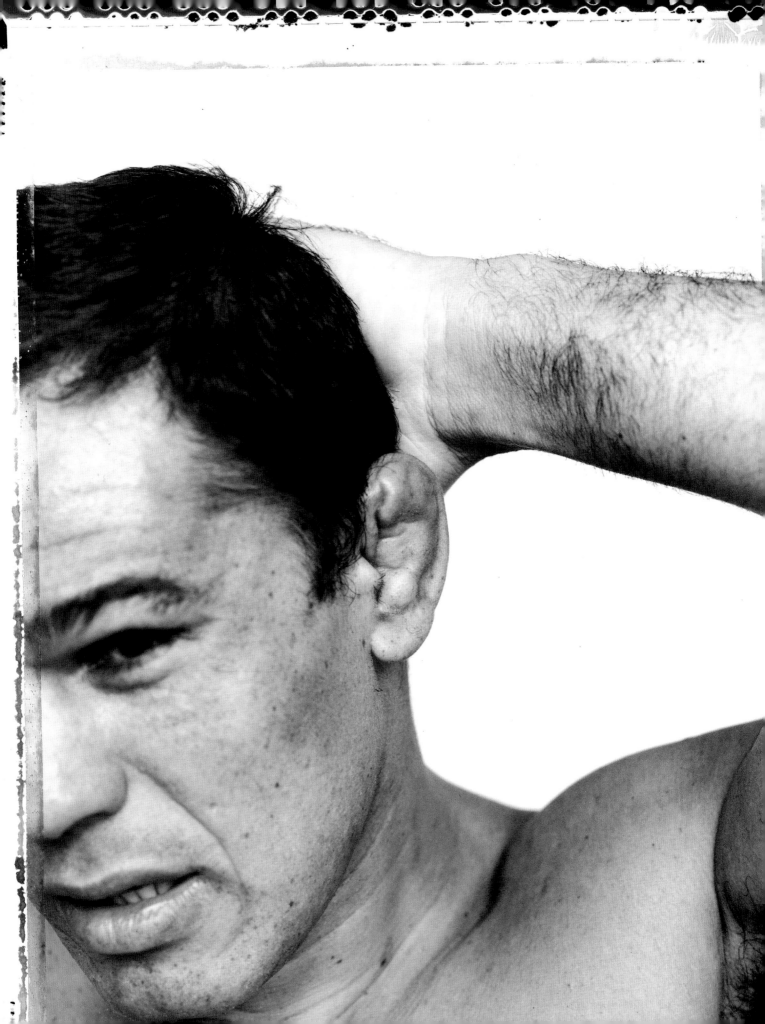

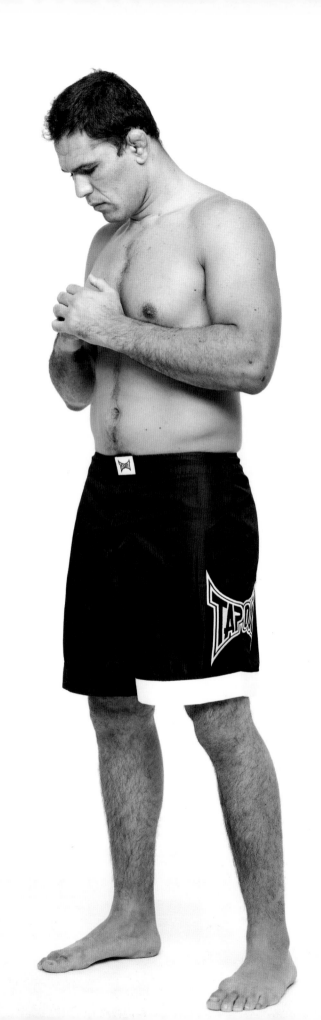

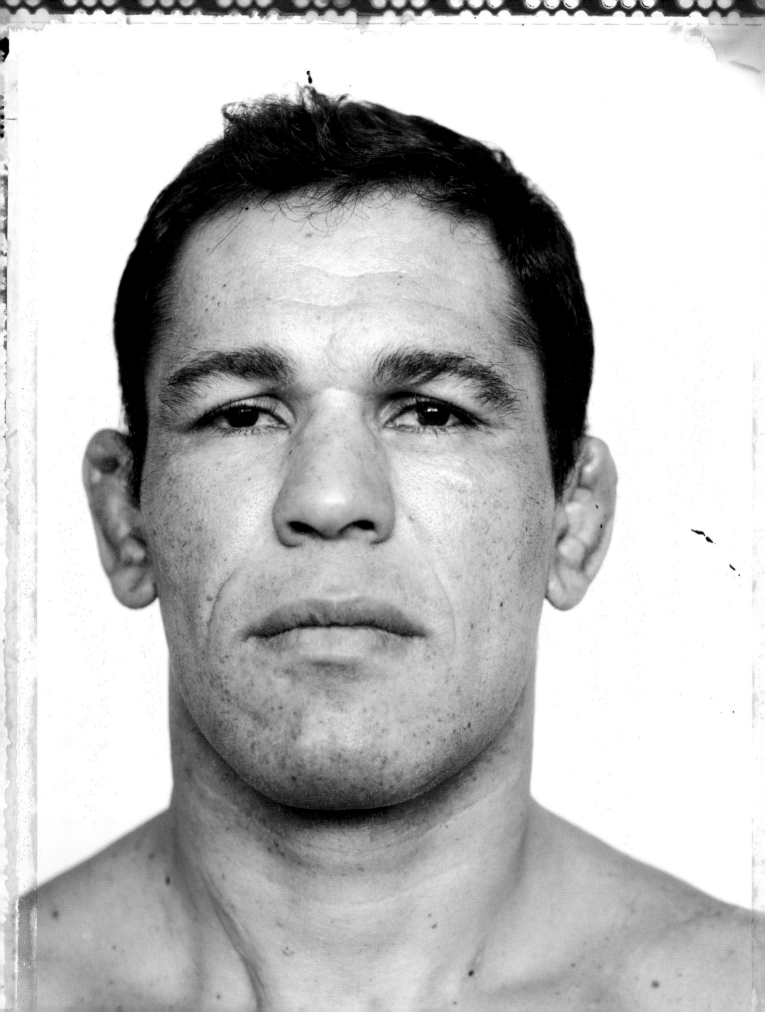

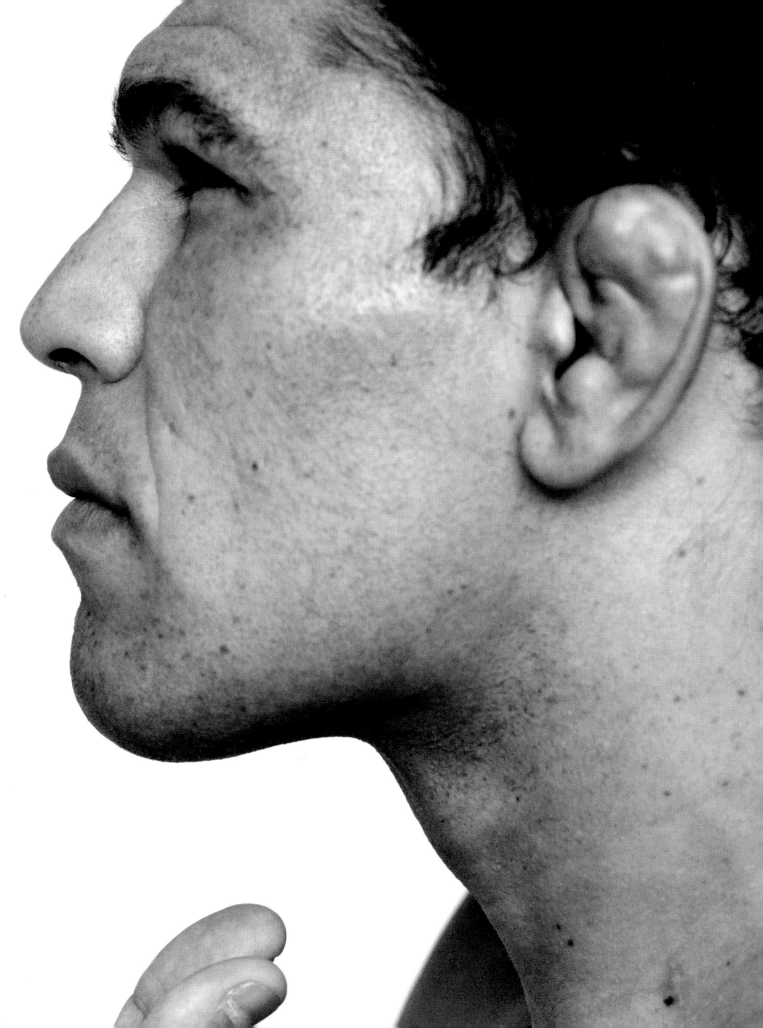

griff

I don't have a motto, but I've always liked the <u>Aeneid</u> quote —
"Fortune favors the brave".

—FORREST GRIFFIN

i n

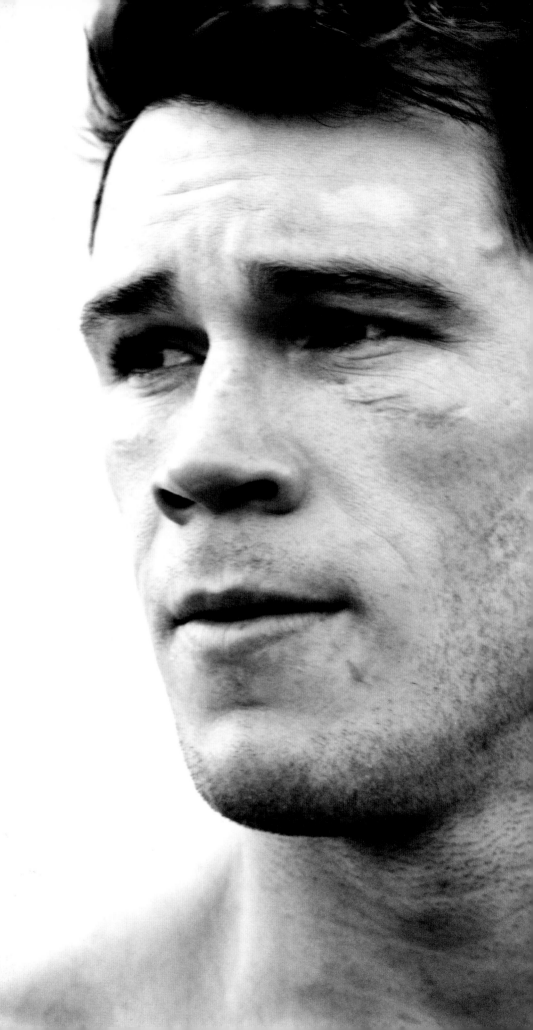

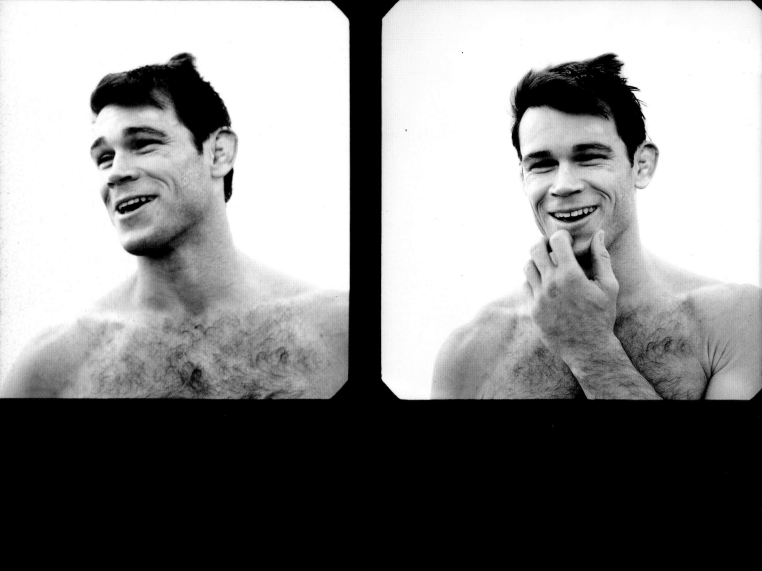

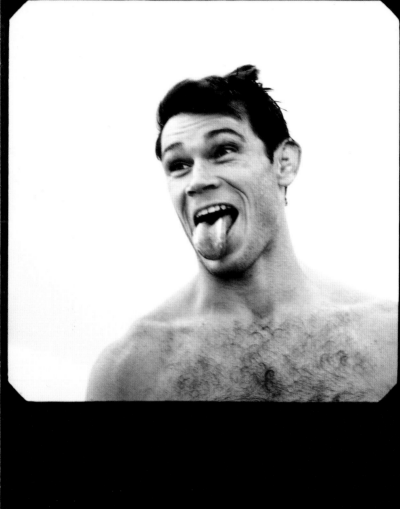

kos

It's just business.

—JOSH KOSCHECK

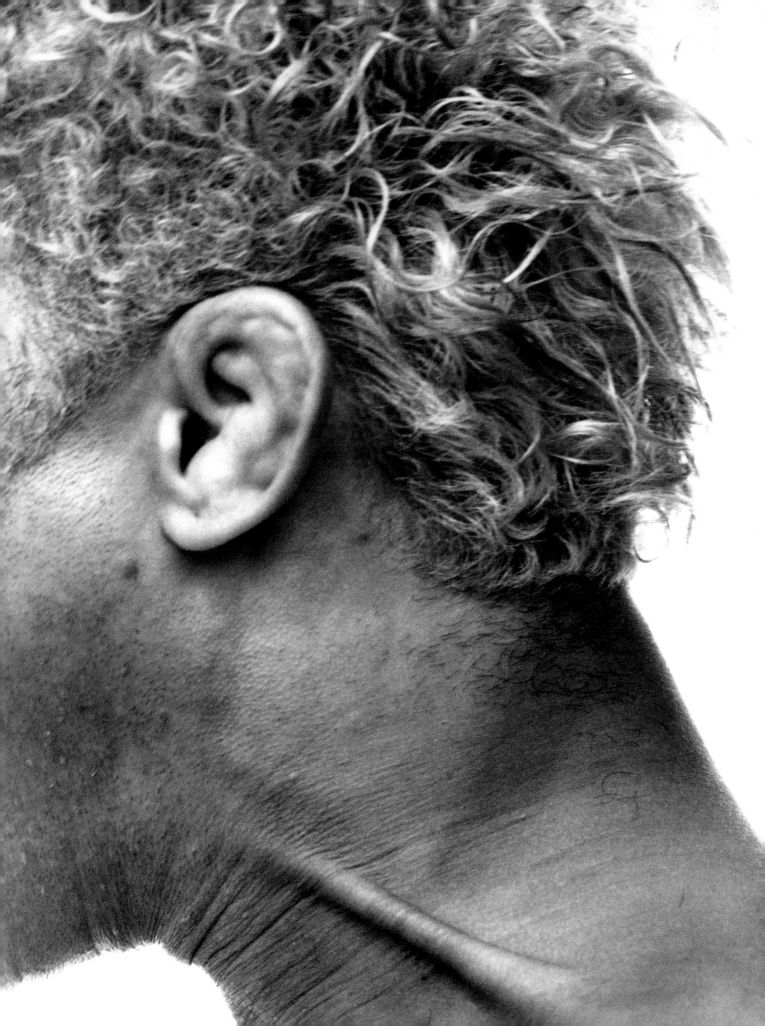

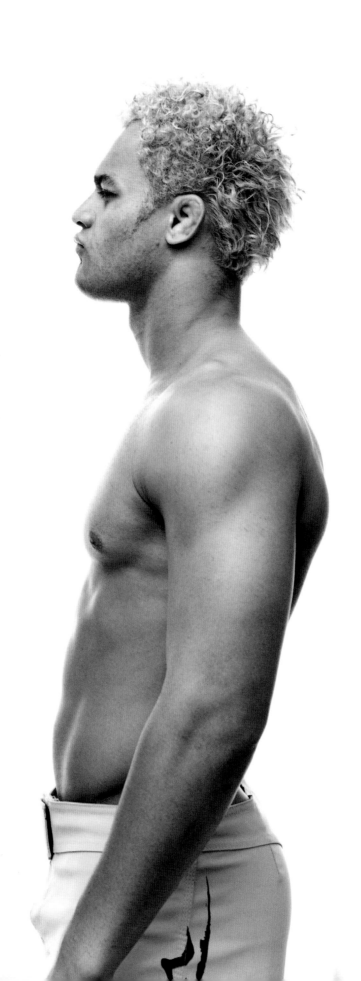

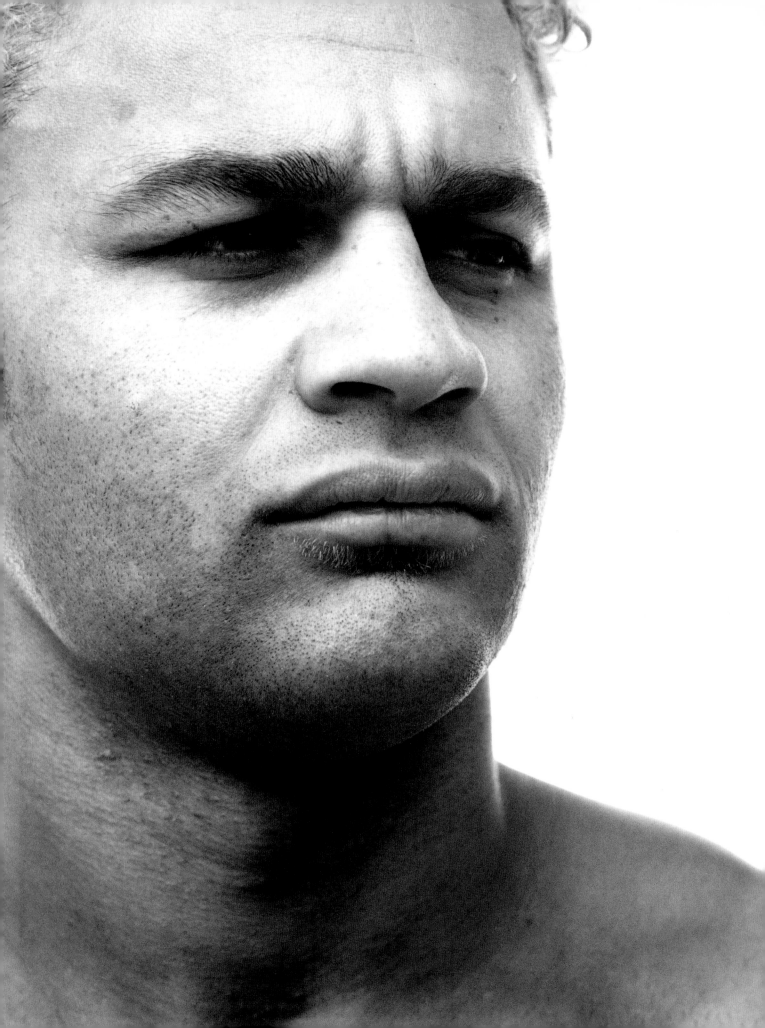

sand
man

As soon as you think you're too good,
your ass is going to get knocked out.

—JAMES IRVIN

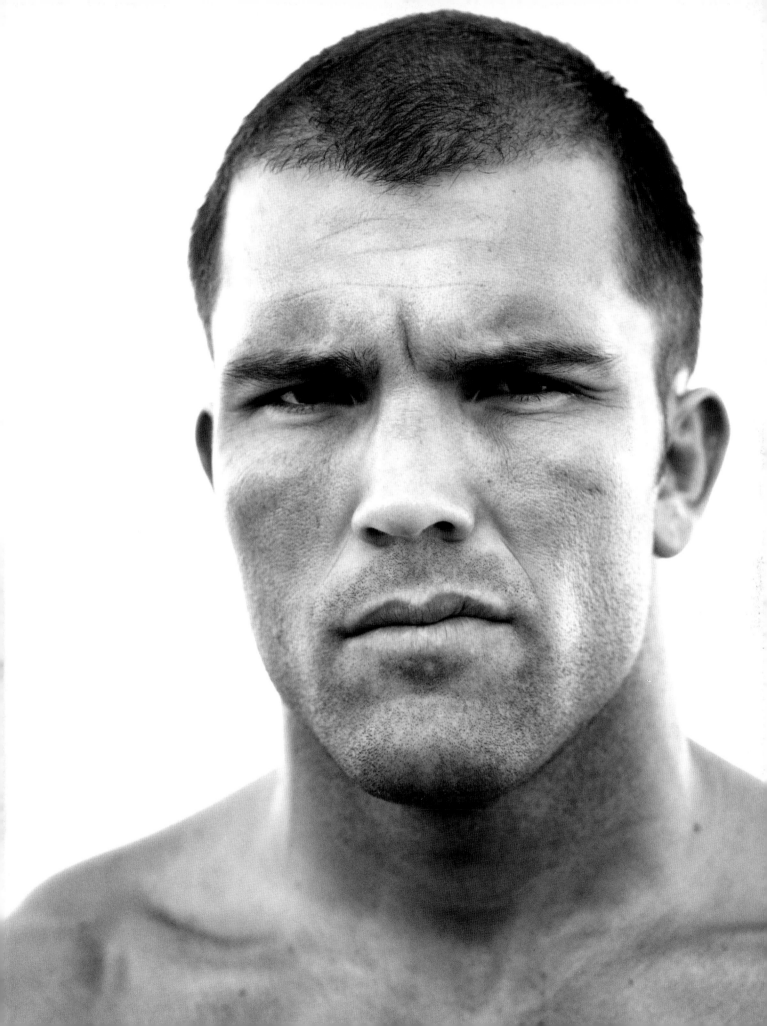

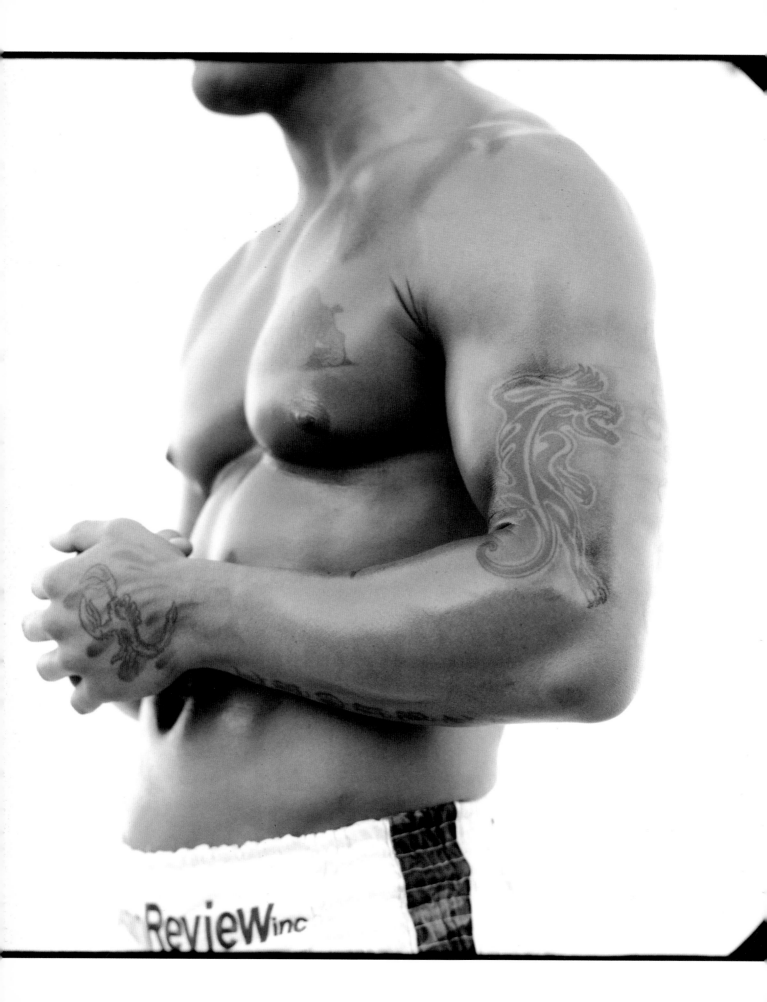

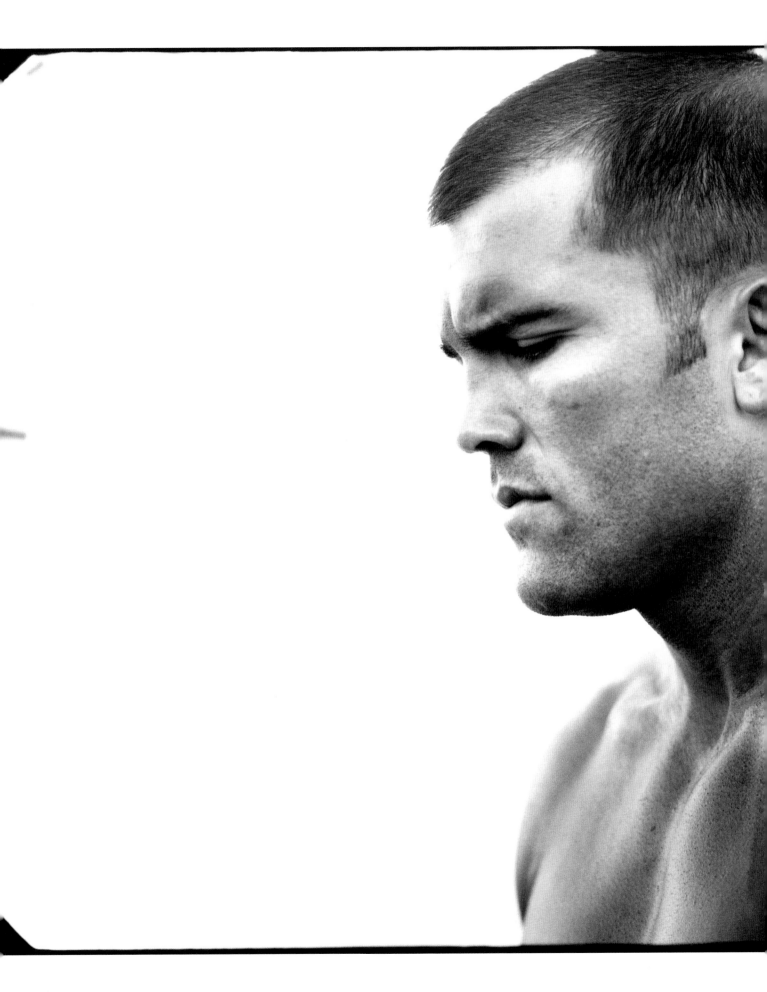

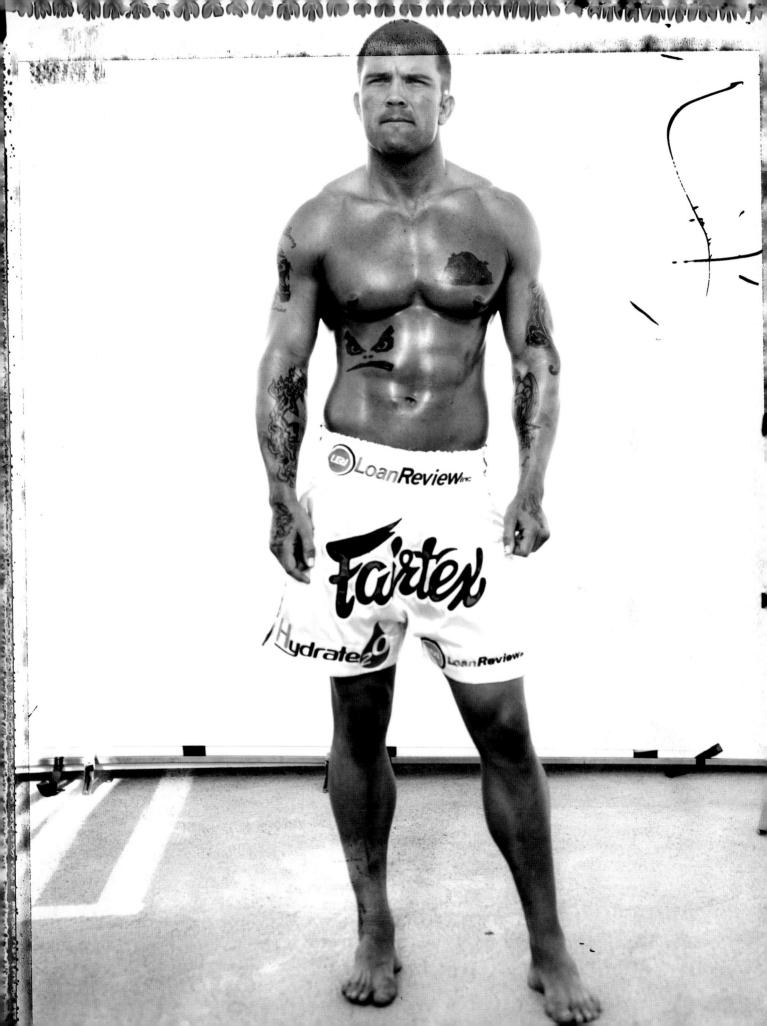

da spyder

I'm never scared. If you're scared to fight somebody, you shouldn't be fighting.

When I'm training I'm just having fun, thinking about punching somebody in the face.

—KENDALL GROVE

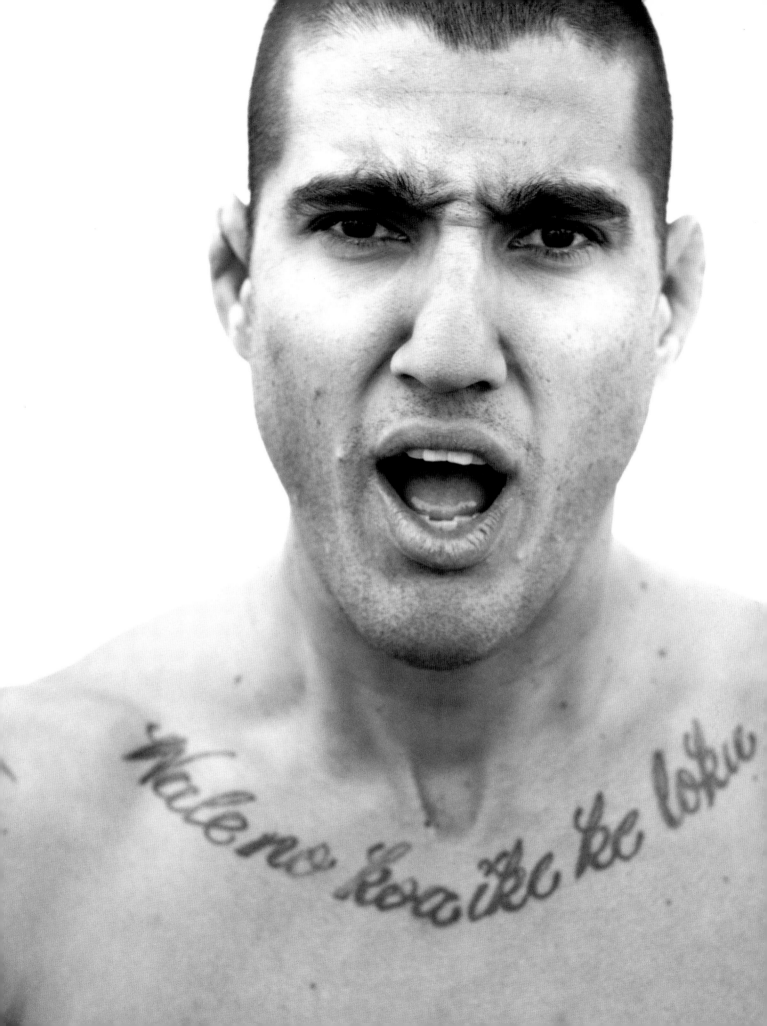

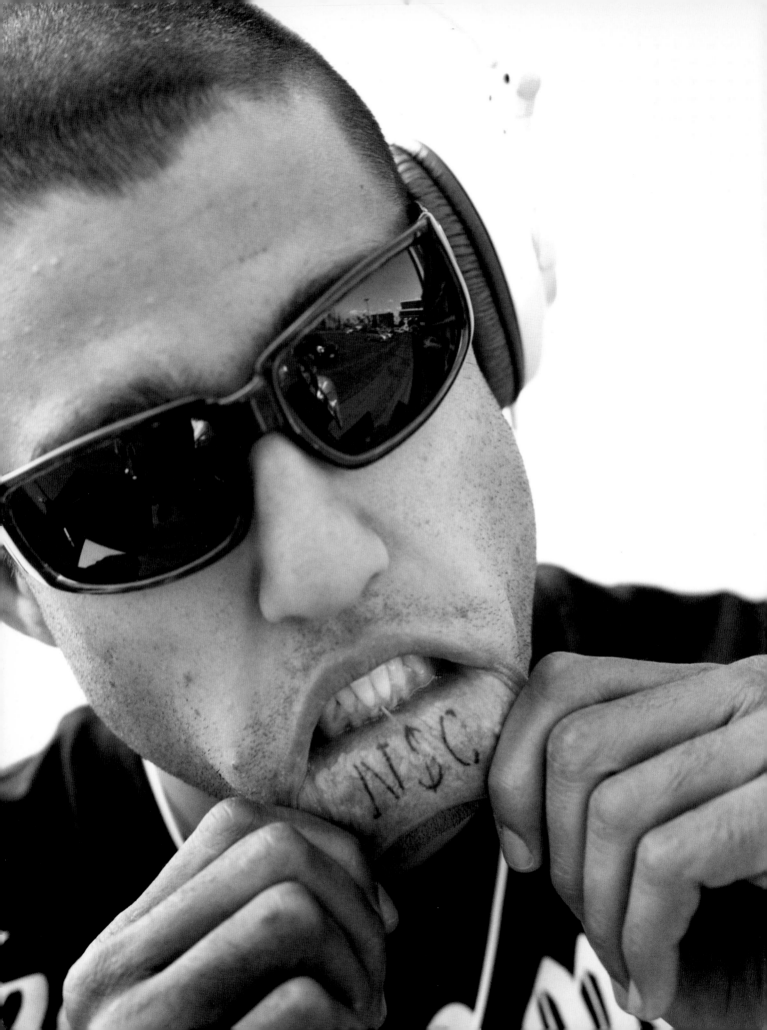

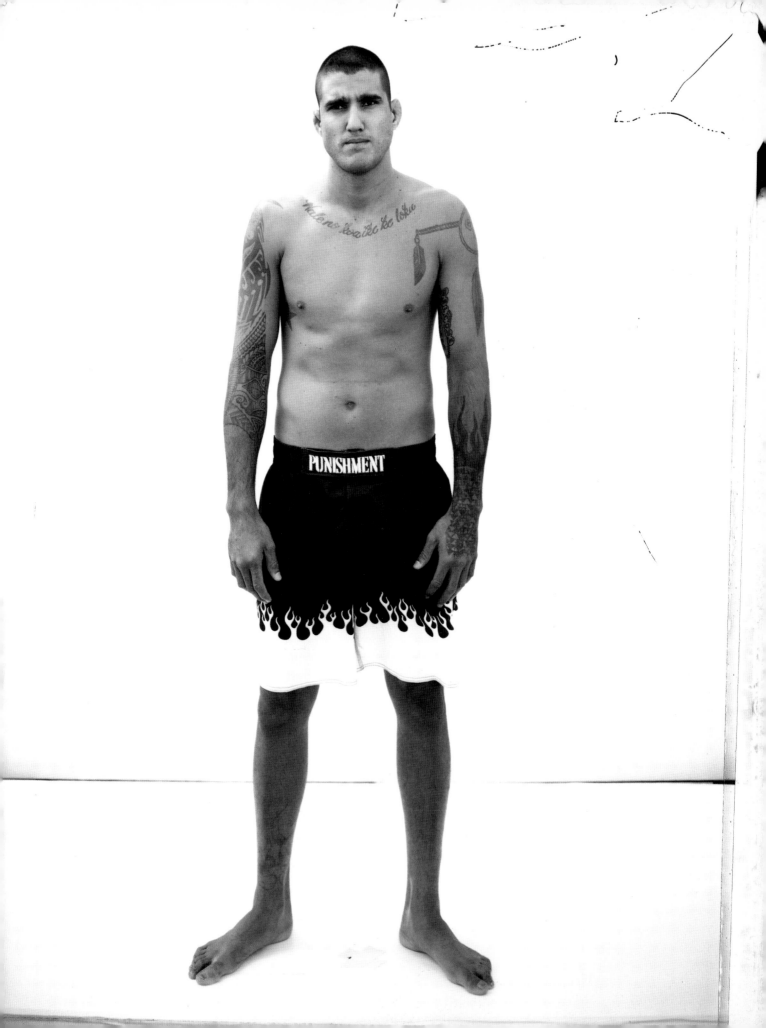

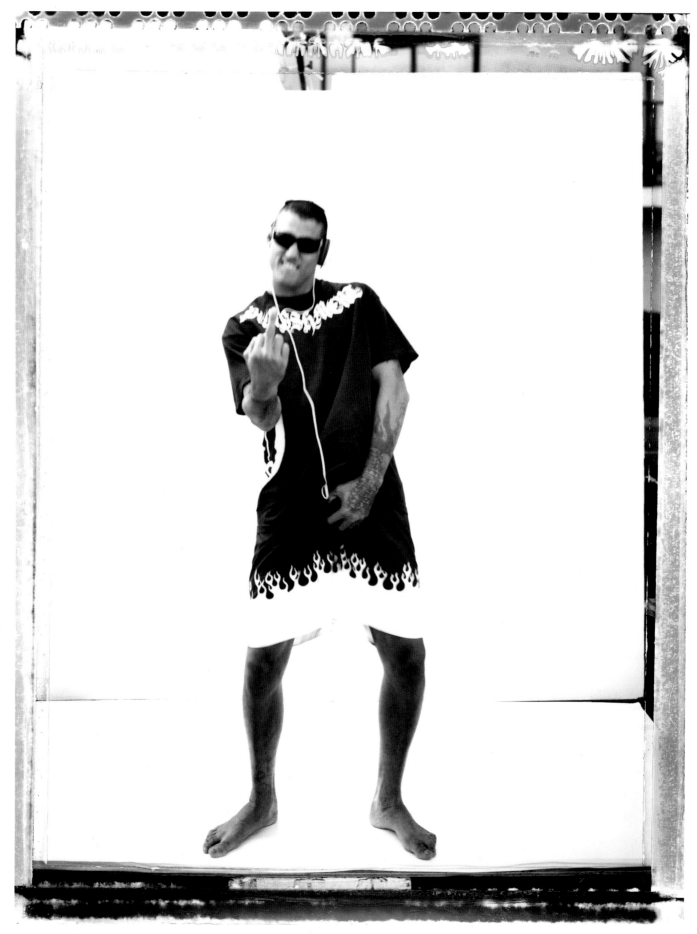

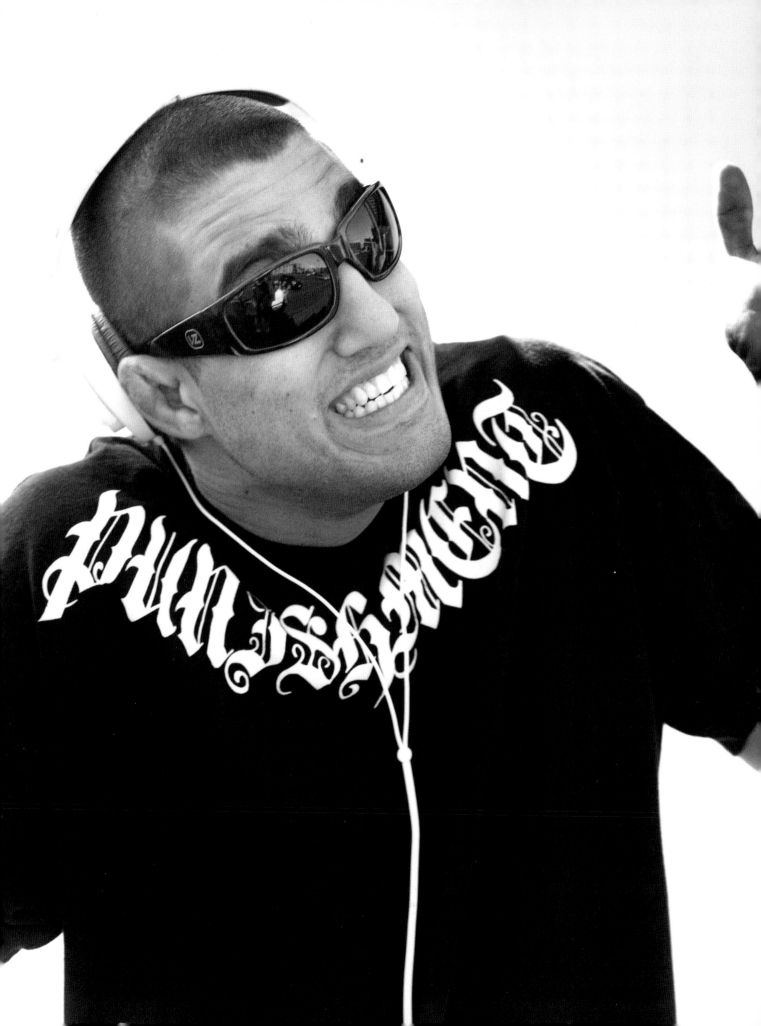

the assas-sin

My fighting style is aggressive at times. When I get going, it gets kind of brutal.

—HOUSTON ALEXANDER

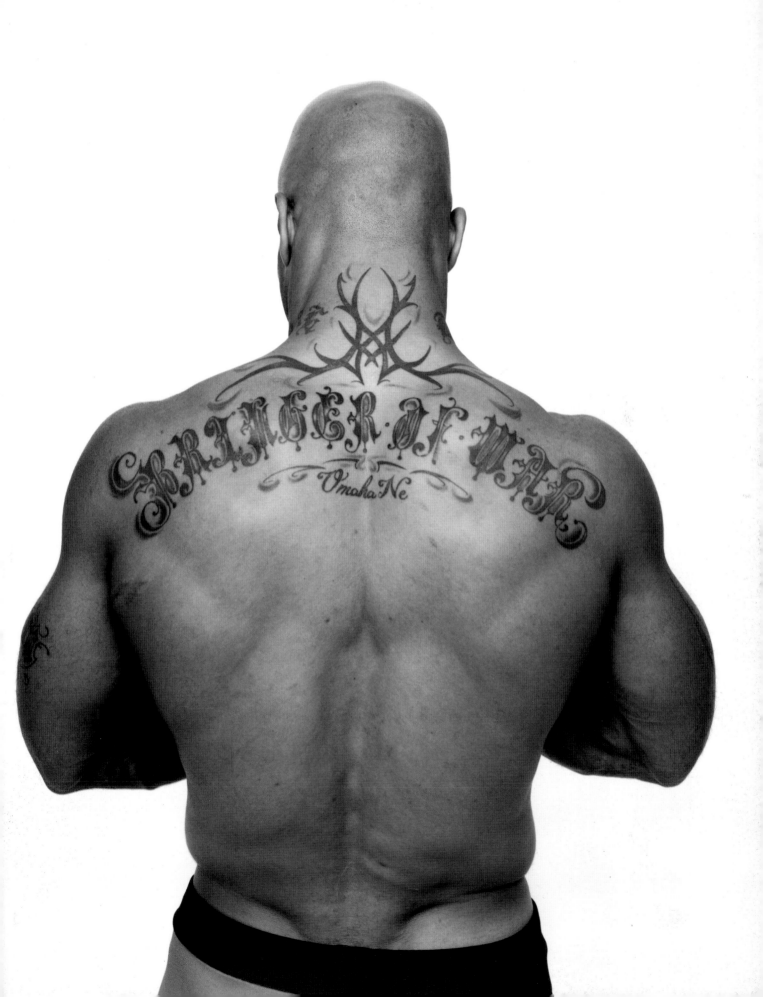

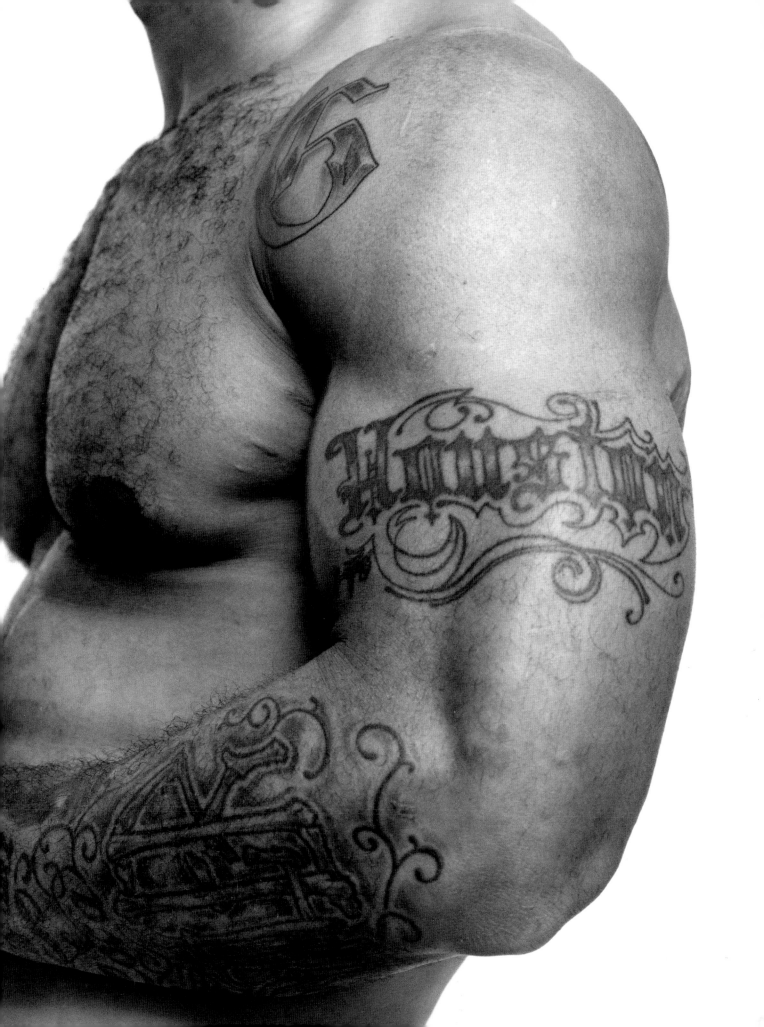

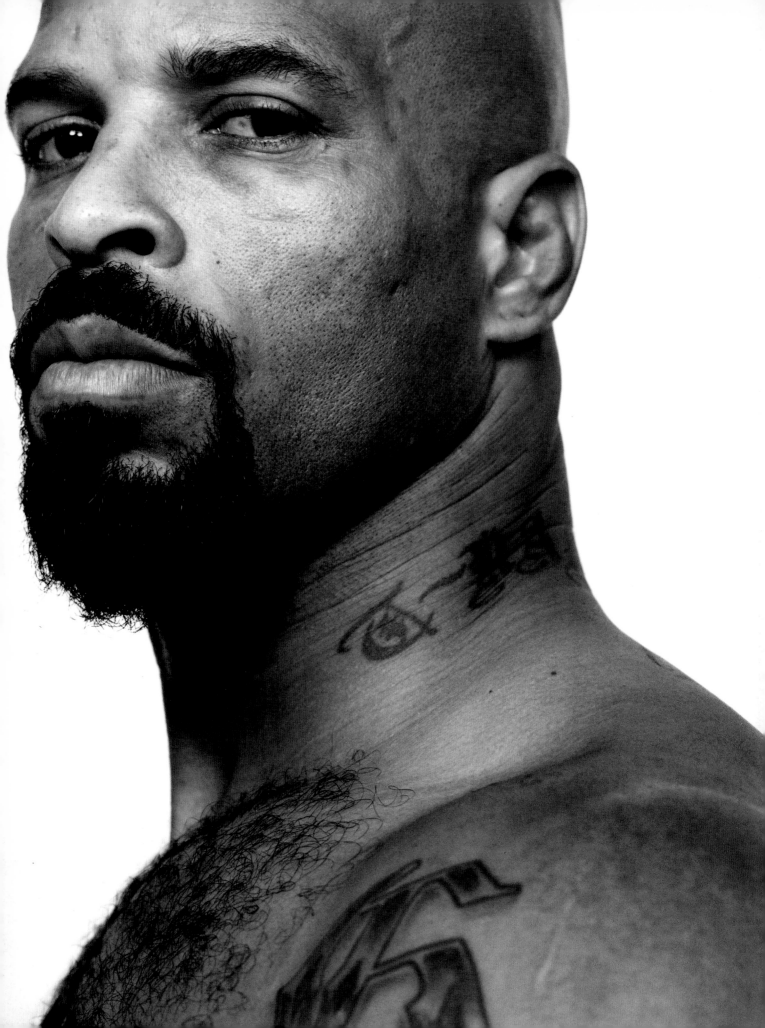

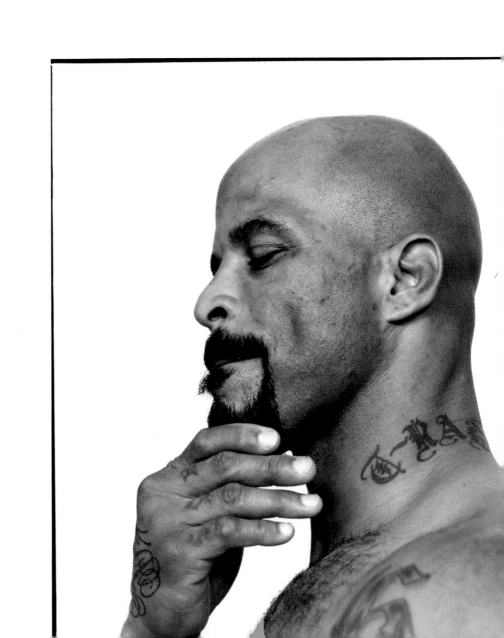

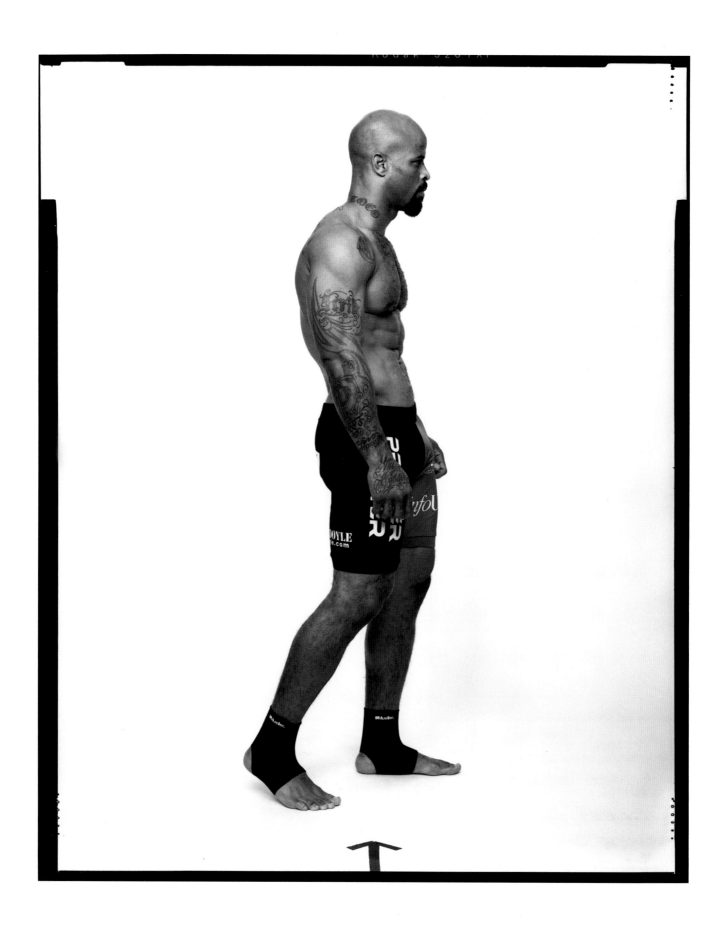

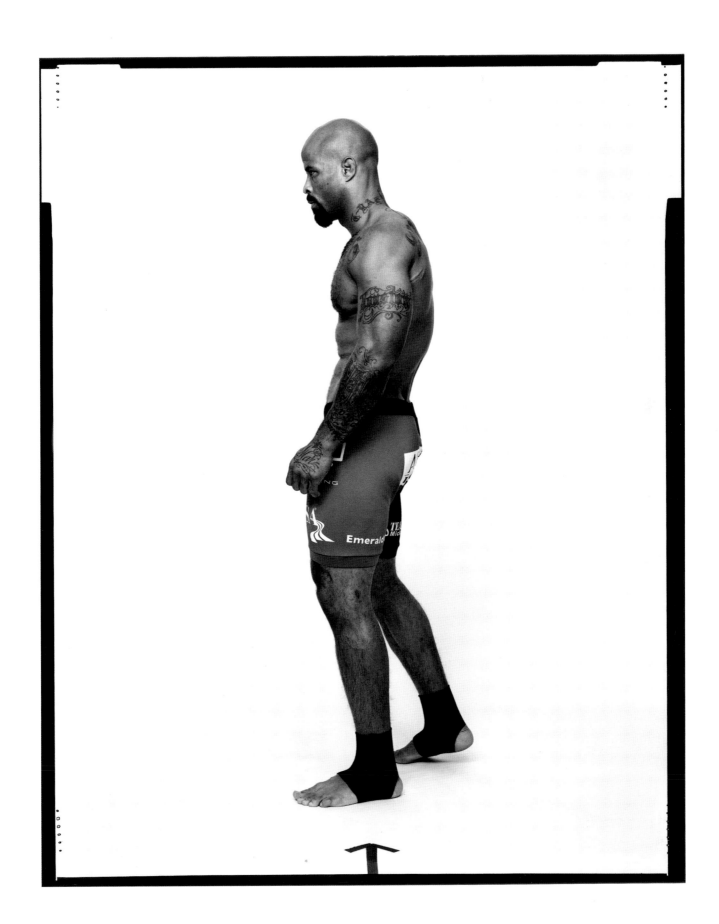

shogun

Just to step inside the Octagon is a challenge in itself, and
you've got to respect anyone who does it.

—MAURICIO RUA

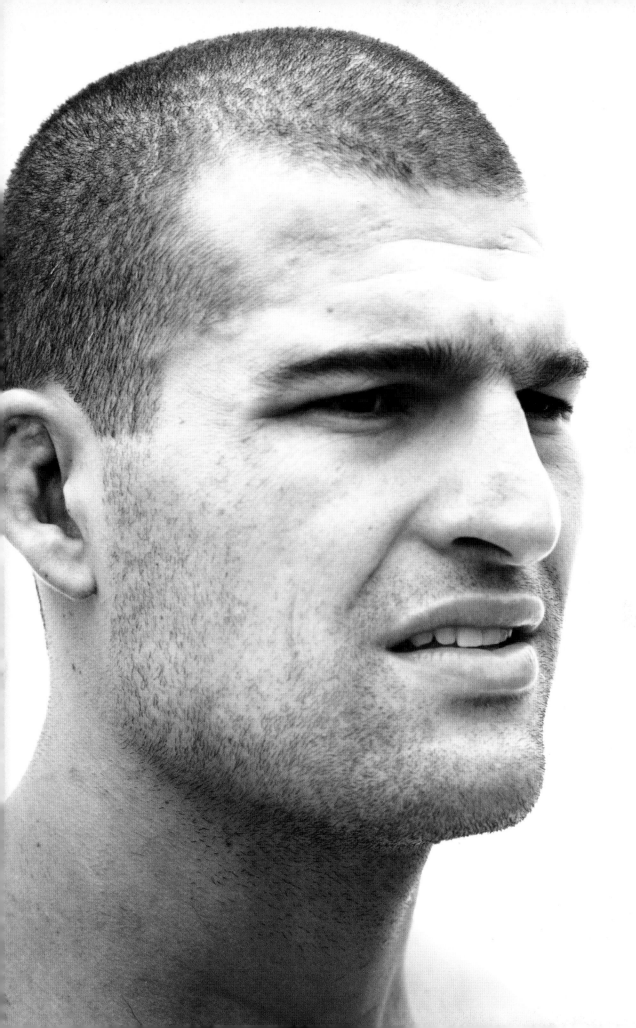

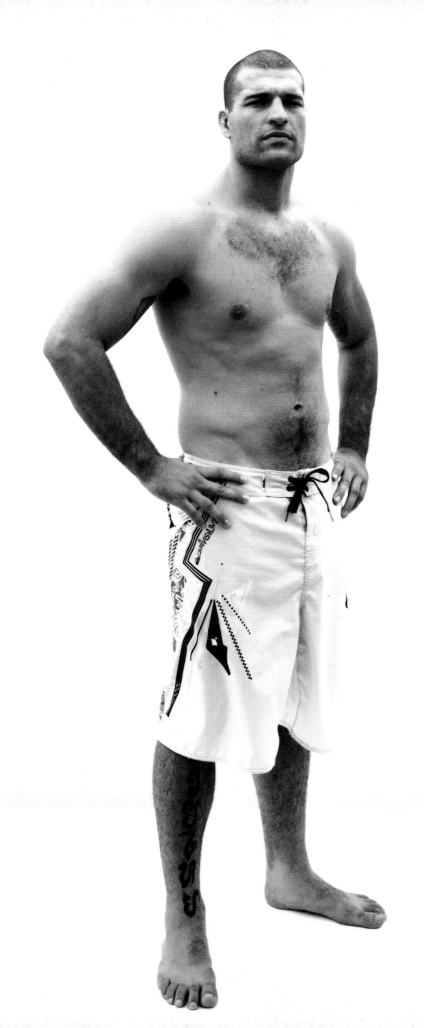

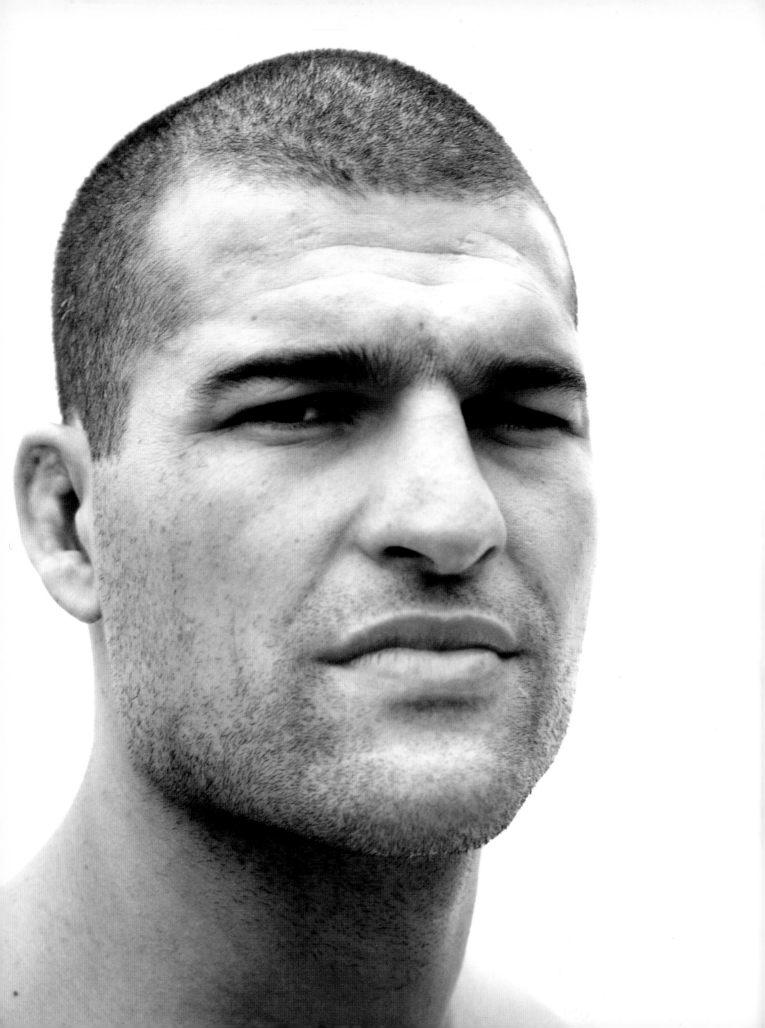

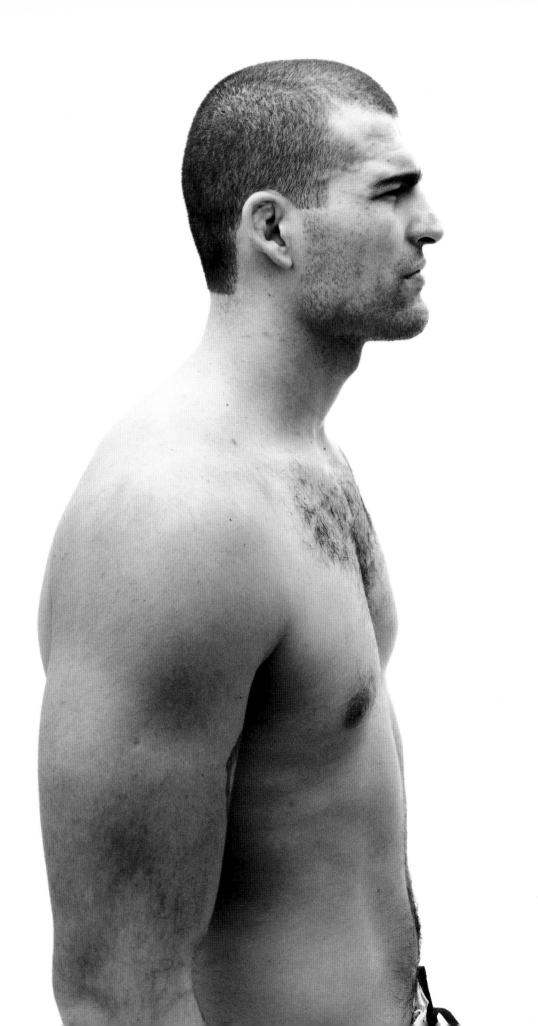

kaz

I handle defeat by taking one step back.
It gives me more determination.

—KAZUHIRO NAKAMURA

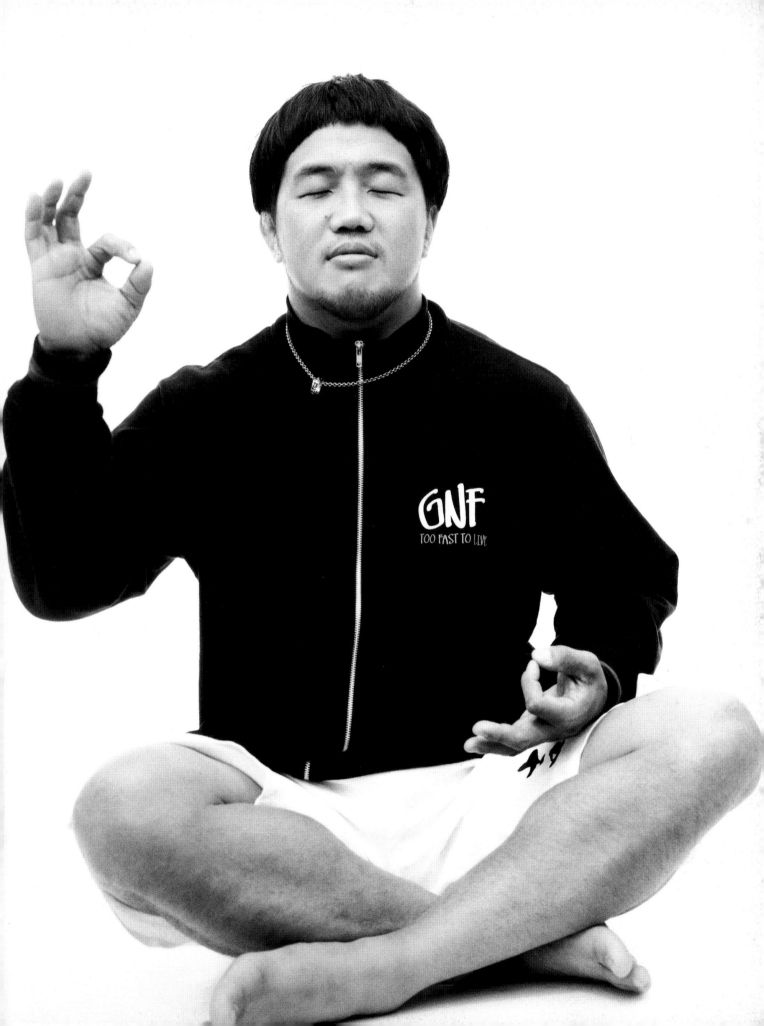

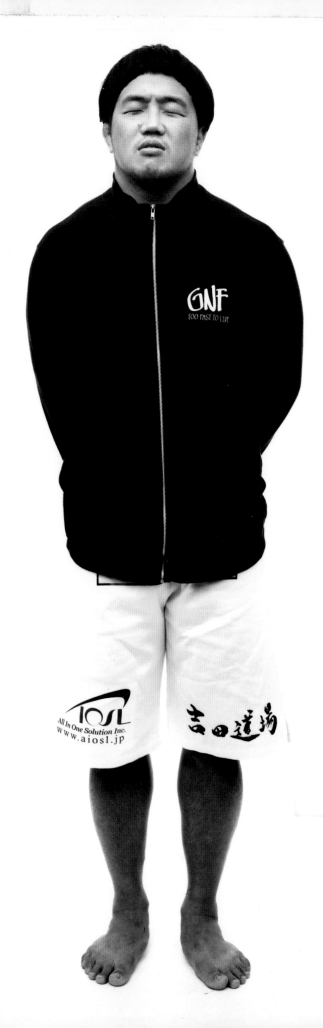

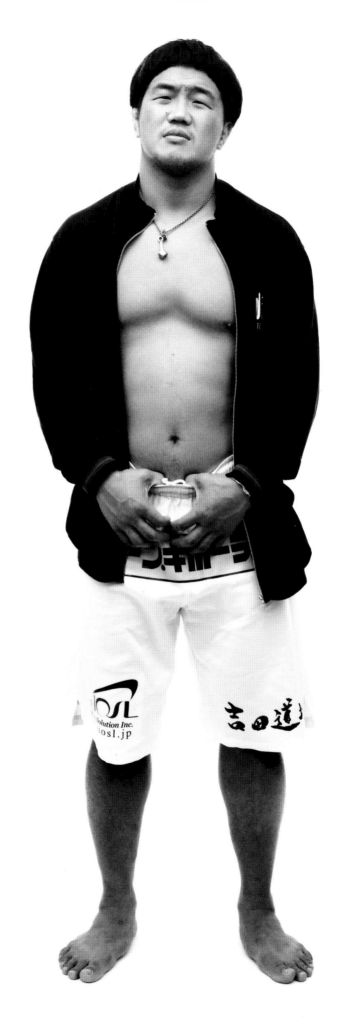

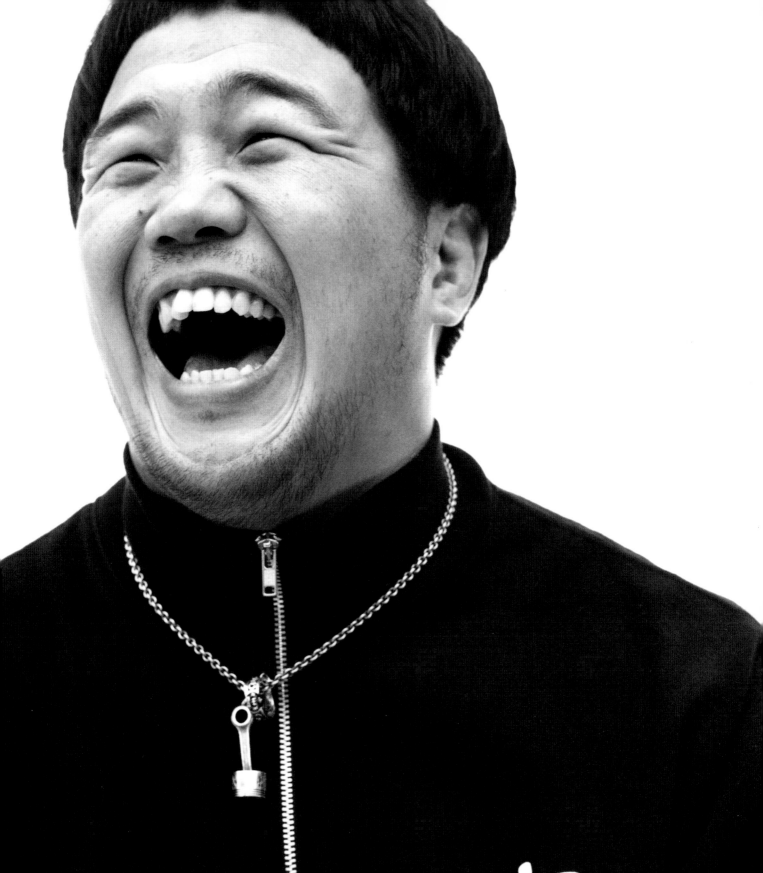

hughes

I don't depend on anybody.

When I win, I get the glory. When I lose, I get the defeat.

—MATT HUGHES

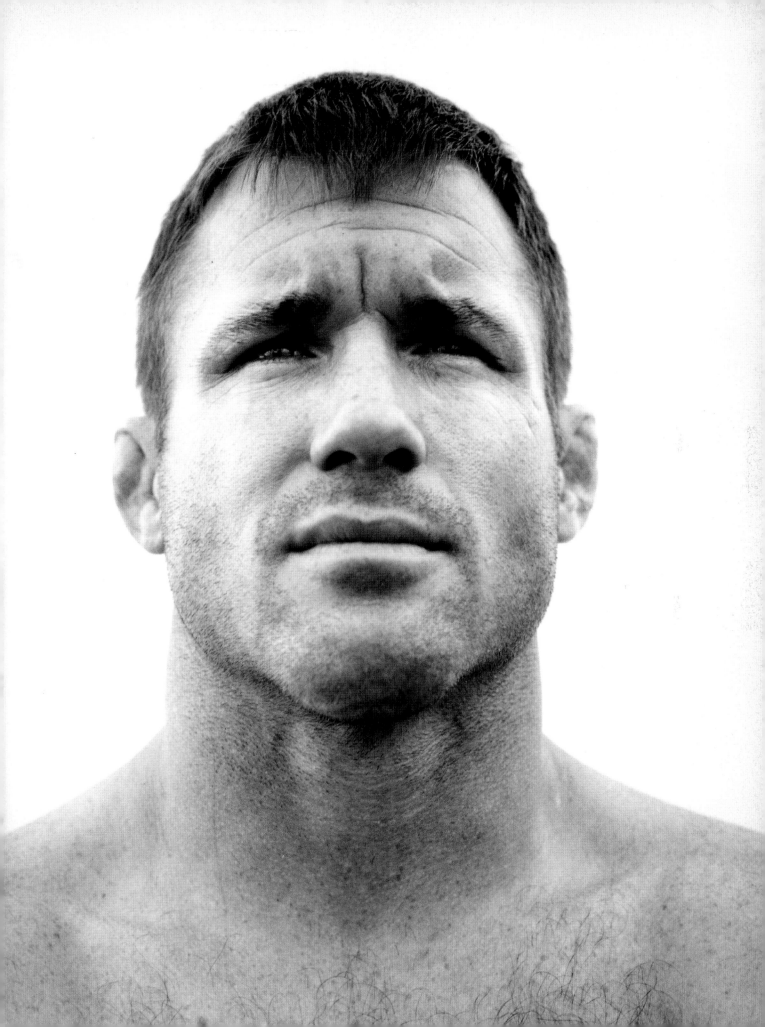

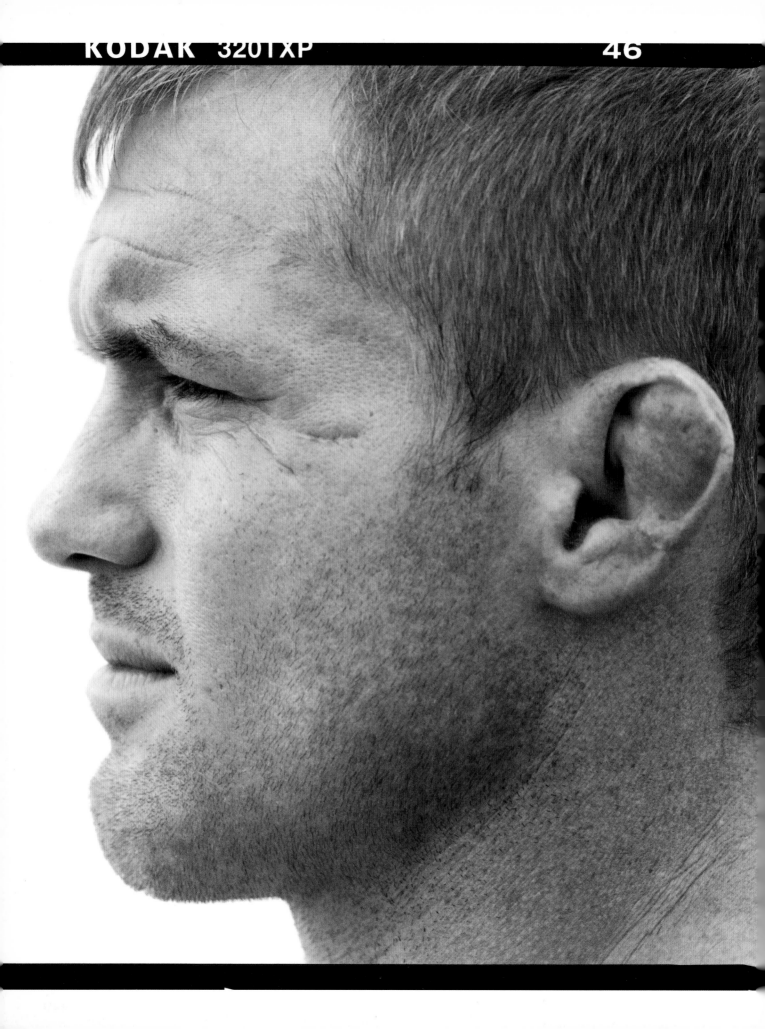

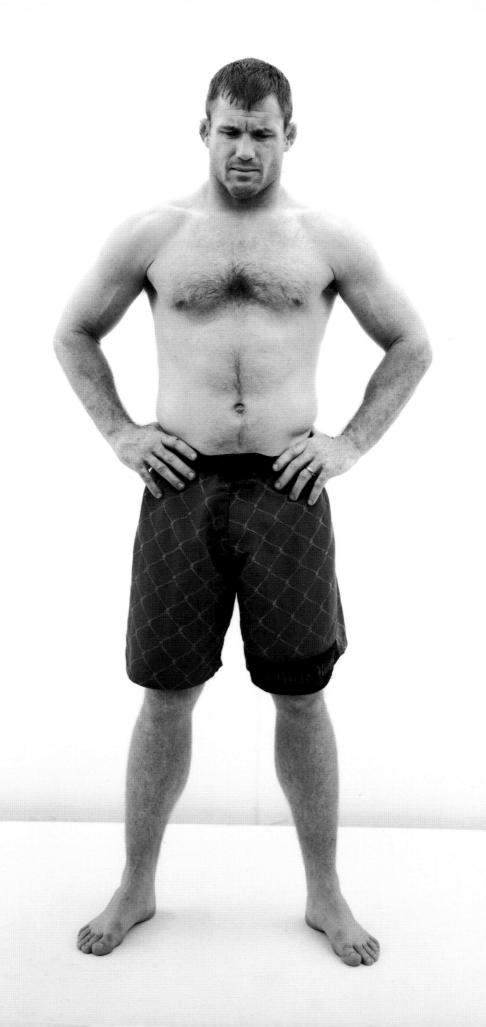

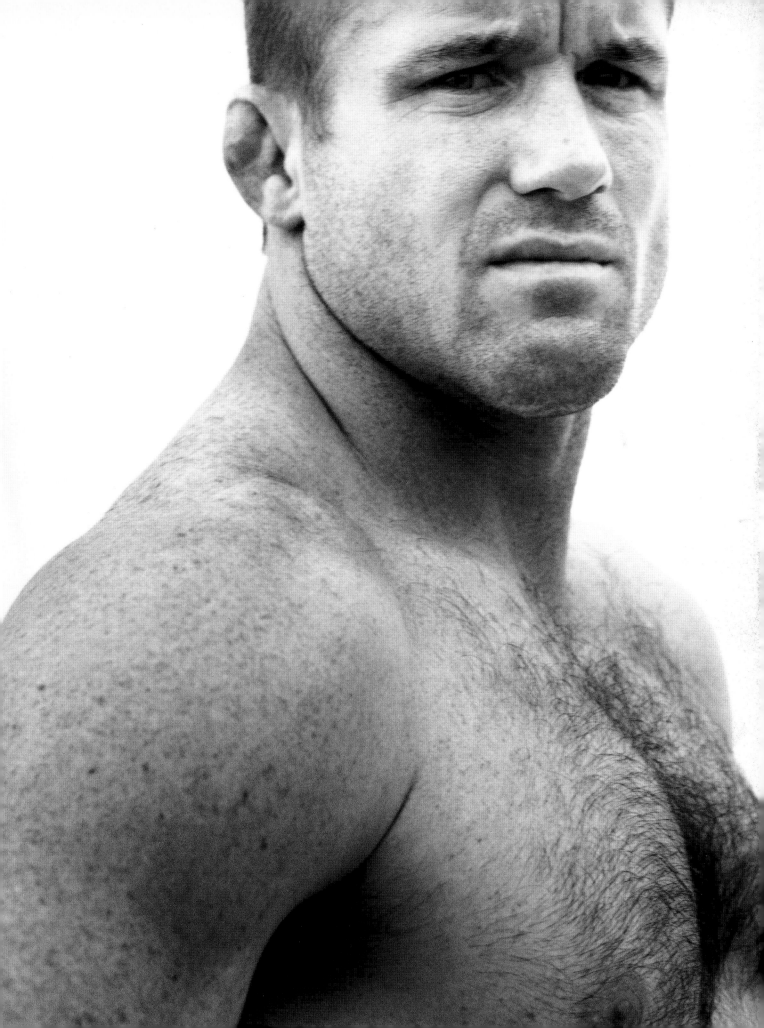

legion-
arius

There's more **emotion** in MMA. This is the sport of the future.

—ALESSIO SAKARA

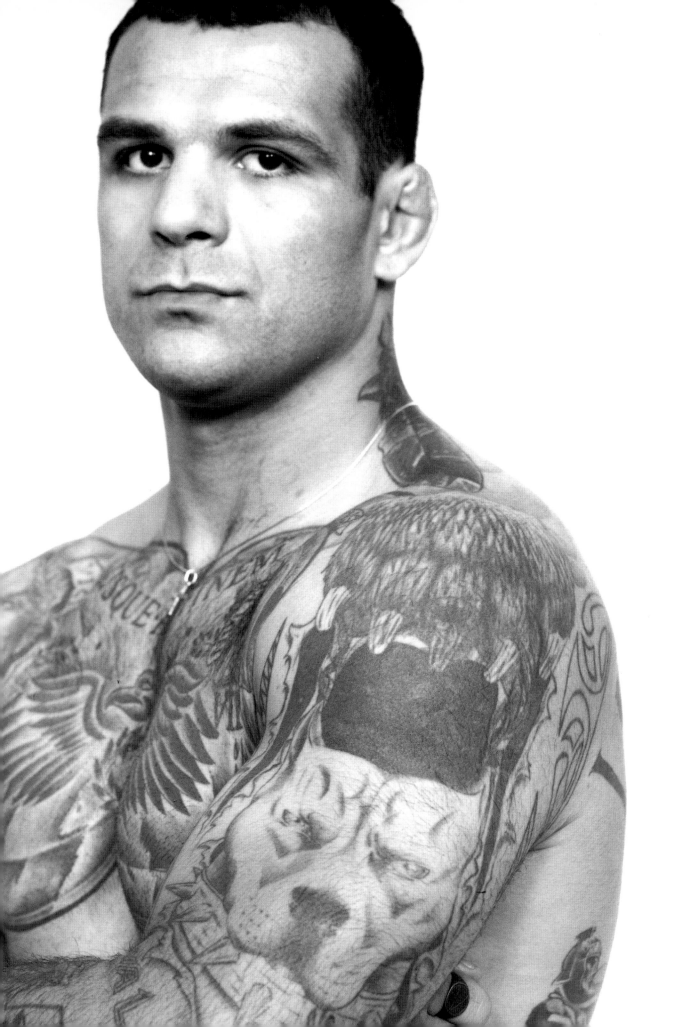

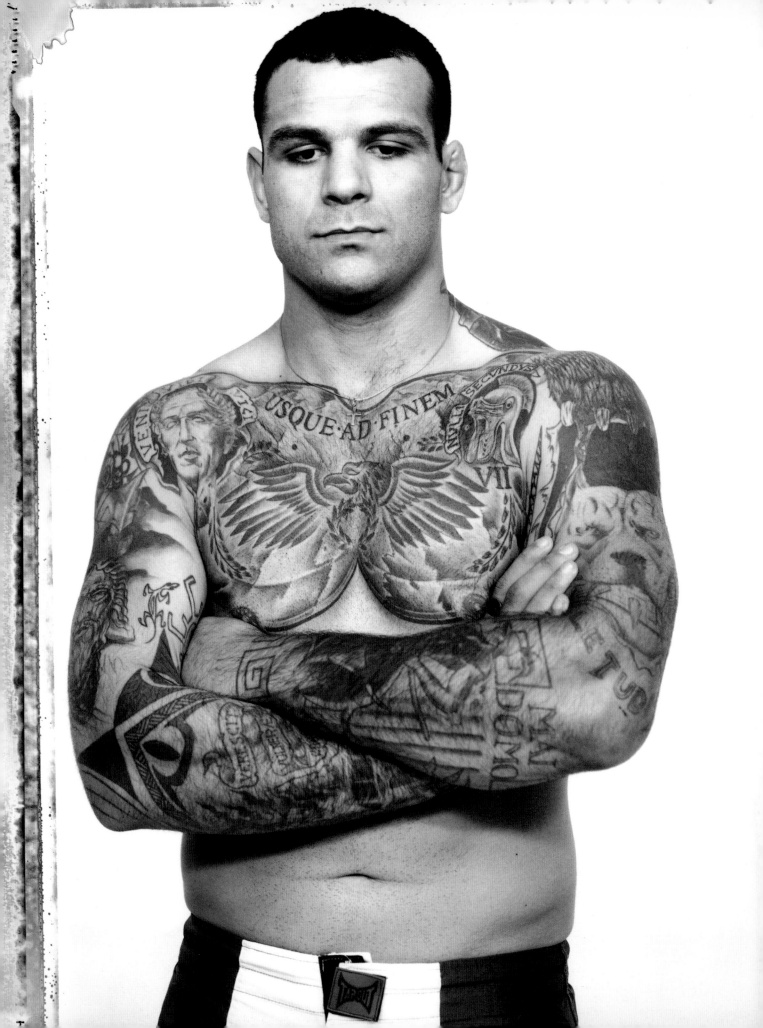

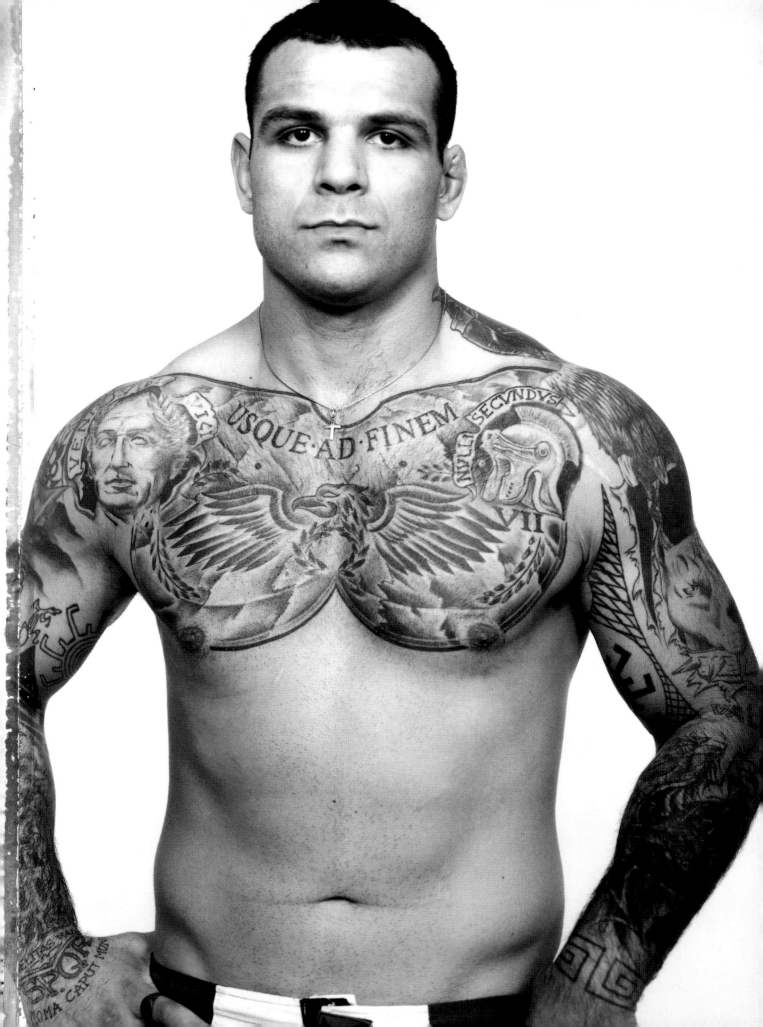

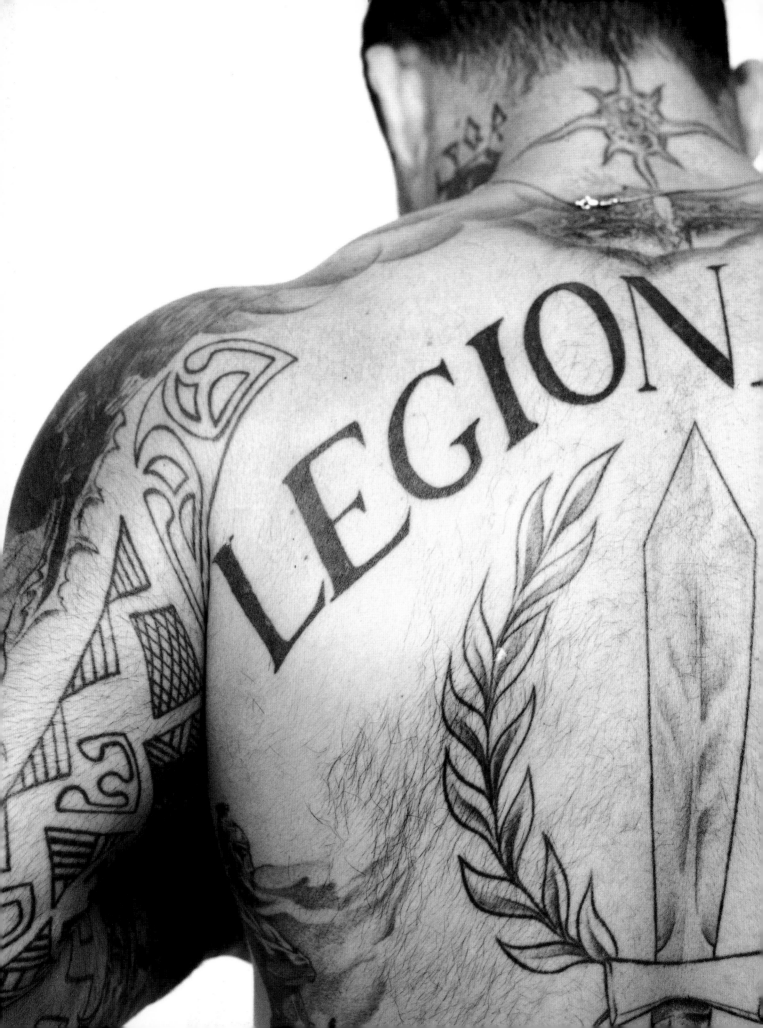

rush

Fighting is in human nature.

We all fight for different purposes in a certain way.

—GEORGES ST-PIERRE

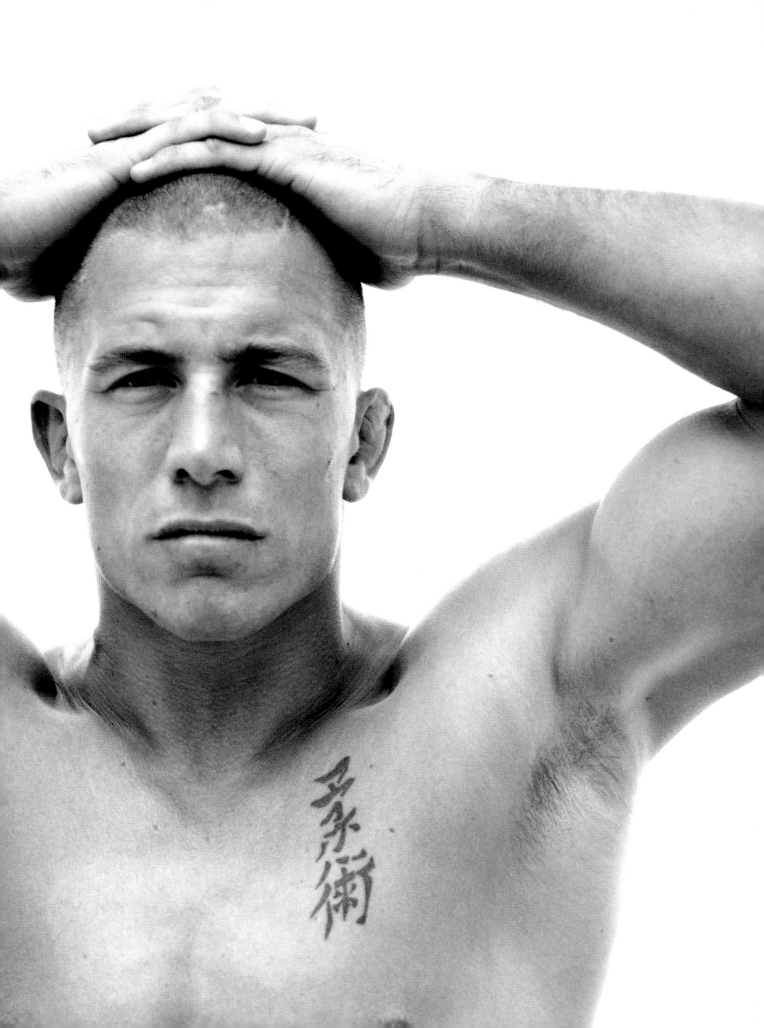

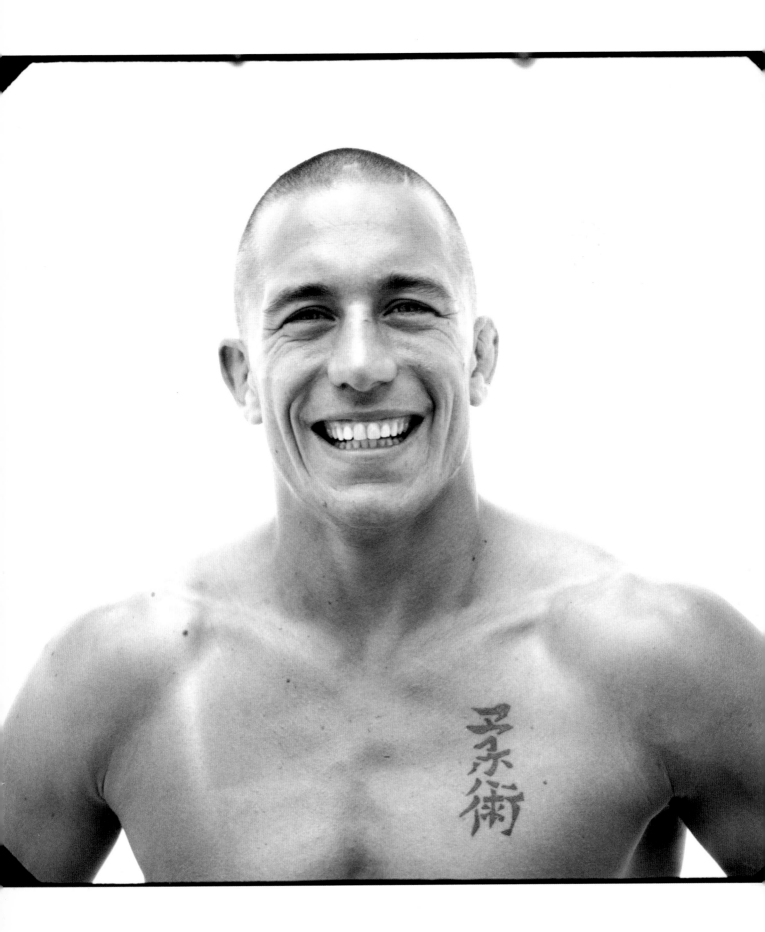

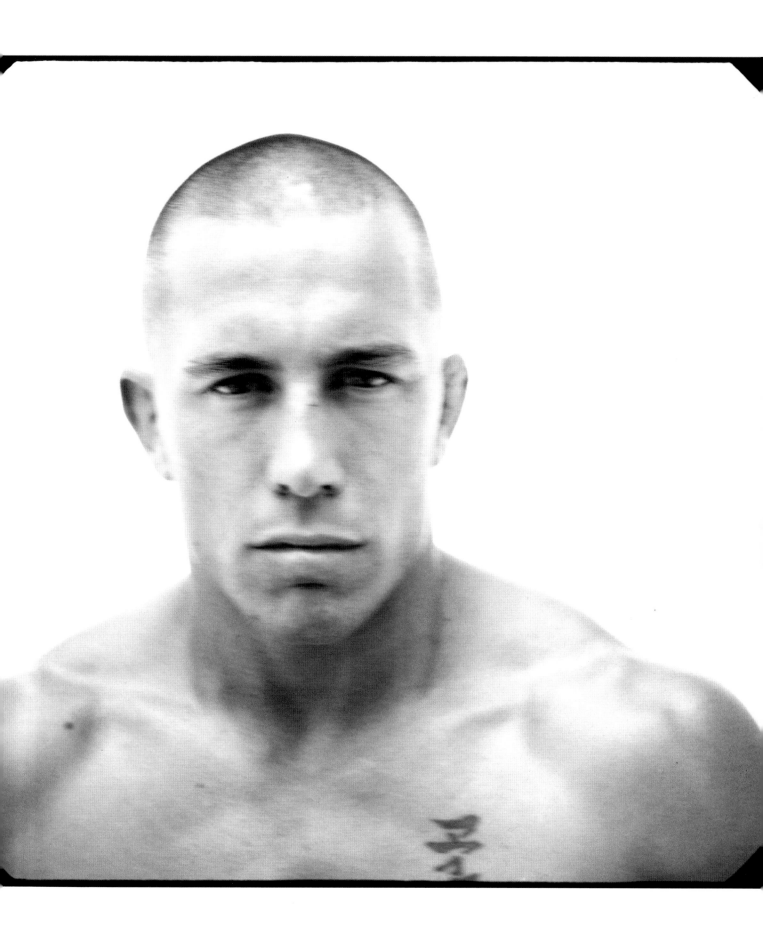

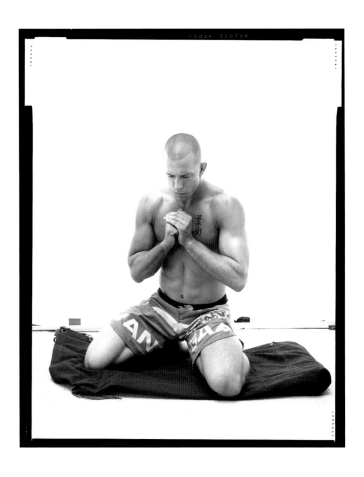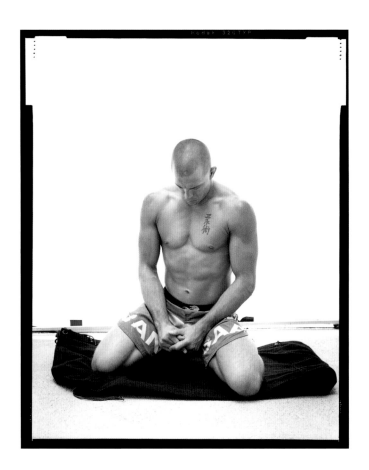

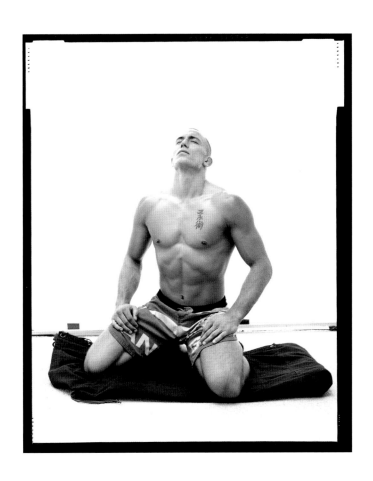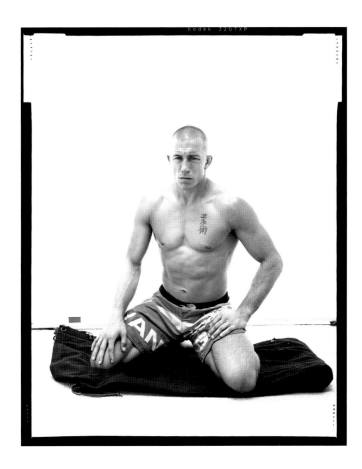

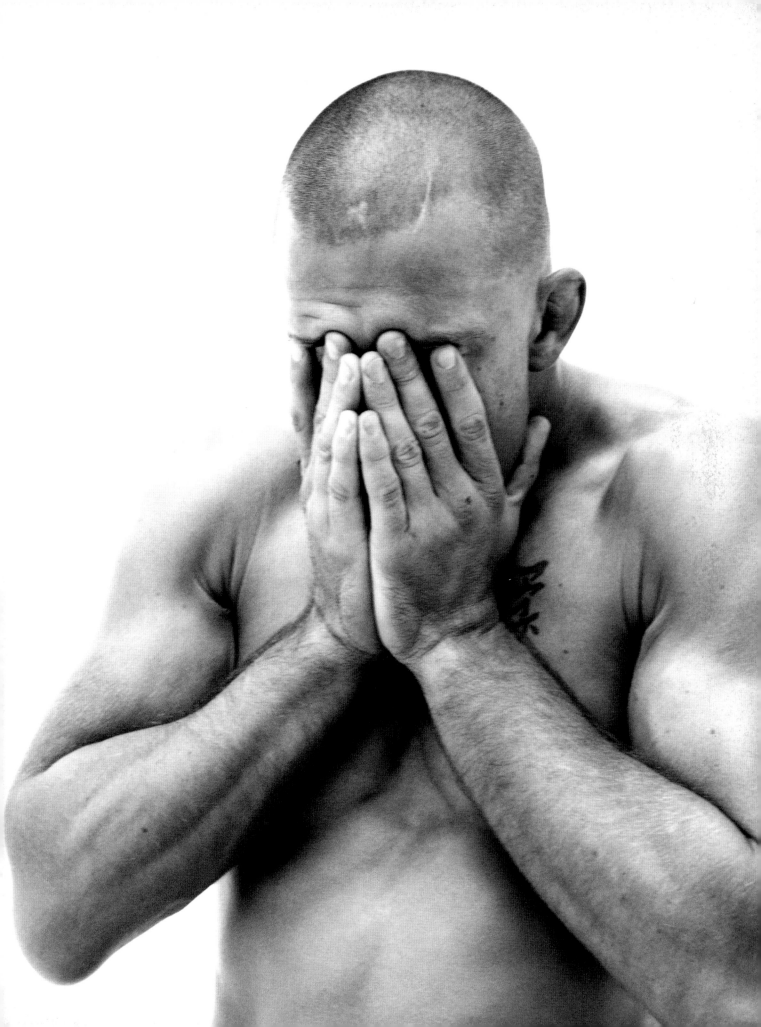

fitch

There's something in us as human beings that needs a little bit of conflict.

—JON FITCH

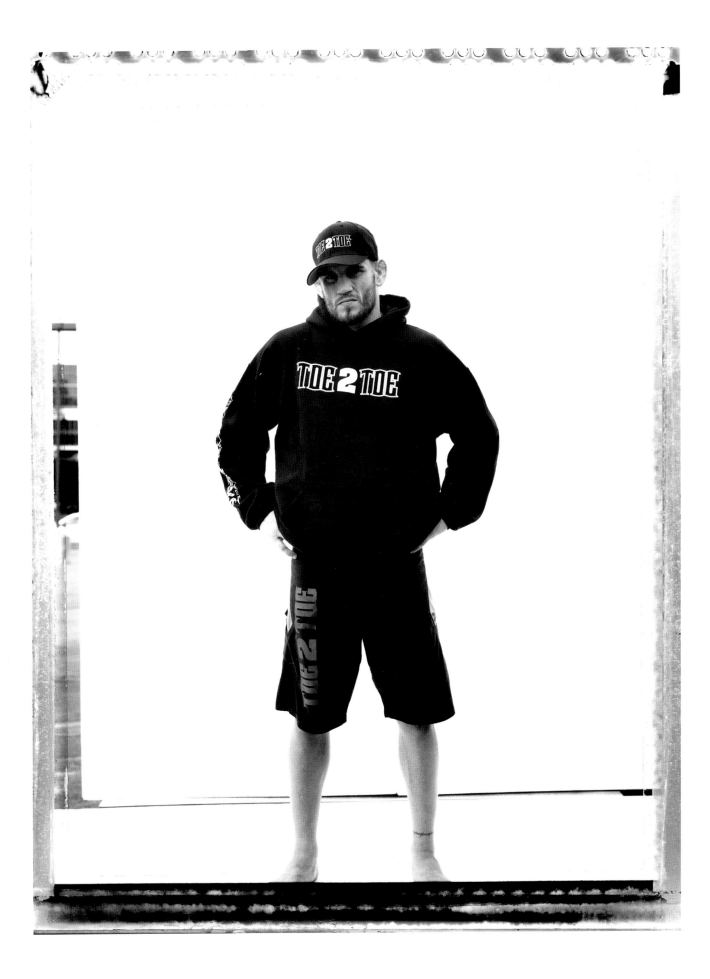

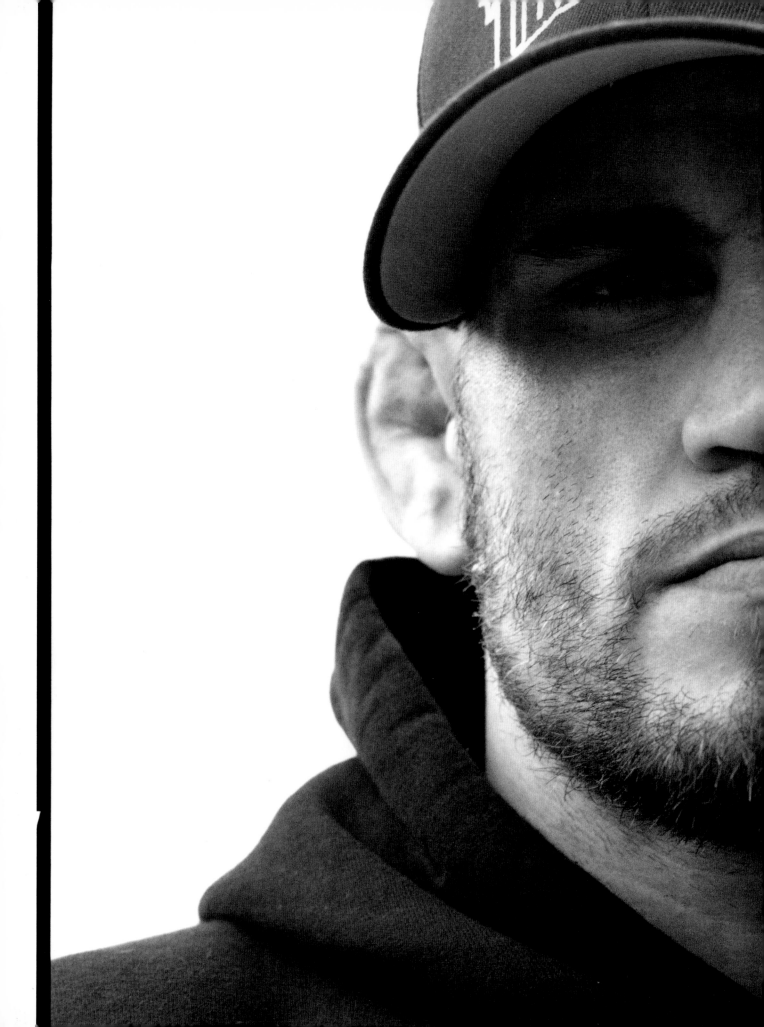

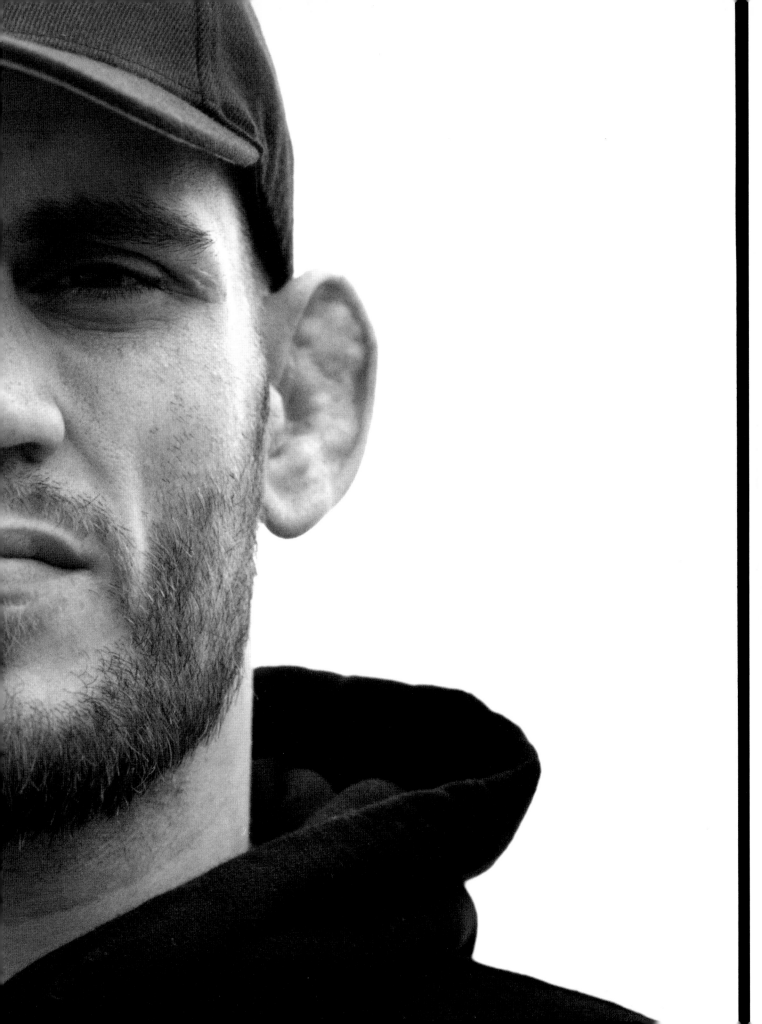

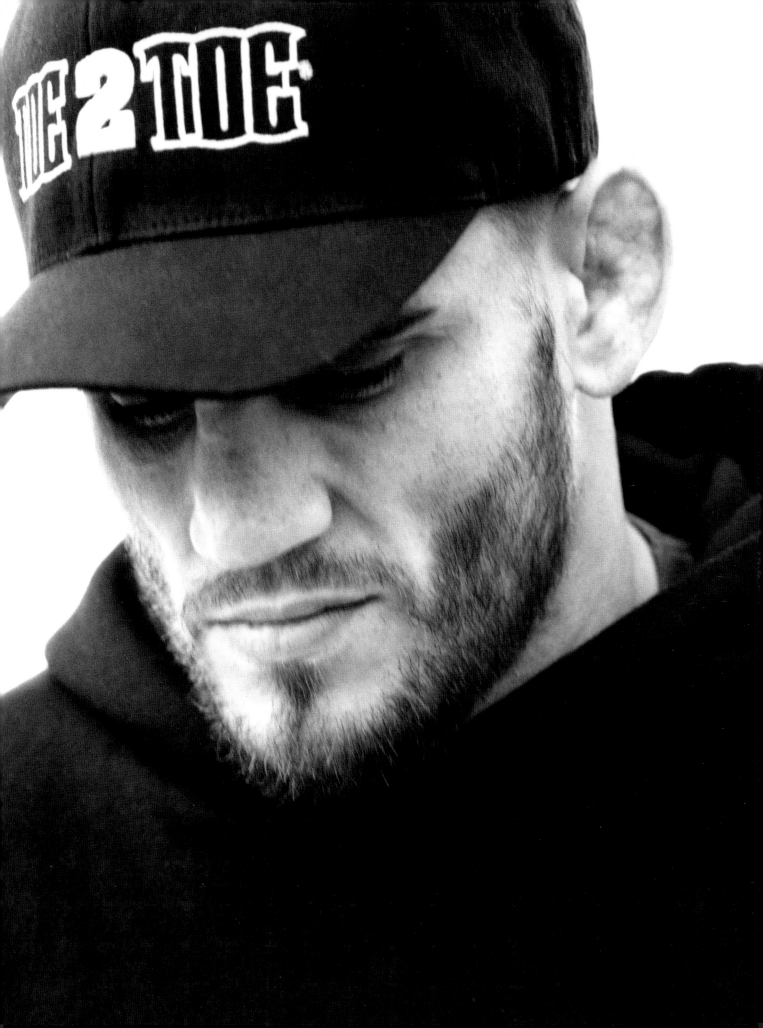

the spider

After a fight, I just like to sit back, relax. I think about the fight a little bit but not too much. In my mind, that fight's gone and now it's on to the next.

—ANDERSON SILVA

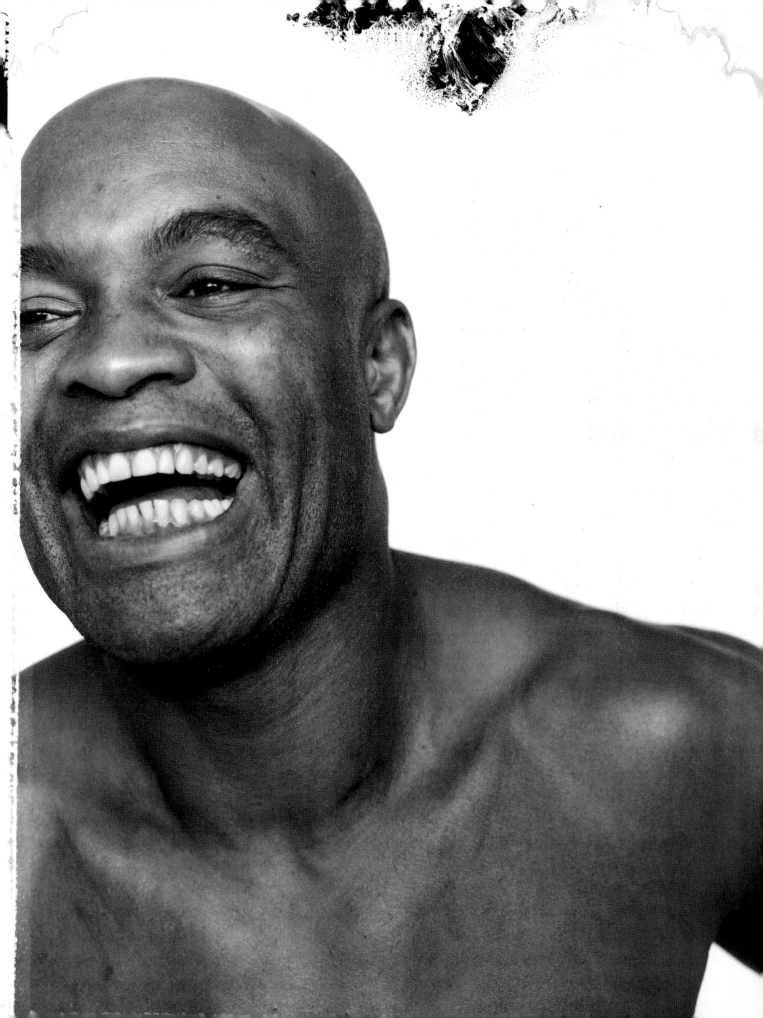

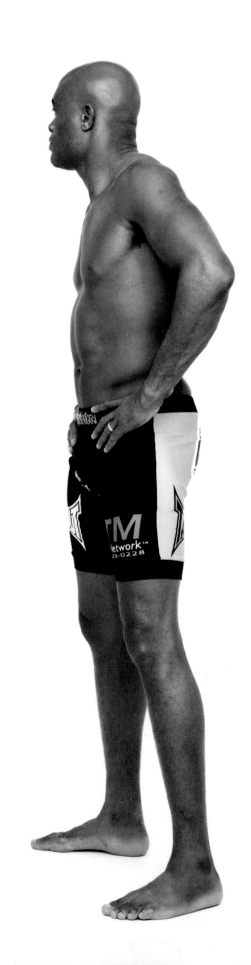

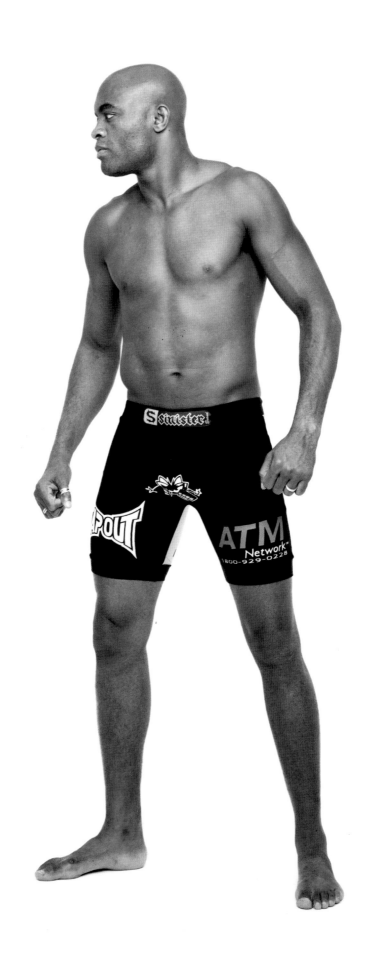

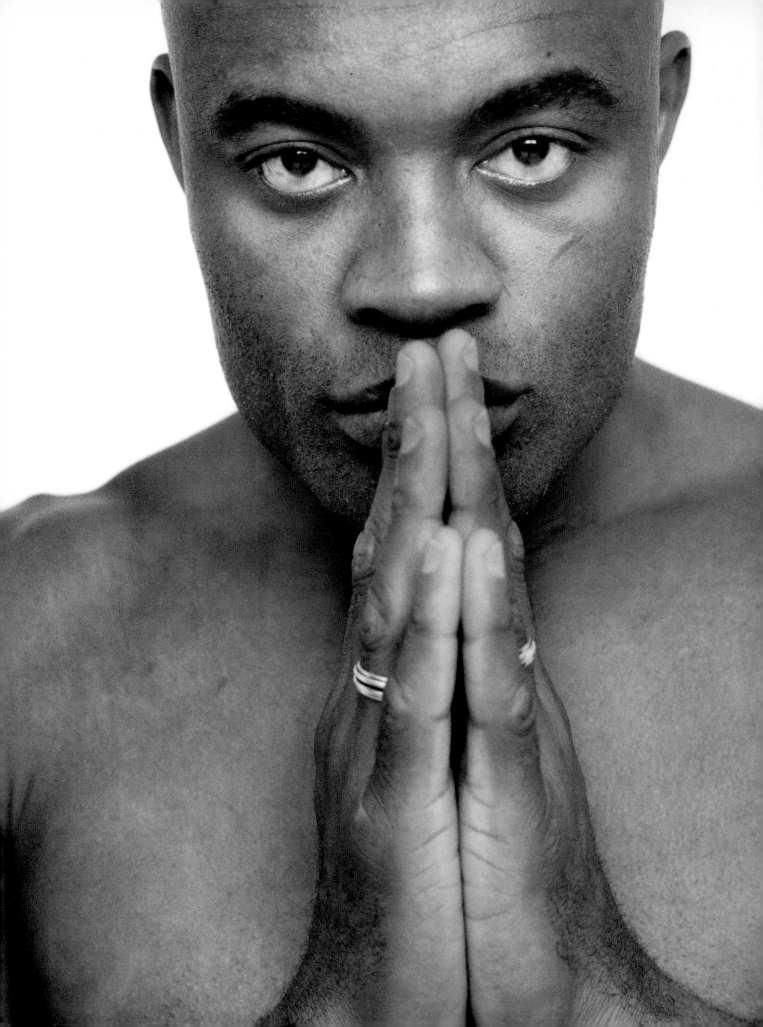

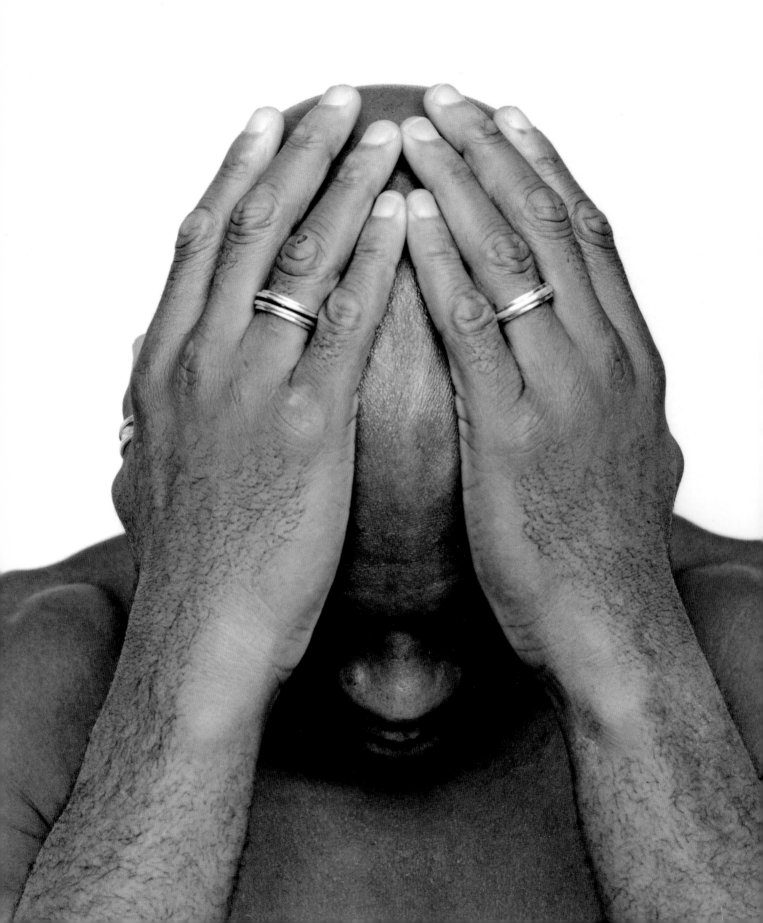

ace

Sometimes you feel like quitting—
everybody feels like quitting.
In life, it's ok to feel like quitting.
Just don't quit.

—RICH FRANKLIN

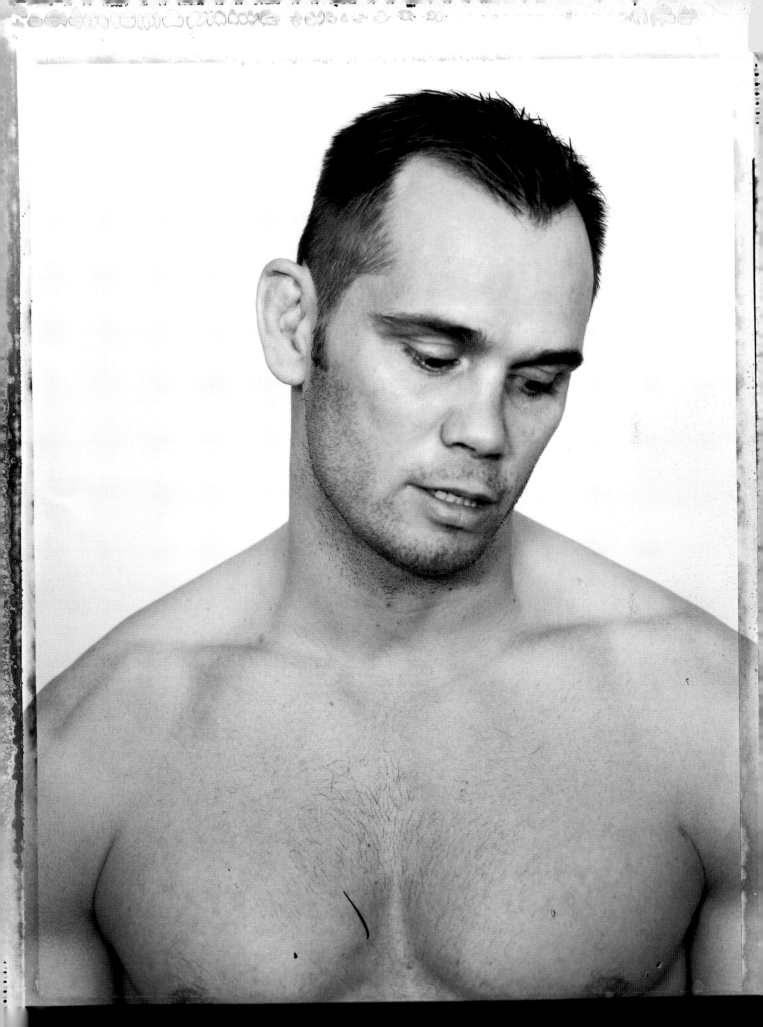

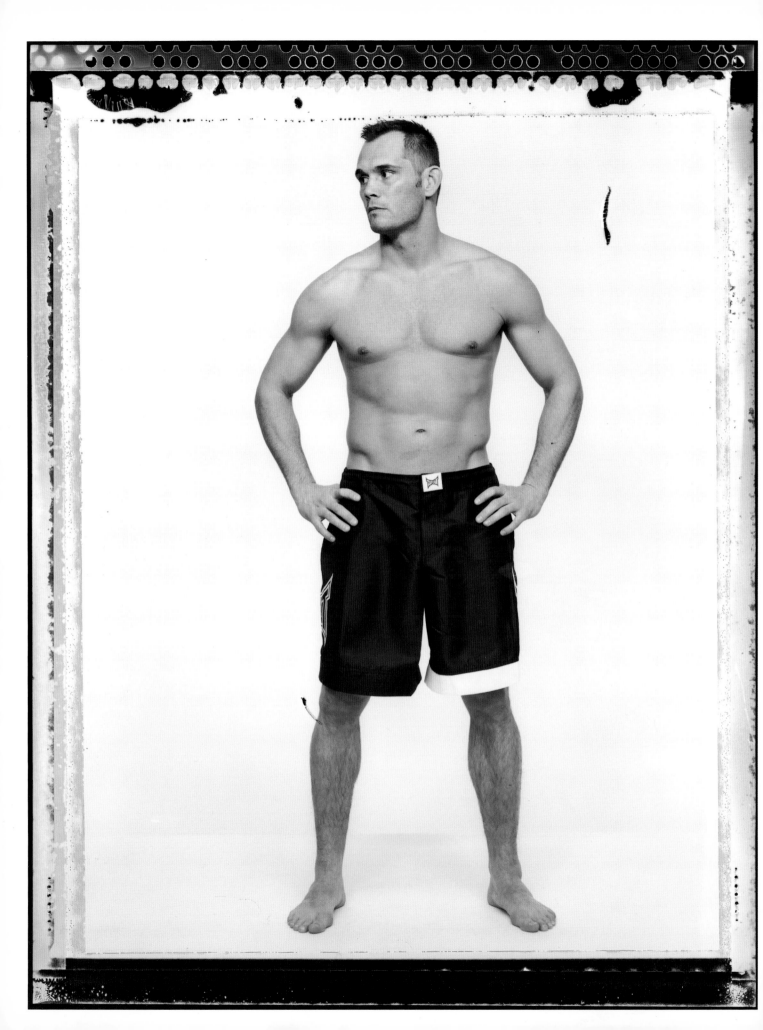

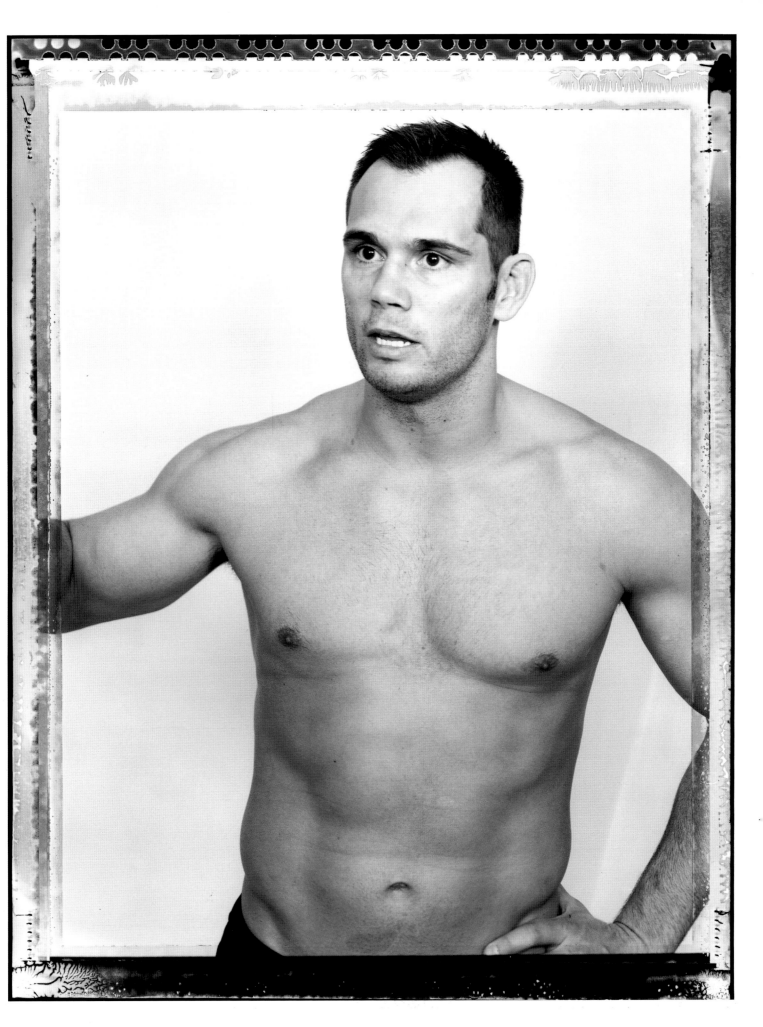

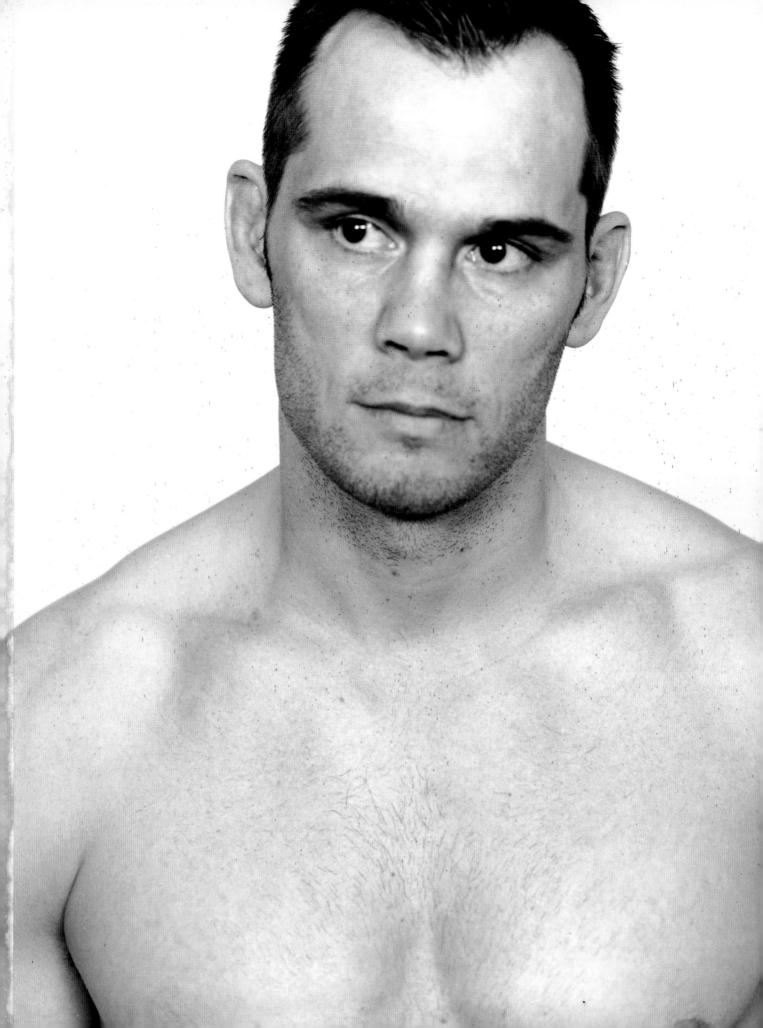

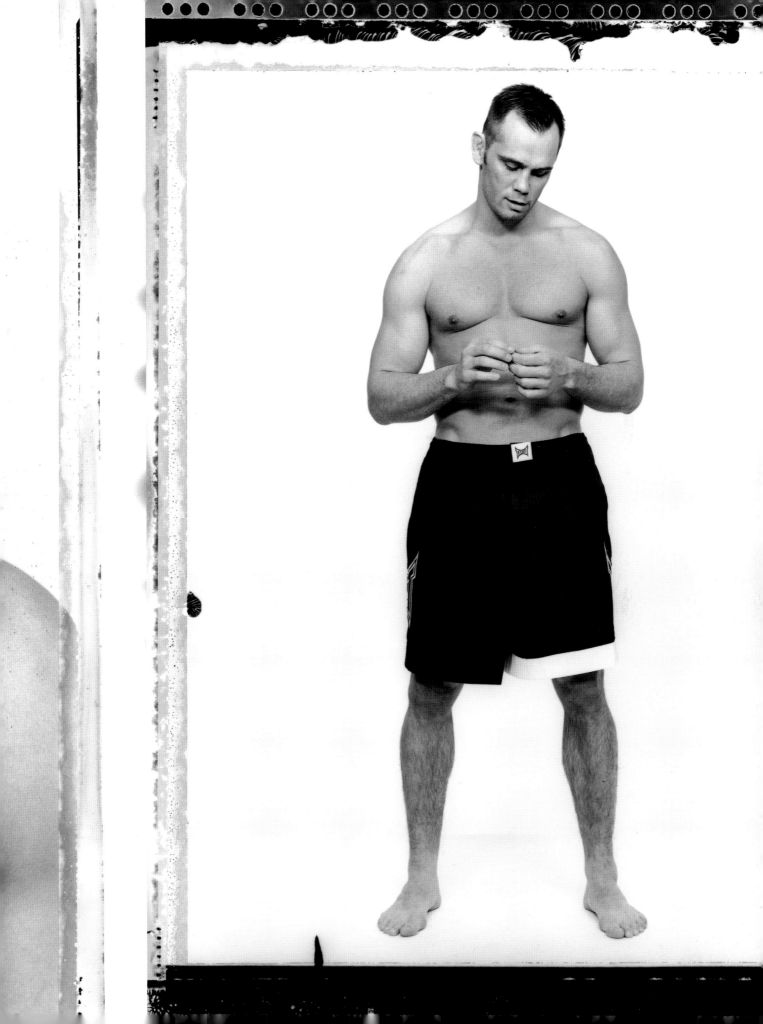

the prod-igy

My fighting style is that I go after you ruthlessly but with tons of technique. I'm not just a mindless brawler. I'm thinking the whole time I'm going after you.

When they say you can't, you must.

—BJ PENN

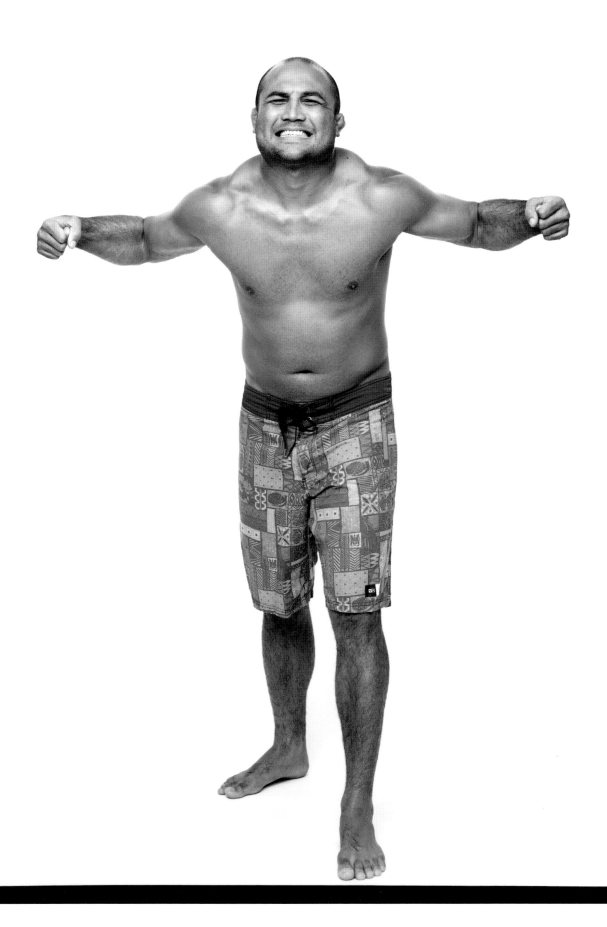

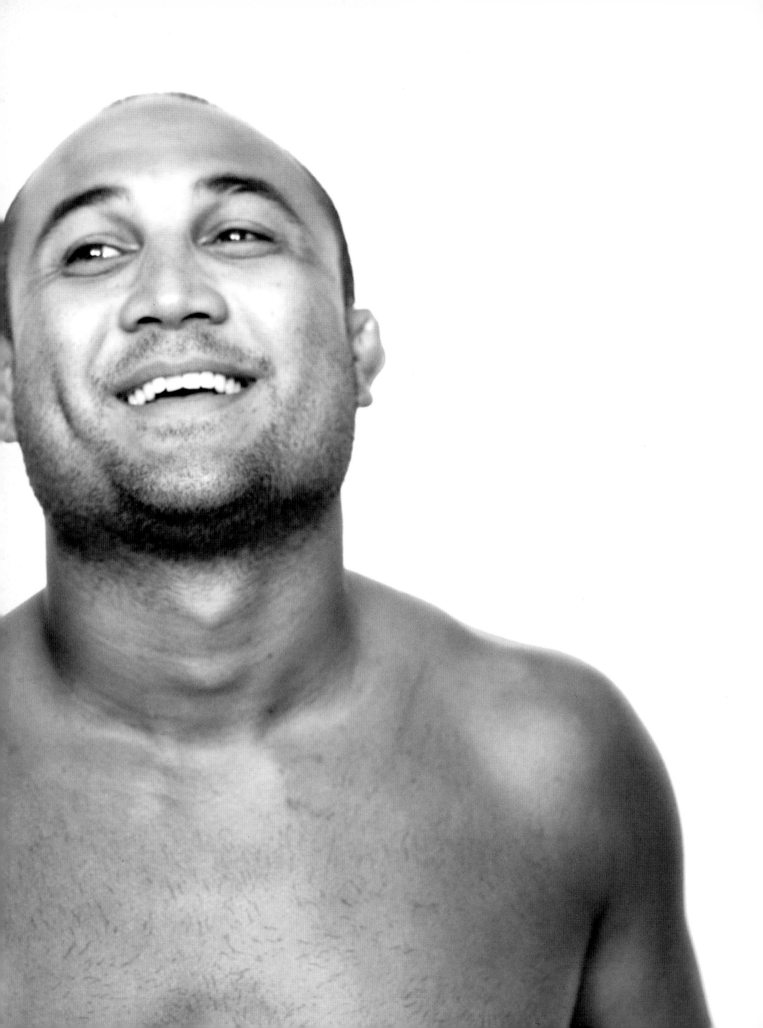

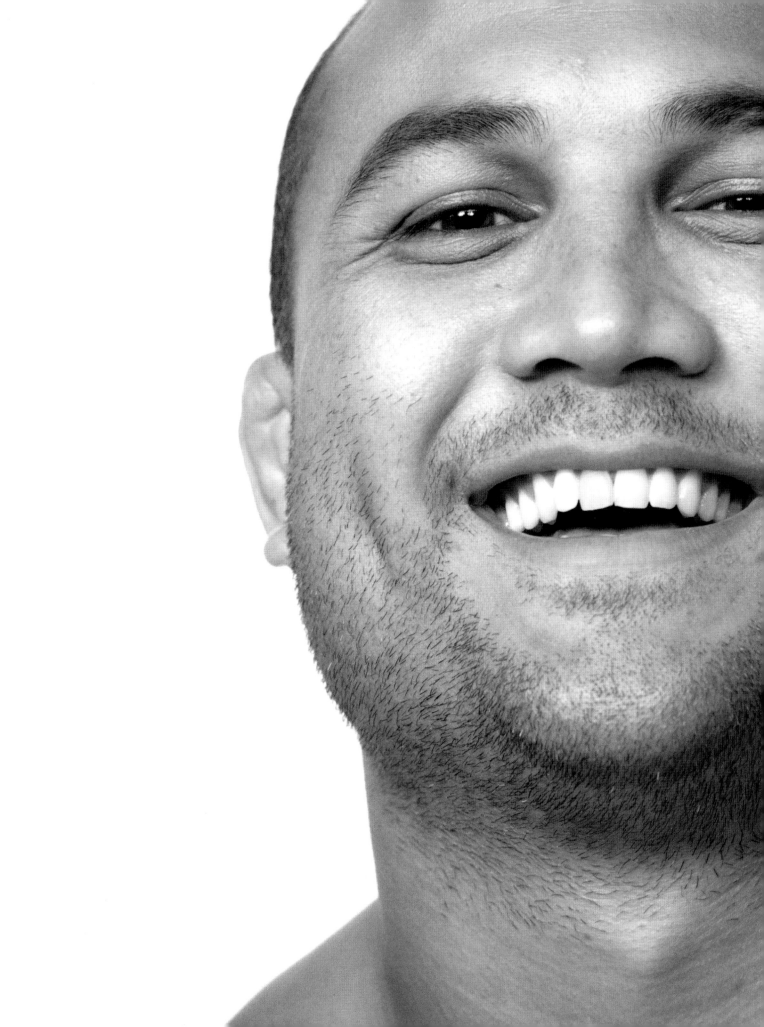

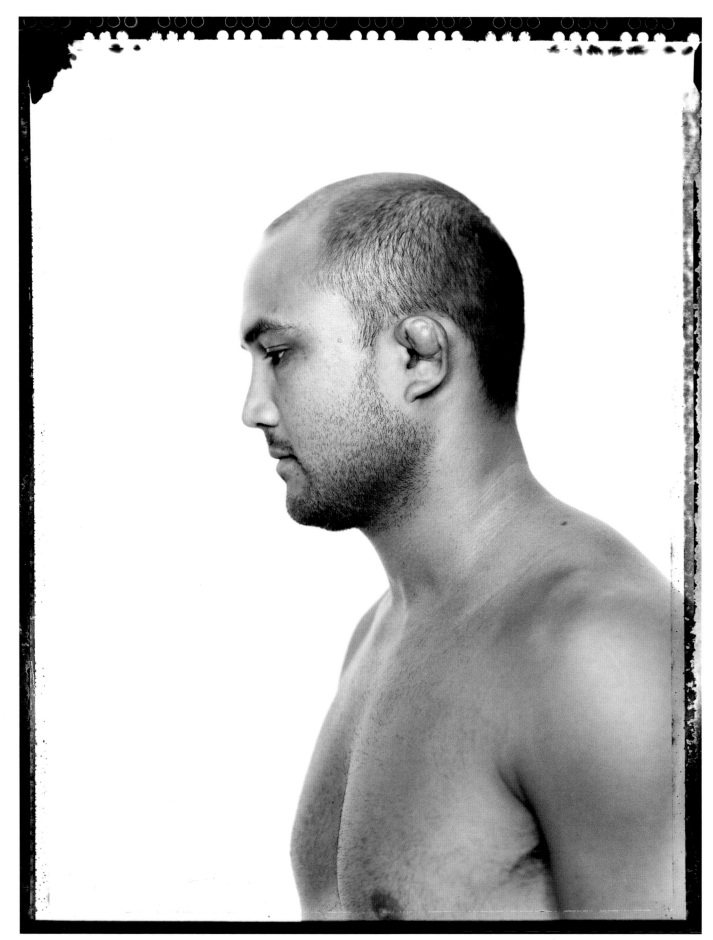

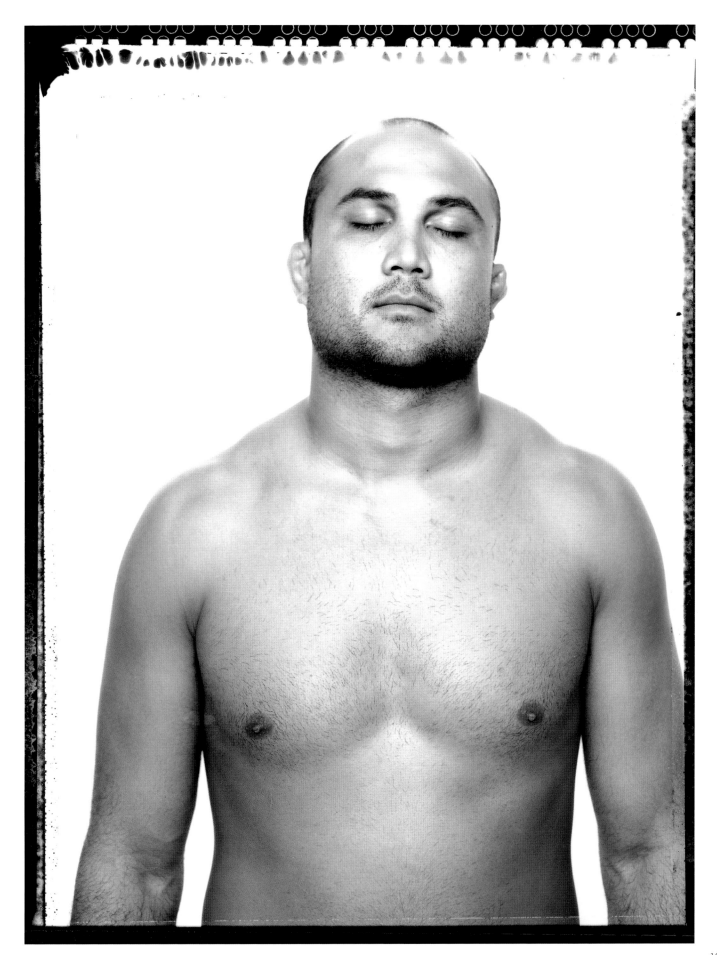

the heat

When it comes down to it in a fight, sometimes your techniques are out the window, your endurance is down the drain, you've got nothing else inside that cage, **you're barely standing on your feet,** but what makes you go is your heart and that spirit that you've got—that's the only thing.

—KARO PARISYAN

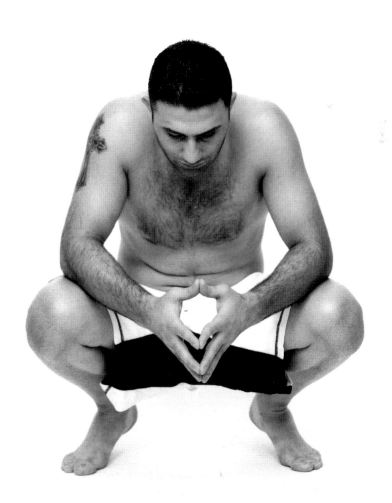

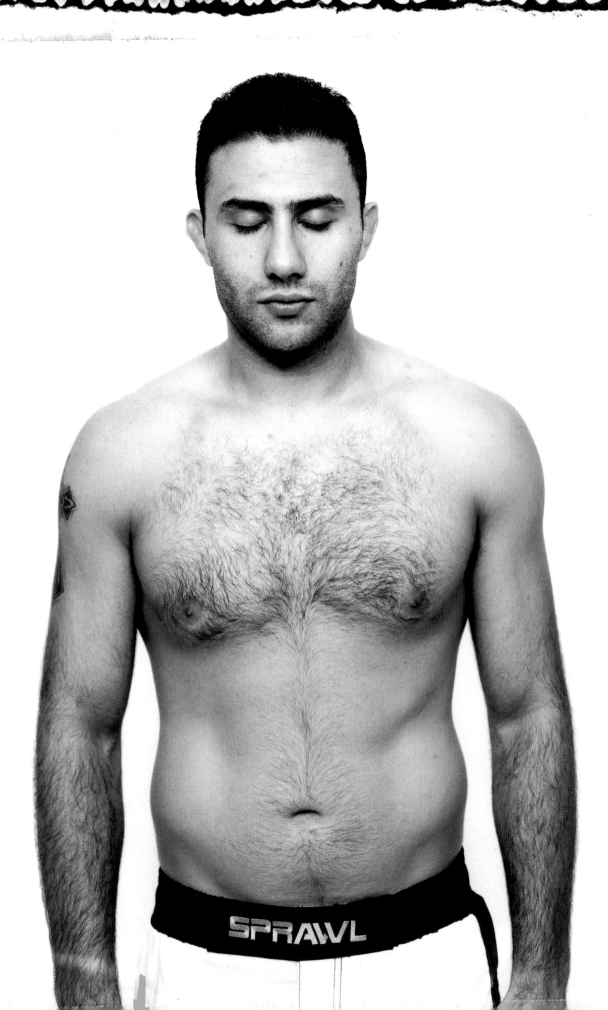

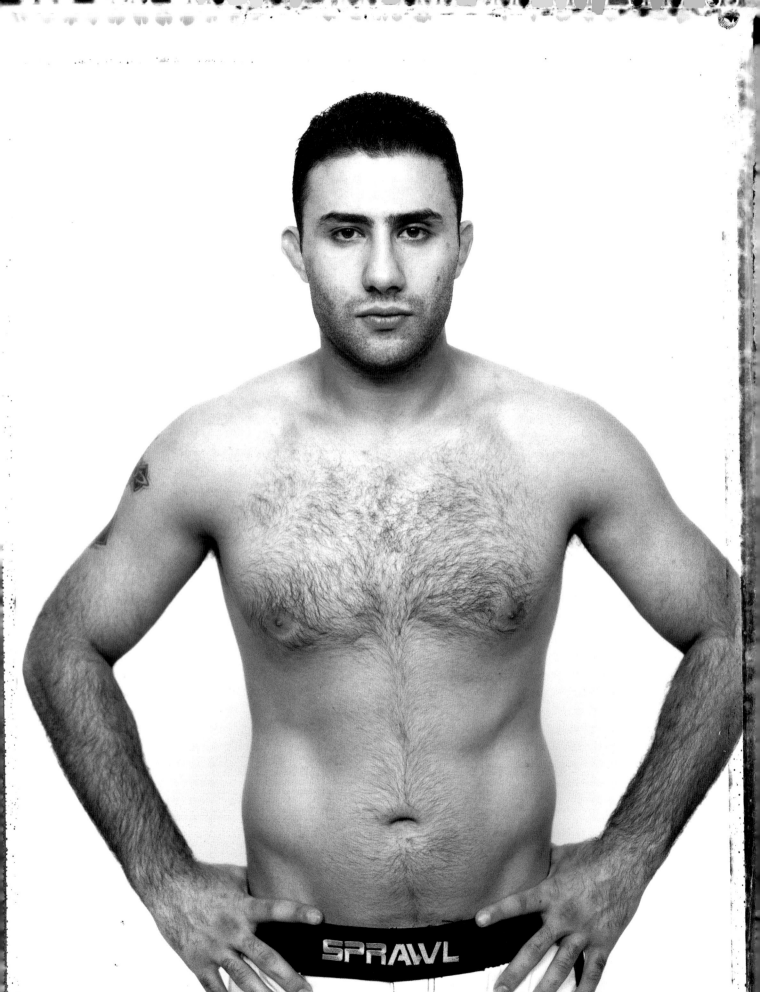

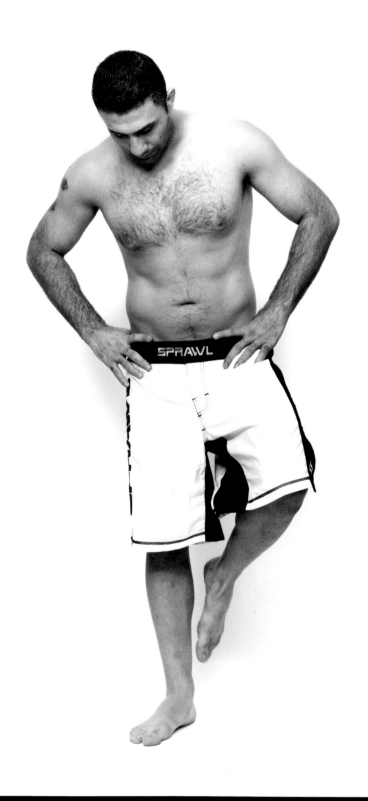

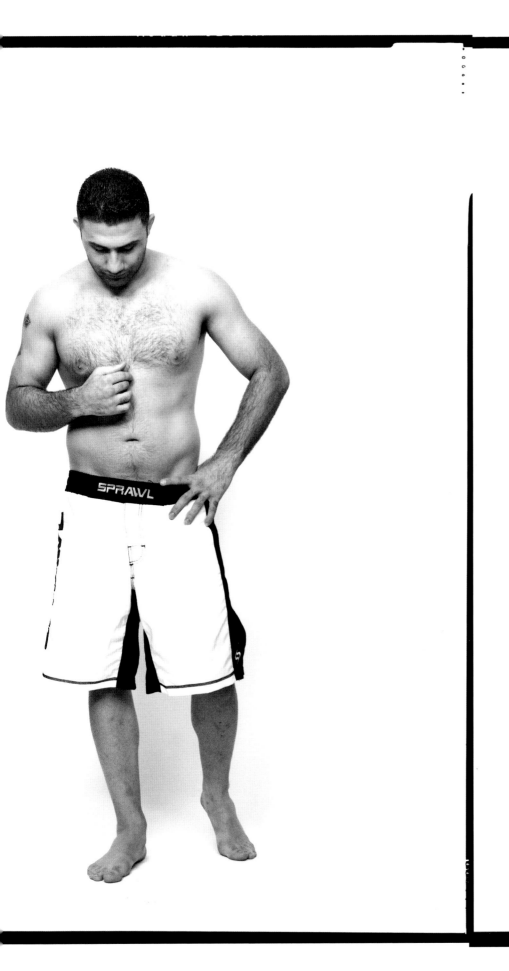

sugar

A big heart—

that's what I most admire in an opponent. An opponent that's willing
to go the distance and is not intimidated at all—
I admire that the most.

—RASHAD EVANS

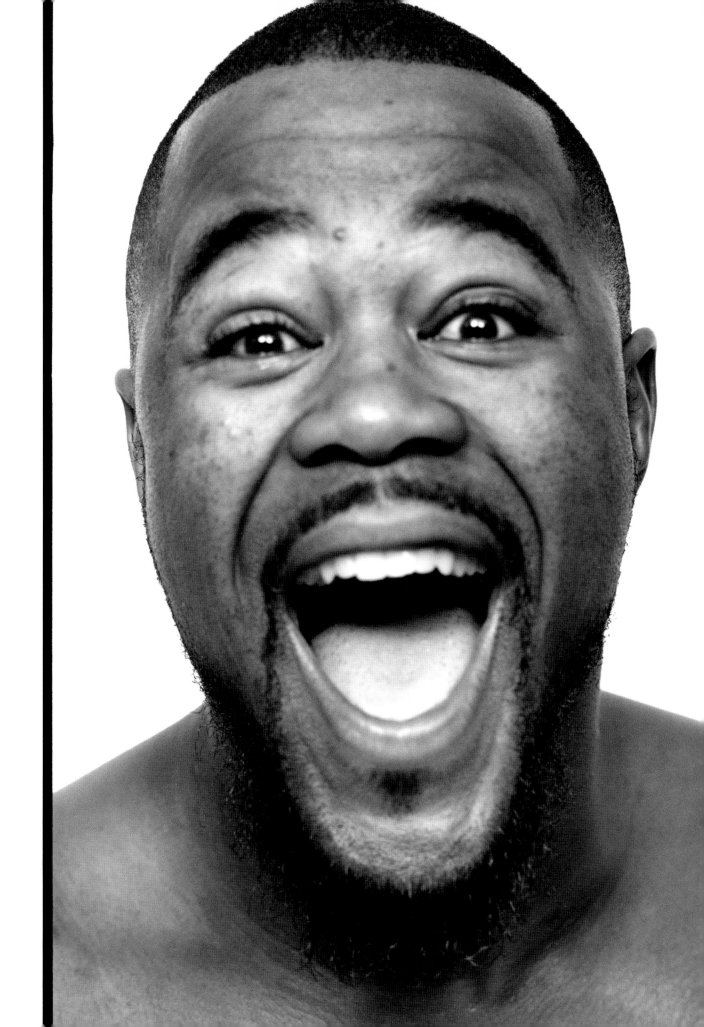

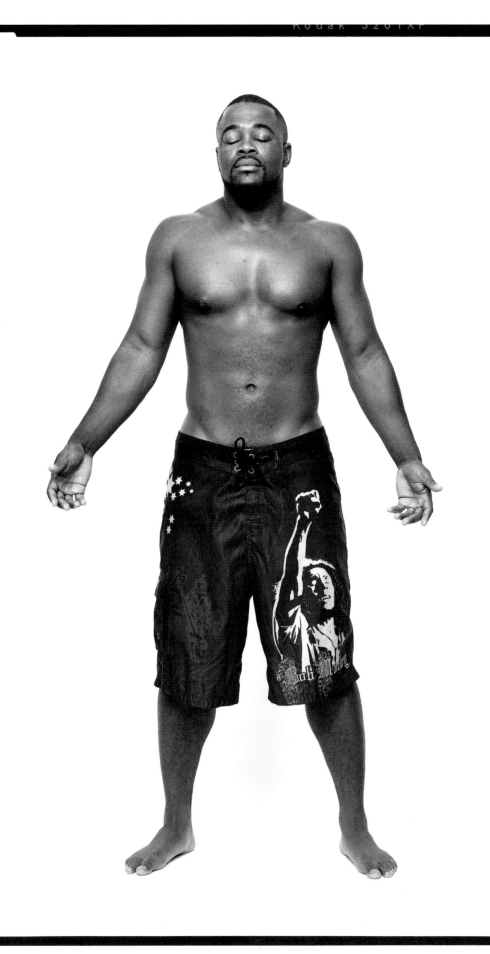

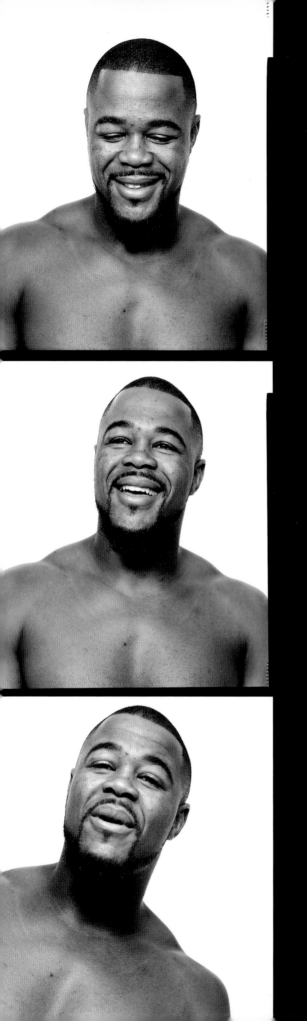

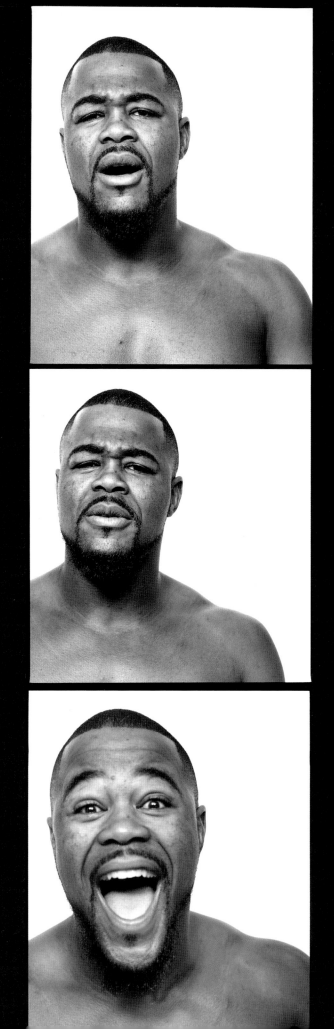

hand-

It's just him versus me—I've just got to go over there and beat him. **It's hard, but it's simple.** It's one thing to think about: Walk across the cage and just beat that guy.

some

I want to have my hard work pay off and be the best. I want to be able to make my mark and be able to make an impression. I don't want to be some guy that didn't make his mark.

—MATT WIMAN

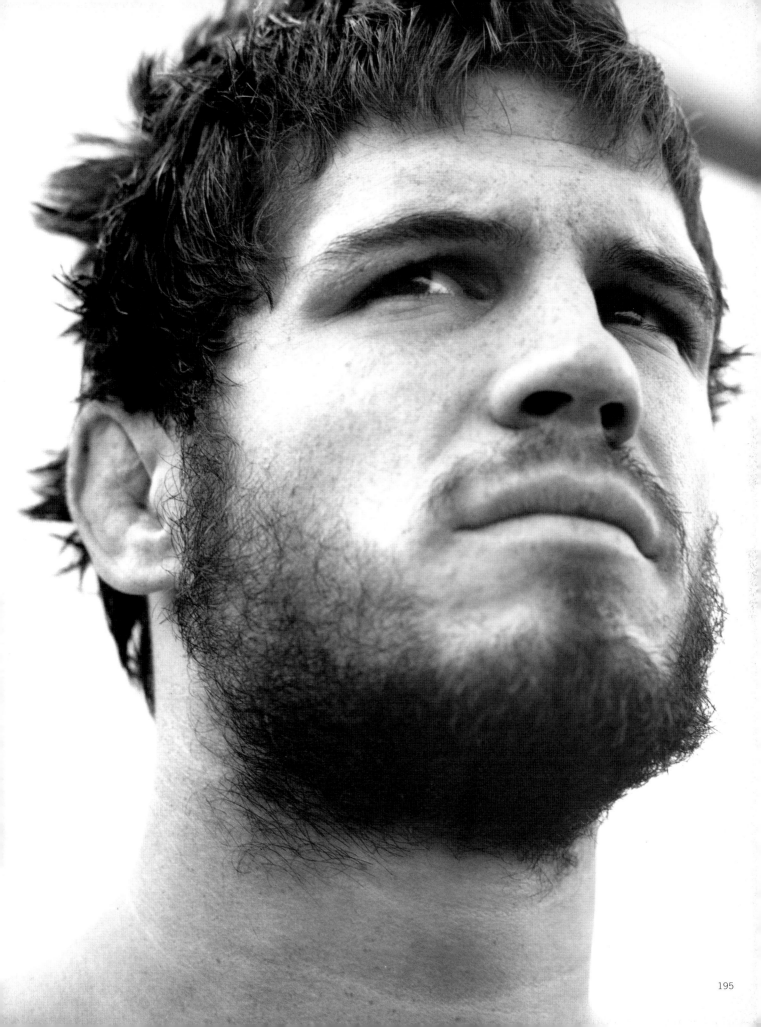

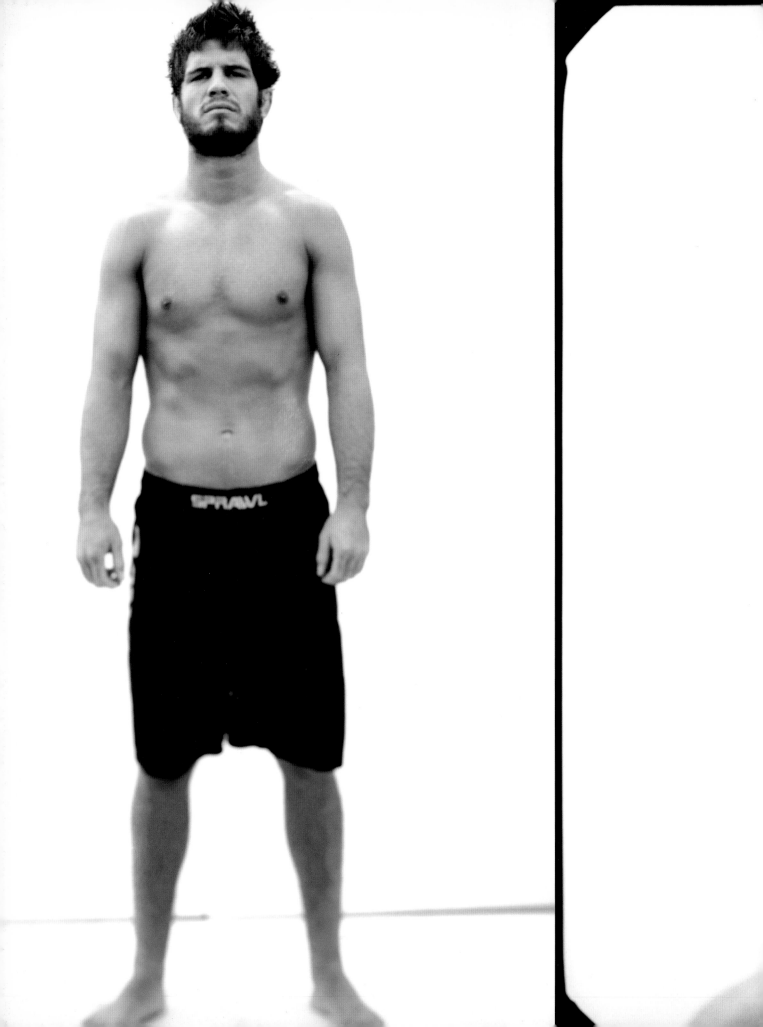

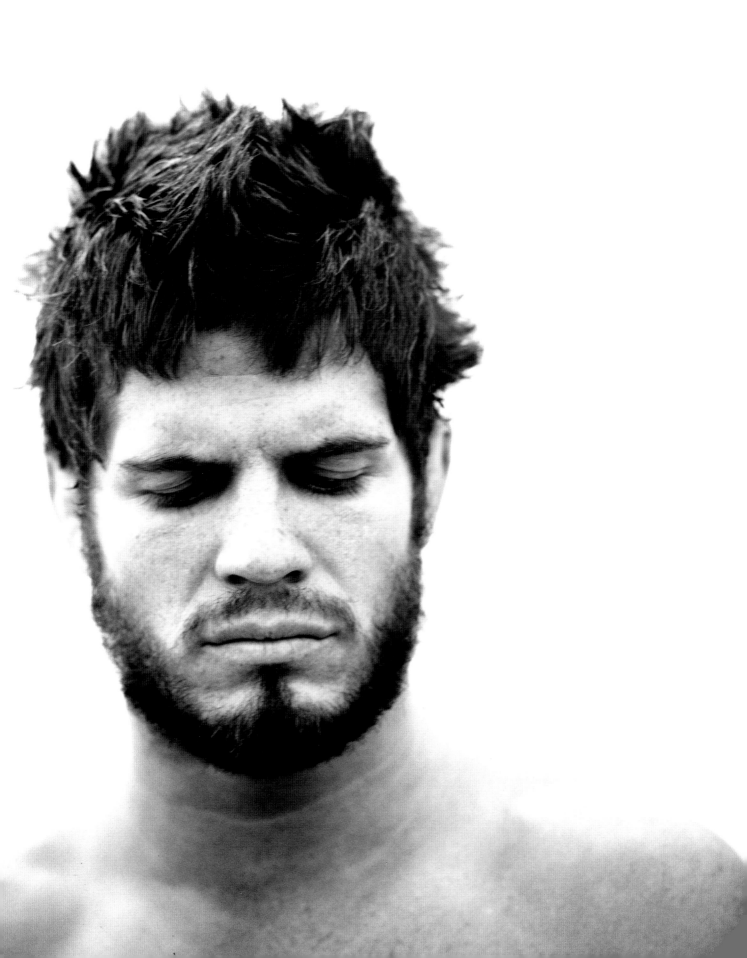

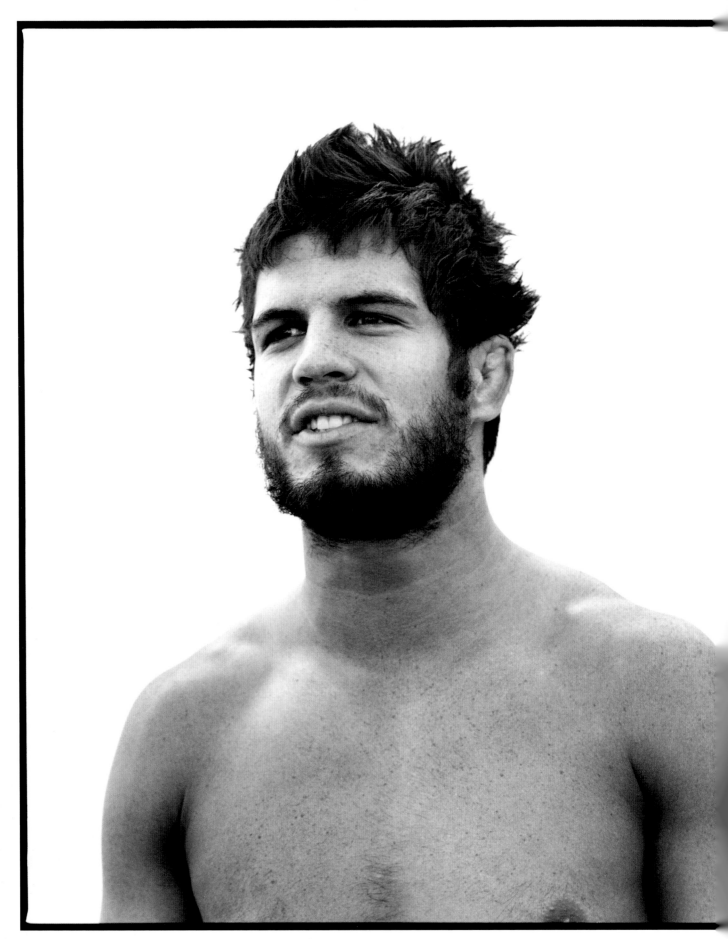

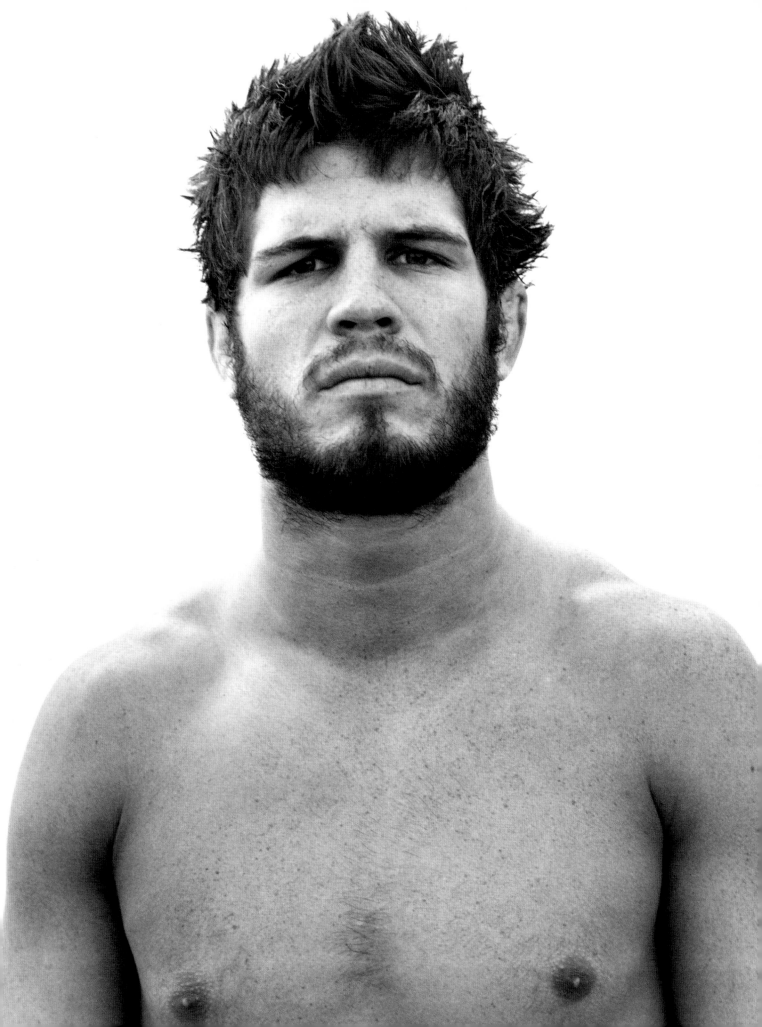

When I start to walk into the Octagon
I close my mind and I'm on autopilot.

napão

—GABRIEL GONZAGA

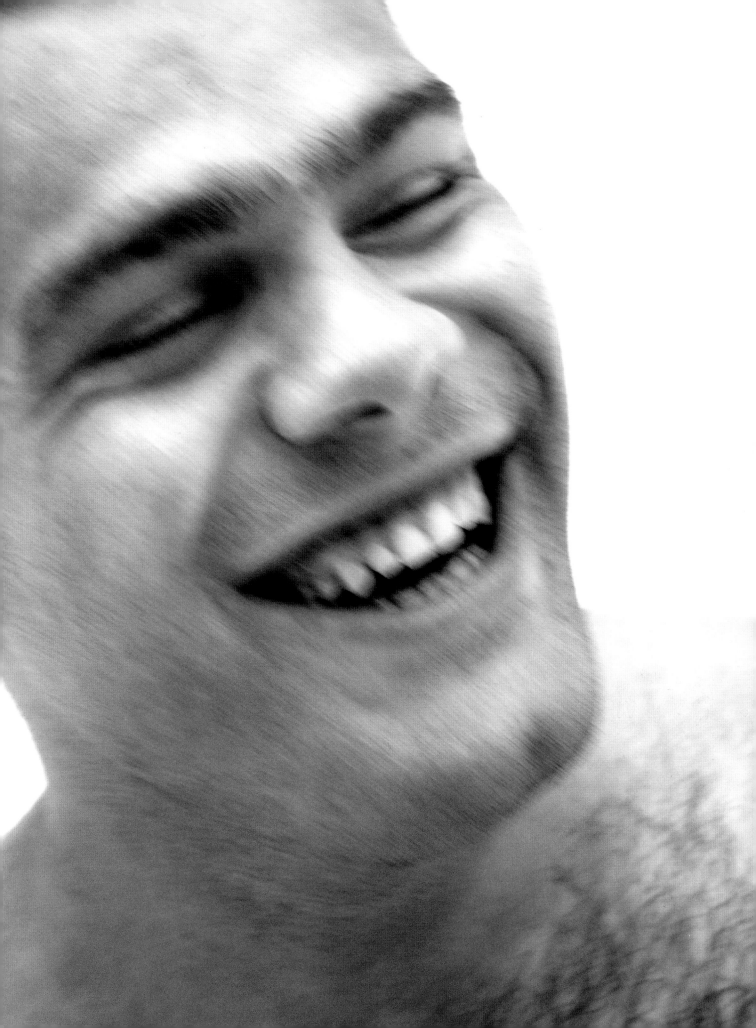

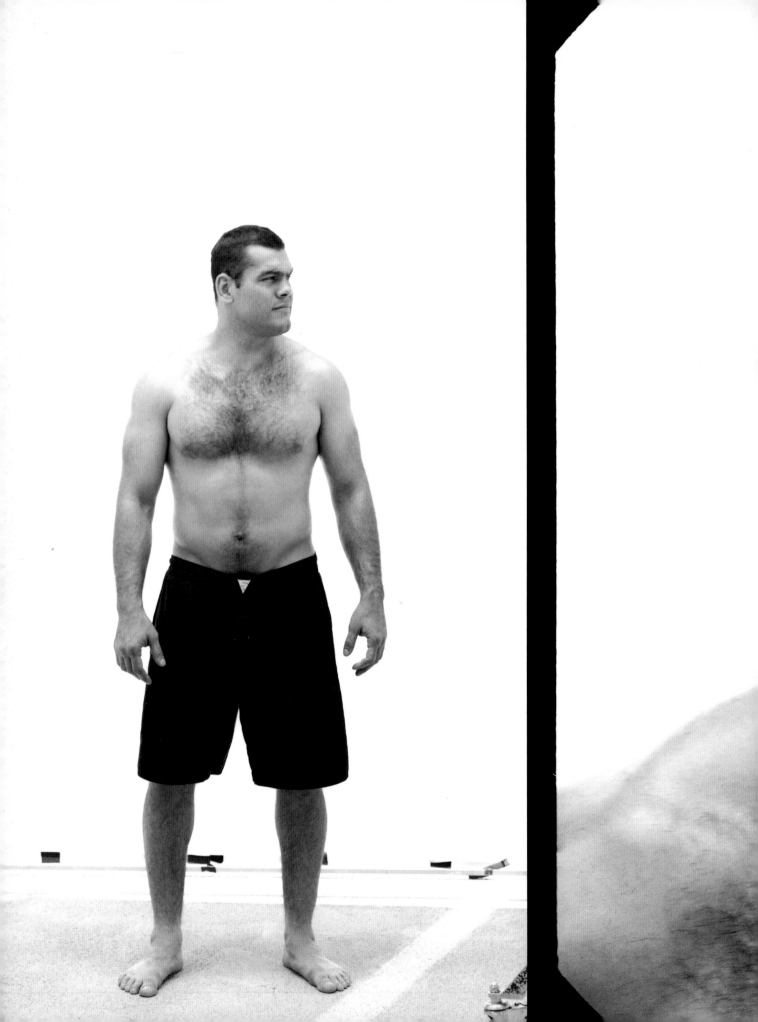

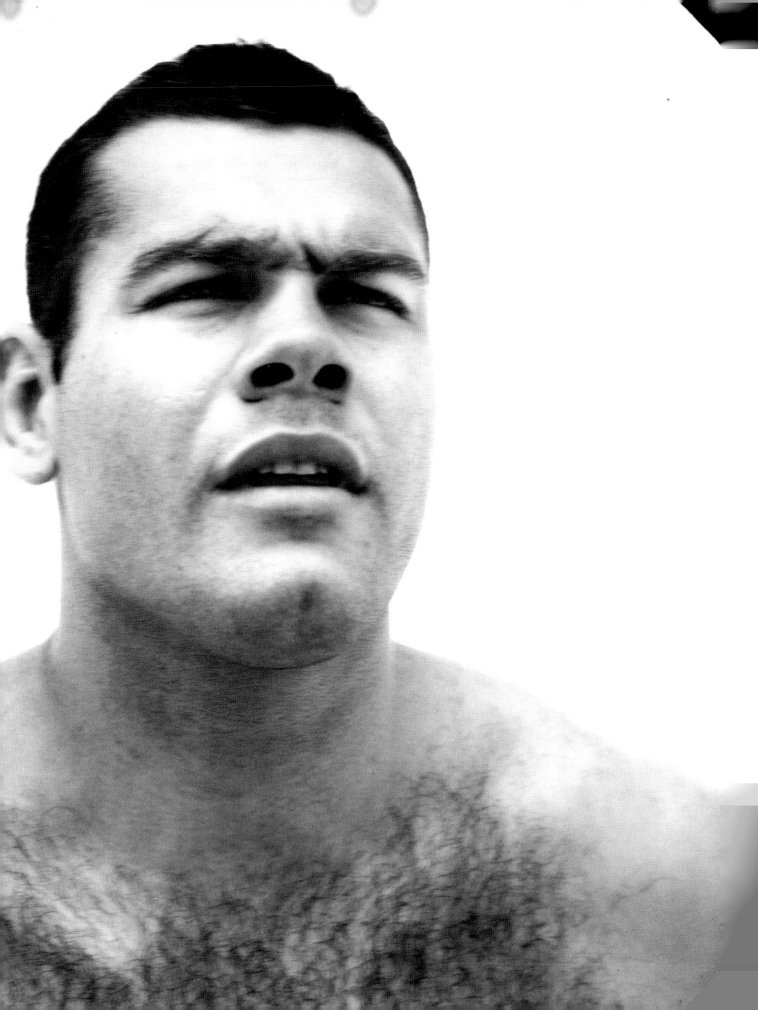

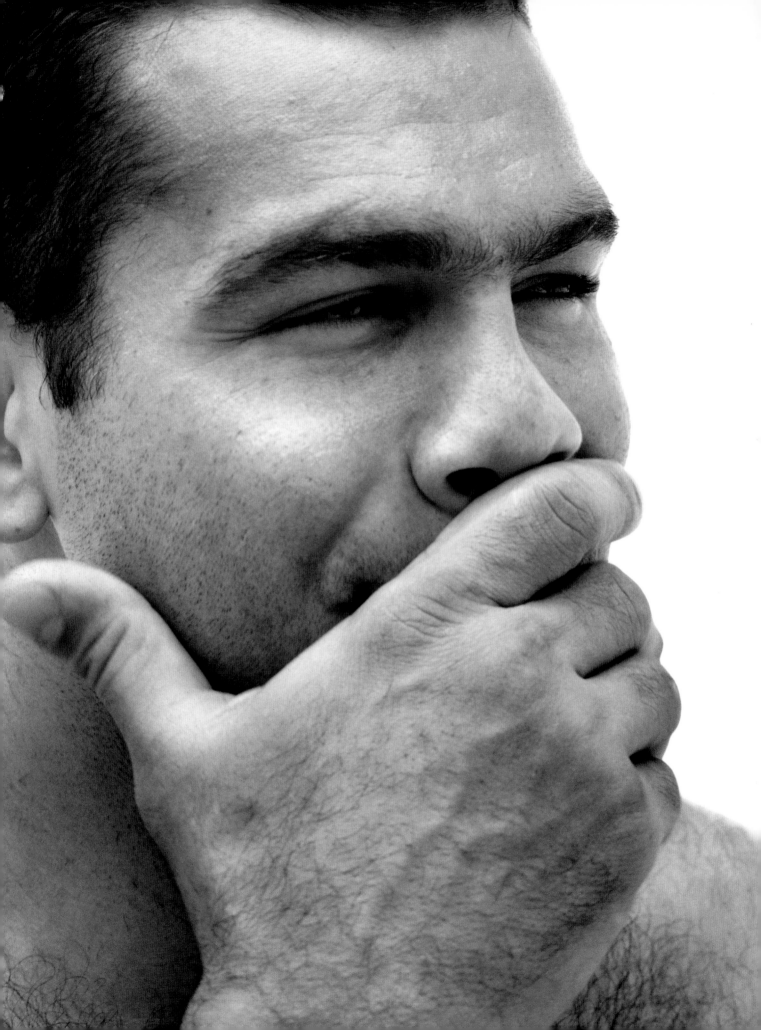

silva

"Once I'm in the Octagon, it's a job. And I know that to get better, I have to think that way. If I relax at all, I can lose."

—THIAGO SILVA

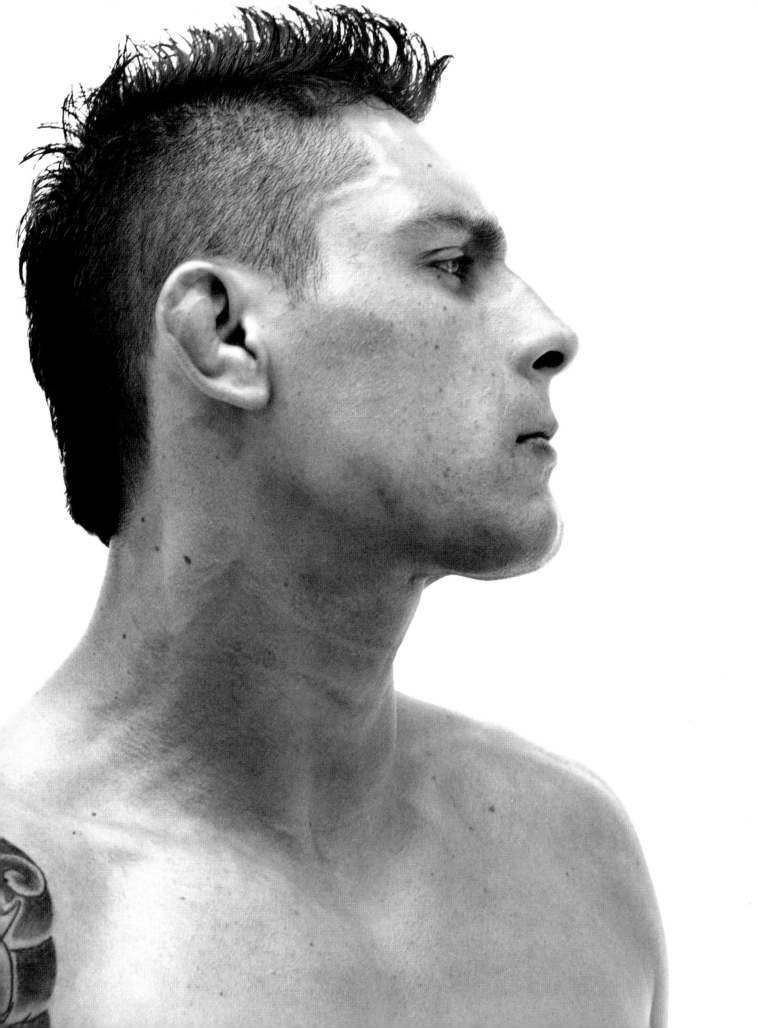

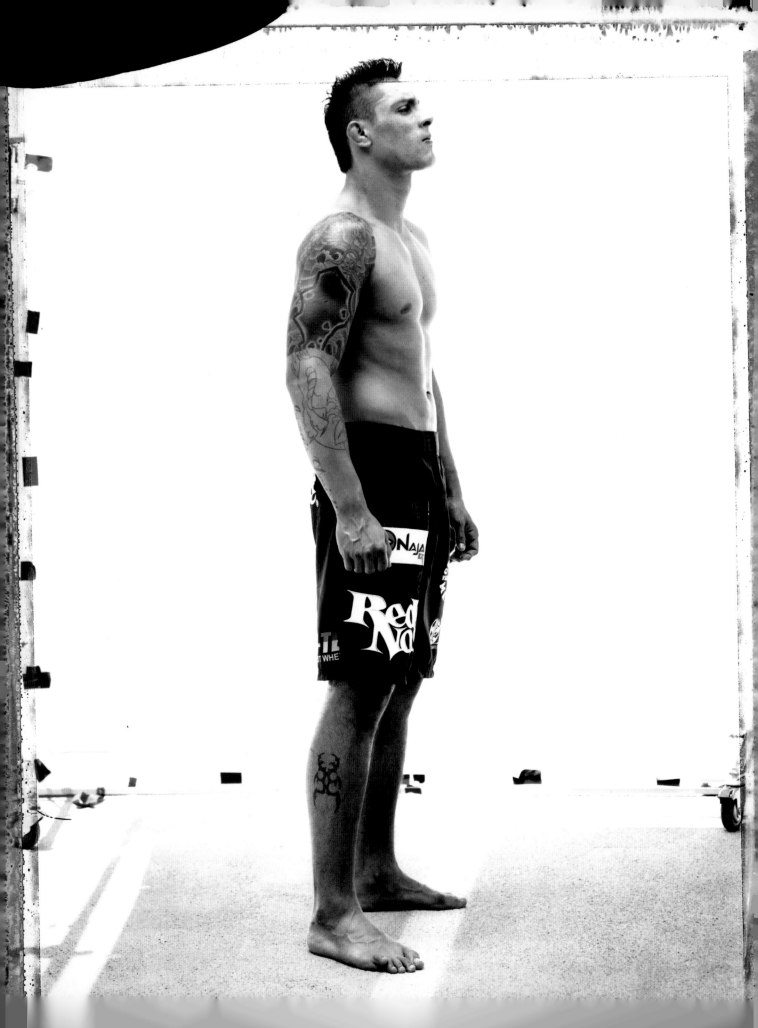

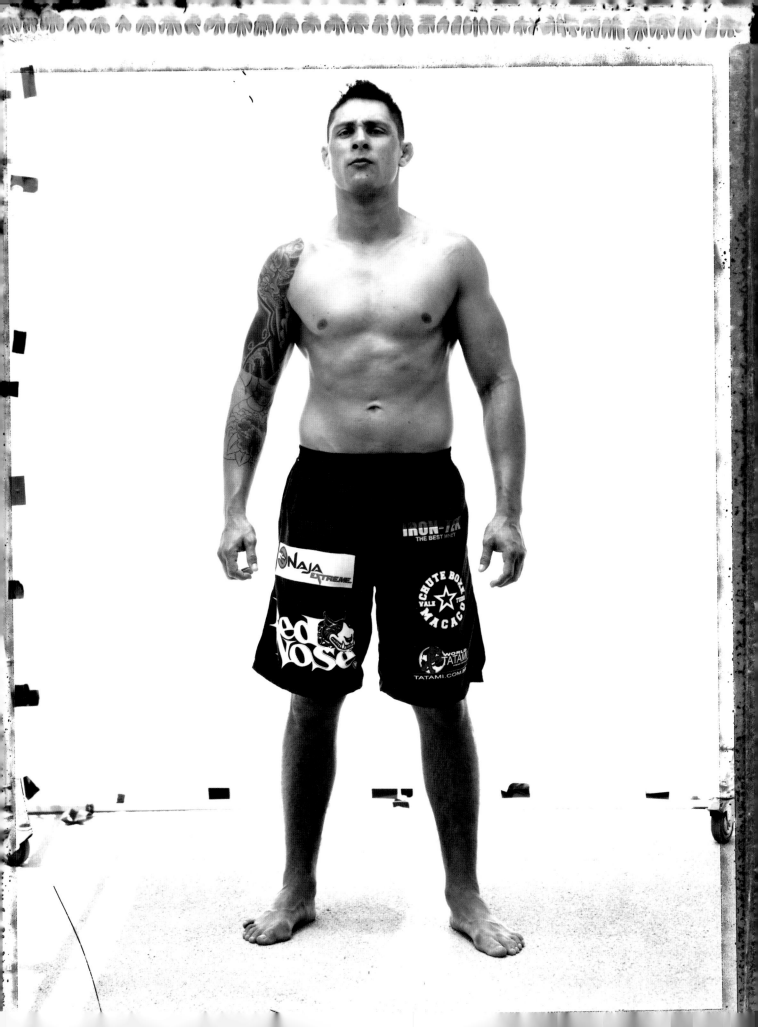

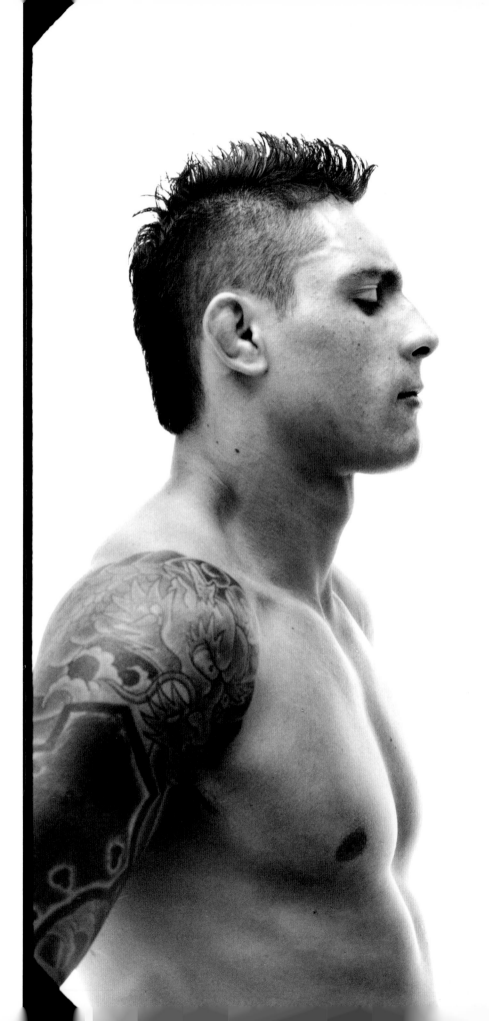

axe

I like to beat my opponent.
I like to knock out my opponent.
I like to fight standing—

mur-

because it's very emotional for the public.

derer

—WANDERLEI SILVA

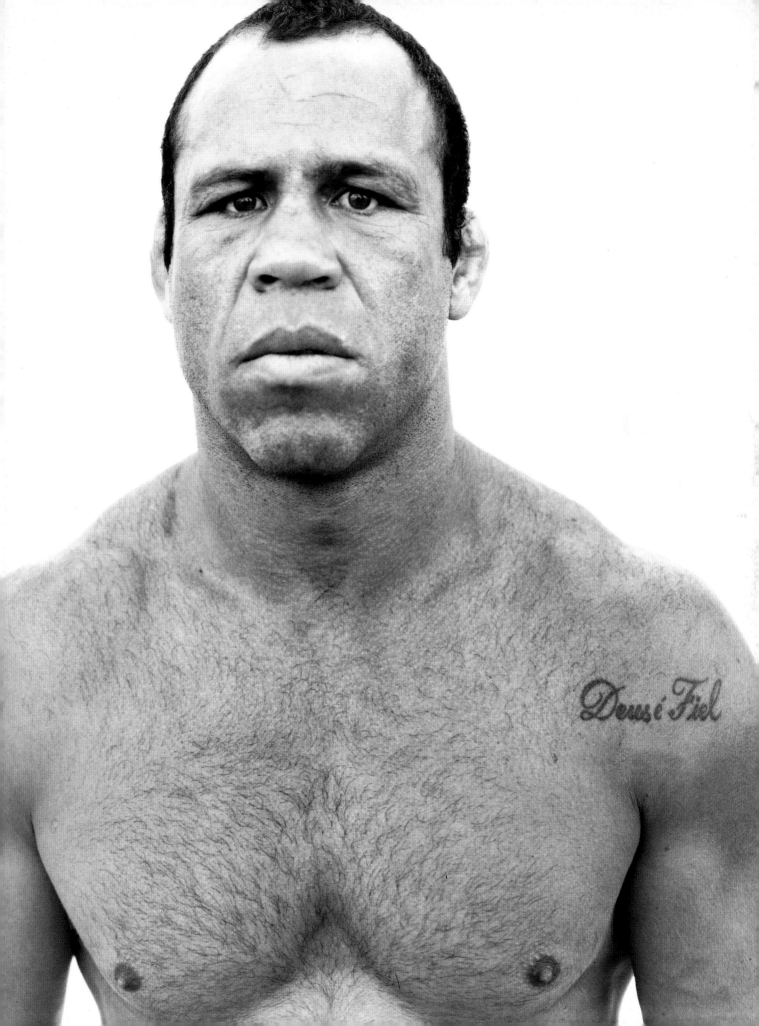

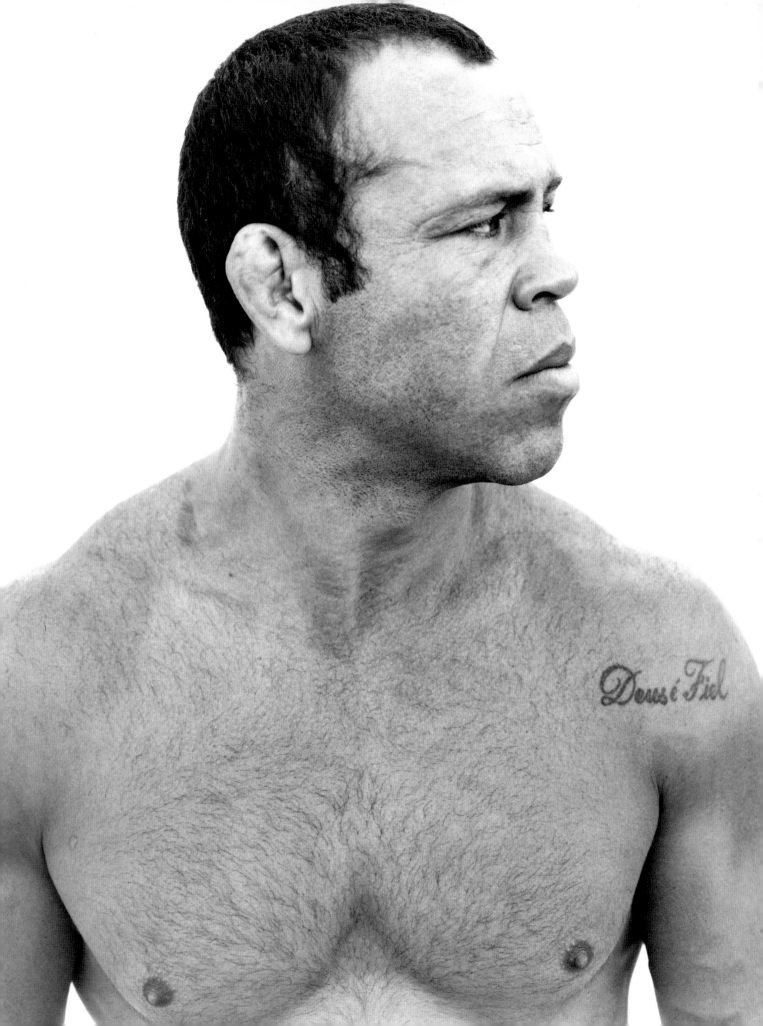

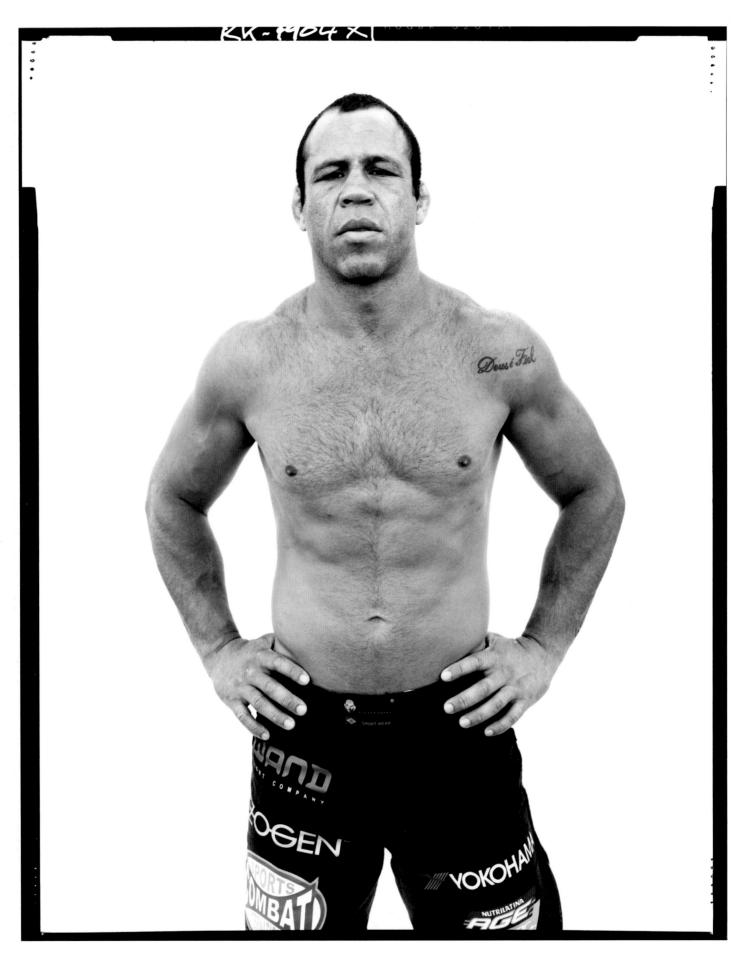

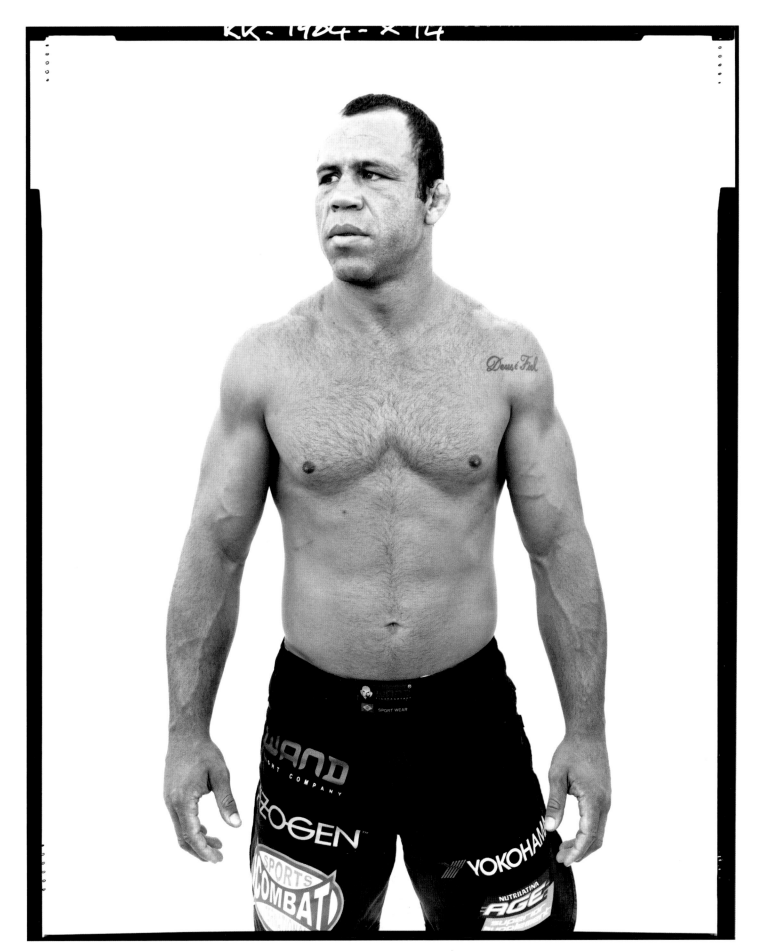

RR·1984 - X 14

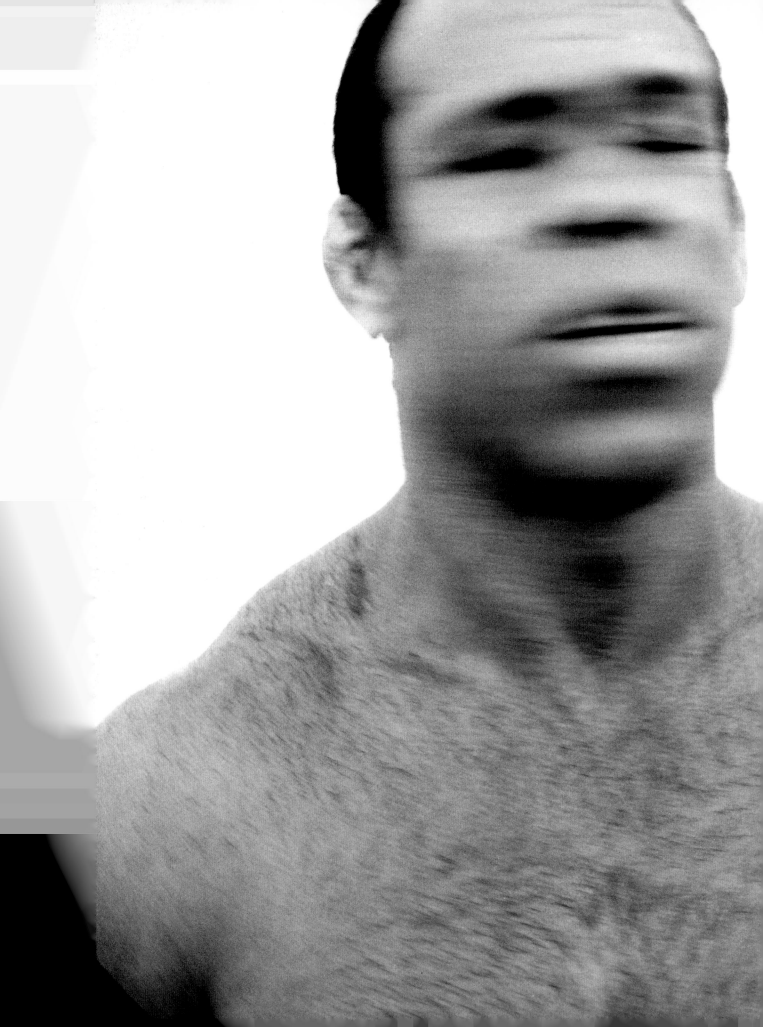

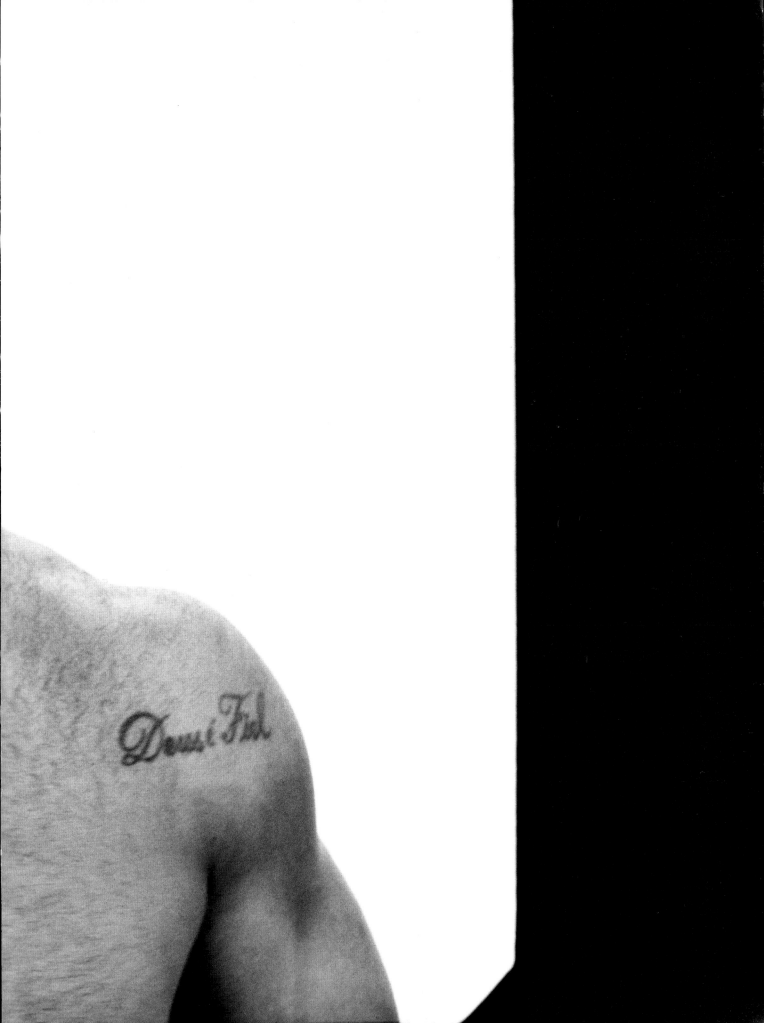

dana

Fighters are a breed apart.

They walk into a fight knowing that they may not come out the same person or with the same perspective as when they went in. And they accept this. They accept it because they fight to compete, they fight for the love of the sport, and they fight to test themselves in the truest way possible.

UFC fighters are some of the most real guys I know. They rise and they fall, and unlike the average person, both can happen in a single night. A fighter can teach us something about ourselves, about success and failure, about life. But they are not living a life like us. They are here to test the limits of what it really feels like to be alive.

—DANA WHITE

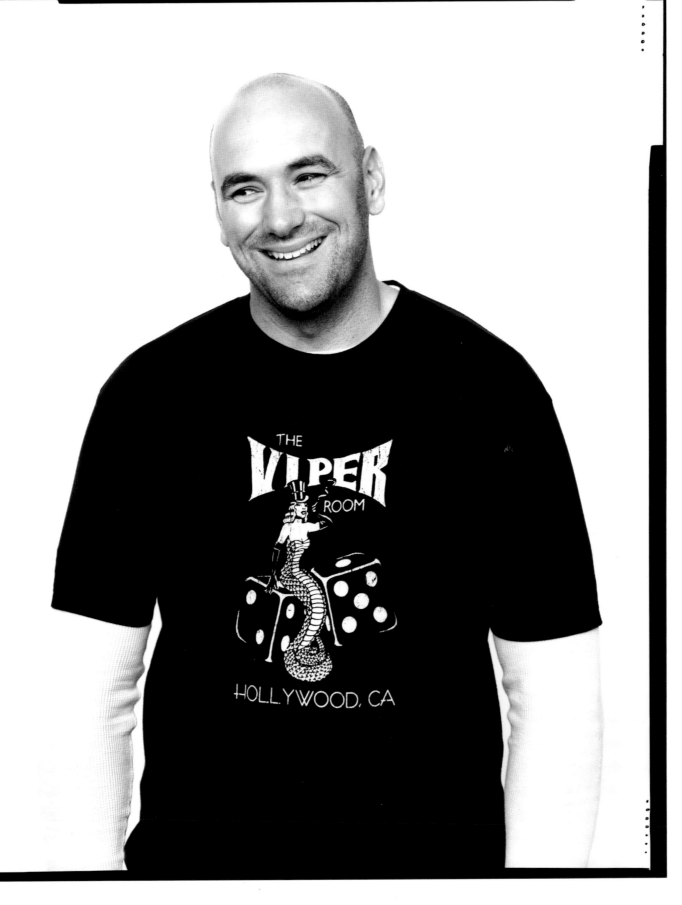

the stats

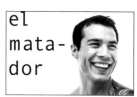

30 – 35 QUINTON JACKSON (rampage)
CLASS: Light Heavyweight
HEIGHT: 6' 1" WEIGHT: 205 lbs.
STRENGTH: Wrestling, strength,
slamming ability
BIRTHPLACE: Memphis, TN
DOB: June 20, 1978

62 – 67 ROGER HUERTA (el mata-dor)
CLASS: Lightweight
HEIGHT: 5' 9" WEIGHT: 155 lbs.
STRENGTH: Well rounded, composed
and confident, an exciting fighter
BIRTHPLACE: Los Angeles, CA
DOB: May 20, 1983

36 – 41 KEITH JARDINE (dean of mean)
CLASS: Light Heavyweight
HEIGHT: 6' 2" WEIGHT: 205 lbs.
STRENGTH: Well rounded
BIRTHPLACE: Butte, MT
DOB: October 31, 1975

68 – 73 CHEICK KONGO (kongo)
CLASS: Heavyweight
HEIGHT: 6' 4" WEIGHT: 240 lbs.
STRENGTH: Training since 5 years old,
focus and dedication to MMA
BIRTHPLACE: Paris, France
DOB: May 17, 1975

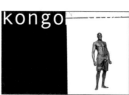

10 – 17 CHUCK LIDDELL (ice man)
CLASS: Light Heavyweight
HEIGHT: 6' 2" WEIGHT: 205 lbs.
STRENGTH: Excellent striker,
well-rounded grappler
BIRTHPLACE: Santa Barbara, CA
DOB: December 17, 1969

42 – 47 MATT SERRA (terror)
CLASS: Welterweight
HEIGHT: 5' 6" WEIGHT: 170 lbs.
STRENGTH: Submissions,
aggressive style
BIRTHPLACE: East Meadow, NY
DOB: June 2, 1974

74 – 79 IVAN SALAVERRY (ivan)
CLASS: Middleweight
HEIGHT: 6' 0" WEIGHT: 185 lbs.
STRENGTH: Well rounded
BIRTHPLACE: Toronto, Canada
DOB: January 11, 1971

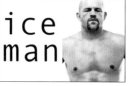
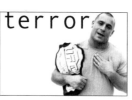
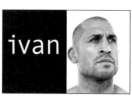

18 – 23 DIEGO SANCHEZ (night mare)
CLASS: Welterweight
HEIGHT: 5' 11" WEIGHT: 170 lbs.
STRENGTH: Excellent grappling skills
BIRTHPLACE: Albuquerque, NM
DOB: December 31, 1981

48 – 53 KENNY FLORIAN (ken flo)
CLASS: Lightweight
HEIGHT: 5' 10" WEIGHT: 155 lbs.
STRENGTH: Great jujitsu,
dangerous elbows
BIRTHPLACE: Westwood, MA
DOB: May 26, 1976

80 – 85 SPENCER FISHER (the king)
CLASS: Lightweight
HEIGHT: 5' 7" WEIGHT: 155 lbs.
STRENGTH: Stand-up fighting, heart
BIRTHPLACE: Cashiers, NC
DOB: May 9, 1976

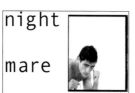
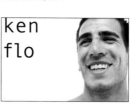
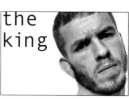

24 – 29 DAN HENDERSON (hendo)
CLASS: Middleweight
HEIGHT: 6' 1" WEIGHT: 185 lbs.
STRENGTH: Mental attitude, wrestling,
knockout power in both hands
BIRTHPLACE: Downey, CA
DOB: August 24, 1970

54 – 61 MAC DANZIG (danzig)
CLASS: Lightweight
HEIGHT: 5' 8" WEIGHT: 155 lbs.
STRENGTH: Mind, experience
BIRTHPLACE: Cleveland, OH
DOB: January 2, 1980

86 – 91 ANTONIO RODRIGO NOGUEIRA (mino-tauro)
CLASS: Heavyweight
HEIGHT: 6' 3" WEIGHT: 240 lbs.
STRENGTH: Stamina, great jujitsu
and boxing skills
BIRTHPLACE: Bahia, Brazil
DOB: June 2, 1976

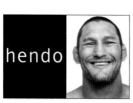
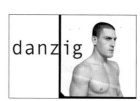
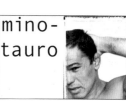

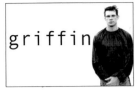

92 – 97 FORREST GRIFFIN
CLASS: Light Heavyweight
HEIGHT: 6' 3" WEIGHT: 205 lbs.
STRENGTH: Well rounded,
good grappling skills
BIRTHPLACE: Columbus, OH
DOB: March 16, 1979

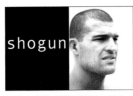

124 – 129 MAURICIO RUA
CLASS: Light Heavyweight
HEIGHT: 6' 1" WEIGHT: 205 lbs.
STRENGTH: Very aggressive, excellent
background in Muay Thai and jujitsu,
strength
BIRTHPLACE: Curitiba, Brazil
DOB: November 25, 1981

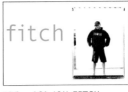

156 – 161 JON FITCH
CLASS: Welterweight
HEIGHT: 6' 0" WEIGHT: 170 lbs.
STRENGTH: Wrestling
BIRTHPLACE: Ft. Wayne, IN
DOB: February 24, 1978

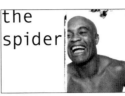

188 – 193 RASHAD EVANS
CLASS: Light Heavyweight
HEIGHT: 5' 11" WEIGHT: 205 lbs.
STRENGTH: Takedowns, takedown
defense
BIRTHPLACE: Niagara Falls, NY
DOB: September 25, 1979

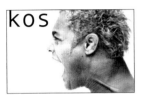

98 – 103 JOSH KOSCHECK
CLASS: Welterweight
HEIGHT: 5' 10" WEIGHT: 170 lbs.
STRENGTH: Wrestling, athleticism
BIRTHPLACE: Waynesburg, PA
DOB: November 30, 1977

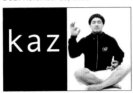

130 – 135 KAZUHIRO NAKAMURA
CLASS: Light Heavyweight
HEIGHT: 5' 10" WEIGHT: 205 lbs.
STRENGTH: Takedown skill, conditioning
BIRTHPLACE: Hiroshima, Japan
DOB: February 21, 1979

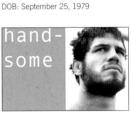

162 – 169 ANDERSON SILVA
CLASS: Middleweight
HEIGHT: 6' 2" WEIGHT: 185 lbs.
STRENGTH: Very well rounded,
phenomenal striker
BIRTHPLACE: Curitiba, Brazil
DOB: April 14, 1975

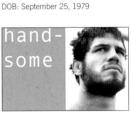

194 – 199 MATT WIMAN
CLASS: Lightweight
HEIGHT: 5' 10" WEIGHT: 155 lbs.
STRENGTH: Jujitsu and stand-up
BIRTHPLACE: Denver, CO
DOB: September 19, 1983

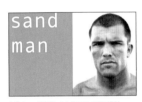

104 – 109 JAMES IRVIN
CLASS: Light Heavyweight
HEIGHT: 6' 2" WEIGHT: 205 lbs.
STRENGTH: Athletic ability,
powerful puncher
BIRTHPLACE: Huntington Beach, CA
DOB: September 12, 1978

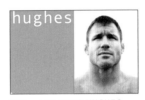

136 – 141 MATT HUGHES
CLASS: Welterweight
HEIGHT: 5' 9" WEIGHT: 170 lbs.
STRENGTH: Takedowns, wrestling ability,
physical strength
BIRTHPLACE: Hillsboro, IL
DOB: October 13, 1973

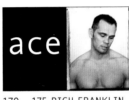

170 – 175 RICH FRANKLIN
CLASS: Middleweight
HEIGHT: 6' 1" WEIGHT: 185 lbs.
STRENGTH: Excellent striking skills,
good conditioning, well rounded
BIRTHPLACE: Cincinnati, OH
DOB: October 5, 1974

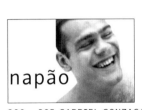

200 – 205 GABRIEL GONZAGA
CLASS: Heavyweight
HEIGHT: 6' 2" WEIGHT: 242 lbs.
STRENGTH: Striking and submissions
BIRTHPLACE: Rio de Janeiro, Brazil
DOB: May 18, 1979

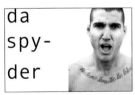

110 – 115 KENDALL GROVE
CLASS: Middleweight
HEIGHT: 6' 6" WEIGHT: 185 lbs.
STRENGTH: Height, heart,
and a desire to never give up
BIRTHPLACE: Maui, HI
DOB: November 12, 1982

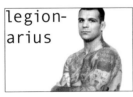

142 – 147 ALESSIO SAKARA
CLASS: Middleweight
HEIGHT: 6' 0" WEIGHT: 185 lbs.
STRENGTH: Striking
BIRTHPLACE: Rome, Italy
DOB: September 2, 1981

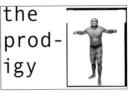

176 – 181 BJ PENN
CLASS: Lightweight
HEIGHT: 5' 9" WEIGHT: 155 lbs.
STRENGTH: Excellent submissions,
strong stand-up
BIRTHPLACE: Kailua, HI
DOB: December 13, 1978

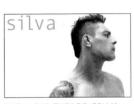

206 – 211 THIAGO SILVA
CLASS: Light Heavyweight
HEIGHT: 6' 1" WEIGHT: 205 lbs.
STRENGTH: Striking, aggressiveness
BIRTHPLACE: São Paulo, Brazil
DOB: November 12, 1982

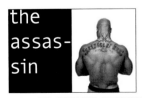

116 – 123 HOUSTON ALEXANDER
CLASS: Light Heavyweight
HEIGHT: 6' 0" WEIGHT: 205 lbs.
STRENGTH: Punching power,
athleticism, overall strength
BIRTHPLACE: East St. Louis, IL
DOB: March 22, 1972

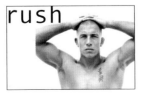

148 – 155 GEORGES ST-PIERRE
CLASS: Welterweight
HEIGHT: 5' 10" WEIGHT: 170 lbs.
STRENGTH: Athleticism,
very well rounded
BIRTHPLACE: Montreal, Québec, Canada
DOB: May 19, 1981

182 – 187 KARO PARISYAN
CLASS: Welterweight
HEIGHT: 5' 10" WEIGHT: 170 lbs.
STRENGTH: Excellent grappler,
great throws
BIRTHPLACE: Yerevan, Armenia
DOB: August 28, 1982

212 – 219 WANDERLEI SILVA
CLASS: Light Heavyweight
HEIGHT: 5' 11" WEIGHT: 205 lbs.
STRENGTHS: Striking power and
technique, intensity, world-class
experience
BIRTHPLACE: Curitiba, Brazil
DOB: July 3, 1976

To my son Oscar,
I hope this book inspires courage, commitment, dedication, and confidence, all the
qualities I encountered when photographing these great athletes.
Love, Papa

Special thanks to my wife and Oscar's mom, Delphine Krakoff. I'd also like to thank my friend and
photography right hand, Cari Vuong; Sam Sheridan, author of *A Fighter's Heart: One Man's Journey
Through the World of Fighting*; Coach's Vice President of Public Relations—Raina Penchansky;
Senior Director of Public Relations—Heather Feit; Creative Director—Rebecca Wong Young;
and the following who contributed their time and talents to creating this book:

UFC
Dana White
Lorenzo Fertitta
Frank Fertitta III
Jim Byrne

Coach
design
Alberta Testanero
production
Diane Ormrod
Nik Glatkauskas
Kevin Canfield
Jeremy Freed
project management
Robin Benerofe
public relations
Danielle Crinnion

Viking Studio
Megan Newman
Amanda Tobier
Miriam Rich
Fabiana Van Arsdell
Amy Hill

ICM
Kate Lee

And all the fighters who so generously gave their time to the project.